Museum

Governance

Marie C. Malaro

Museum
Governance

❖ ❖ ❖

MISSION

ETHICS

POLICY

Smithsonian Institution Press

Washington and London

(∞) The paper used in this publication meets the minimum requirements
of the American National Standard for Permanence of Paper
for Printed Library Materials Z39.48-1984.

Library of Congress Cataloging-in-Publication Data
Malaro, Marie C.
 Museum Governance : Mission, Ethics, Policy / Marie C. Malaro.
 p. cm.
 Includes bibliographical references.
 ISBN 1-56098-363-9
 1. Museums—Management. 2. Nonprofit organizations—Management.
3. Public relations—Museums. 4. Cultural property, Protection of. 5. Ethics.
6. Museum techniques. I. Title.
AM121.M35 1994
069.5—dc20 93-49384

British Library Cataloguing-in-Publication Data is available.
Printed in the United States of America
8 7 6 5 4 3 2 99 98 97 96 95

To my family

Jim,

James Eaton,

and

Amy Louise

❖ Contents

❖ *Preface*

There is a story in *McGuffey's Reader*[1] that illustrates why I wrote this book. The lesson unfolds in a conversation about philanthropy between Mr. Fantom and Mr. Goodman. Mr. Fantom wants "to make all mankind good and happy." Mr. Goodman suggests that it might be wiser to start with one's own neighborhood. This is not for Mr. Fantom. He is filled with the wrongs of the world and can only see reform on a grand scale. When Mr. Goodman suggests some modest local reform projects they can undertake, Mr. Fantom rejects this, explaining that he is much too preoccupied watching for "great occasions" to prove his worth. But Mr. Goodman cautions that if we look only for the "great occasions" and fail to take the many smaller opportunities to do good that are within our grasp, life passes and little improves.

The story deserves the attention of those interested in the nonprofit sector, especially members of nonprofit governing boards. Many serious problems beset the nonprofit sector today, and there is the temptation to dwell on complaining and looking for the grand cure. If there is to be a strengthening of the nonprofit section, however, it must come about through thousands of small good actions by those who govern our many nonprofit organizations. Board members have special opportunities to bring about change, but to do so they must understand their core responsibilities and appreciate the importance of consistent and thoughtful interpretation of those responsibilities.

This book is addressed to board members of cultural nonprofits, and, in particular, to those associated with museums. Its purpose is to encourage more attention, and more informed attention, to core responsibilities and to everyday situations that cumulatively affect the health of the nonprofit sector. When conscientiously governed, nonprofits provide daily proof to the publics they serve that the third sector enriches our society in ways that cannot be duplicated by government or business. It is this daily evidence, not marketing or lobbying, that assures faithful support of our nonprofit sector.

Topics covered in Part 1 include the nature of the nonprofit sector, trusteeship, the role of ethics, trustees and the future of the nonprofit sector, and the scope of board education. Part 2 looks at a series of practical matters that arise in the management of museum collections and provides food for thought for those charged with establishing museum policy. Analyzing and resolving these matters invariably require resorting to the general principles set forth in Part 1. Topics covered include collections management policies, deaccessioning, oversight, restricted gifts, automation of records, and repatriation.

The reader will notice repetition here and there. Each chapter was written to stand on its own, but all harken back to some common principles relating to nonprofit governance. Repetition was purposely retained to impress upon the reader the importance and relevance of those principles to everyday situations.

An essay presents a personal point of view and this volume is most definitely a compilation of essays. It should be read with this in mind.

Part One

❖ ❖ ❖

Lessons
for
Board
Members

1 ❖ On Trusteeship

Anyone who has long observed museums confront a steady parade of governance issues in their efforts to remain afloat could conclude that the nonprofit sector (or at least that part of the sector devoted to cultural organizations) is woefully adrift.[1] In good measure the problem appears to be chronic preoccupation with the perceived crisis of the moment. The result is frantic paddling without evidence of map or compass. Surely better direction should be available for those charged with governance of nonprofits; when searching for direction a good place to start is with fundamental concepts.

Most cultural organizations are nonprofit entities chartered within a particular state to carry out a charitable (that is, educational) purpose. As private (nongovernmental) entities devoted to a public purpose they join the nonprofit or "third" sector of our society. (The other two segments are, of course, government and the for-profit sector.) Governance of nonprofit entities is vested in independent boards of trustees.[2] In a quest for direction, a necessary first step is a clearer understanding of the non-

This chapter is based on a keynote address, "A Pause to Reflect: Where Are We Now," given at the annual American Law Institute–American Bar Association seminar "Legal Problems of Museum Administration," Chicago, March 1992. Copyright to the transcript of the talk © 1992 is held by The American Law Institute. This altered version is published with the concurrence of the American Law Institute–American Bar Association Committee on Continuing Professional Education.

profit sector itself. From there can be explored the role of the board, or "trusteeship," as that term is used within the sector. Thoughtful attention to these two basic topics—the nature of the nonprofit sector and trusteeship—can provide the individual trustee with a wealth of guidance as he or she pursues governance responsibilities.

The Nonprofit Sector

In his book *Managing a Nonprofit Organization*, Thomas Wolf remarks on the negative label we have given to the nonprofit sector.

> Suppose you asked someone "What is an elephant?" and the person answered, "An elephant is a nonhorse." You would probably find the answer unsatisfactory . . . It tells us very little about the essential characteristics of this type of entity.[3]

Most members of the general public never get beyond the unsatisfactory answer; their understanding of the sector remains limited to what it can or cannot now do, rather than knowing the sector's essential characteristics—why it exists. If pressed, they may be able to explain that nonprofits must be formed to serve a public purpose and that "nonprofit" does not mean that the organization cannot earn money. They may even hasten to elaborate that by law any surplus earned by a nonprofit must be devoted to furthering the organization's public purpose. But this nondistribution constraint, as the control on surplus distribution is frequently called, tells the listener nothing positive about the organization. Is there more? Ah, some may add, these nonprofits, especially cultural organizations, usually are exempt from many taxes; they can attract gifts, grants, and government subsidies; they may accept volunteer services and engage in entrepreneurial activity; and they even enjoy special postal rates. But all these are benefits, not essential characteristics. If this is the sum total of one's understanding of the nonprofit sector, one might logically conclude that effective management of a nonprofit consists mainly of skillful manipulation of all benefits that can be claimed. This approach might work for a while but only until benefits become scarce or the right to benefits is challenged. How then does one navigate in uncharted waters?

There definitely is something more to know about the nonprofit sector and it is found in a better understanding of why our society sustains this large third sector. What are the justifications for the sector? A 1990 publi-

cation of the National Center for Nonprofit Boards cites 1988 statistics showing over 1.25 million nonprofit boards in this country. The same publication estimates that such boards control charitable resources of over $100 billion and that nonprofit organizations employ more than 7 percent of the national workforce.[4] No other country can begin to boast of such a benevolent colossus within its borders. Why have we fostered this third sector when other societies find government and the private sector sufficient to their needs? Answering this question gives positive information about the nature of our nonprofit sector.

Only recently has attention been paid to justifying the existence of the nonprofit sector, without doubt because of the sector's growing importance in our lives and because of permutations within the sector itself. Historians, sociologists, economists, lawyers, and others are presenting an array of explanations and theories about how the sector arrived at its present state.[5] Although different viewpoints abound, certain arguments are generally accepted, each with continuing practical applications for those charged with governing cultural nonprofits.

The first argument in support of the nonprofit sector is that the sector fosters diversity. If, like most nations, we looked primarily to our government for support of cultural endeavors, we would have to expect that cultural activities would conform to prevailing majority views. Democratic government responds to the values of the majority, and it can promulgate only one standard at a time. Accordingly, those holding new or relatively unpopular ideas are at a disadvantage when seeking avenues of expression. When cultural endeavors are fostered by a nonprofit sector, the situation is substantially different. The nonprofit sector can accommodate many voices and many alternatives, the only restraints being that the activities must fall within the broad "charitable" category and voluntary support must be obtained.[6] Thus, the nonprofit sector provides a voice for minority groups, for new ideas, for criticism of accepted practices, and for matters that are forbidden to government.

> This pluralist argument for diversity . . . is probably the most important from the point of view of political theory, for it addresses the central paradox of democracy—that the people are sovereign but many: there is not one will of the people but several, sometimes contradictory wills.[7]

Accordingly, the nonprof]it sector supplies diversity, a vital component of democracy and one that cannot be duplicated by government. Diversity is part of the substance of the nonprofit sector.

A second argument in support of the nonprofit sector is that in certain instances the sector encourages greater quality of service or product. In our capitalistic society nearly everything is measured in economic terms and the rules of the marketplace are sacrosanct. Is it efficient? Will it pay for itself? Will it make money? These are inevitable questions in both the for-profit and government sectors. But experience tells us that some endeavors deemed essential to the fabric of our society are thwarted by the marketplace. In other words, if the economist's bottom line must be met, these activities will either fall by the wayside or be compromised. Classic illustrations abound: The theater group that would like to take a chance on a new play but needs to break even at the box office; the artist who does portraits in order to eat rather than abstracts, which are her forte; the privately controlled school that feels compelled to cut back on individual attention in order to stay afloat. For activities of this nature, the nonprofit sector provides a supportive atmosphere not available in the for-profit sector. The nonprofit sector can judge success in terms of quality of product or service, not by measuring the bottom line, and hence provides a home for those endeavors that warrant protection from the rigors of the marketplace.[8] Quality or service for its own sake is part of the substance of the nonprofit sector.

A third argument in support of the nonprofit sector is that it encourages personal participation in the betterment of society, thus permitting individual growth beyond that afforded by the for-profit and government sectors. Volunteerism is at the heart of the nonprofit sector and volunteerism, in the true sense, is virtue in action. But even volunteerism motivated by selfish interests can make for a better and more compassionate individual. One cannot reach out and lend assistance without being reminded of the importance of community—the fact that we are social beings and that ultimately we need each other. The for-profit sector affords little incentive for volunteerism, and government, while able to utilize volunteers, must impose all kinds of restraints in order to preserve the even-handedness and accountability demanded of it. In contrast, the nonprofit sector offers fertile ground for even the faintest desire to do something for the benefit of society, and it can accommodate both spontaneous and highly structured endeavors. Opportunity for individual growth is part of the substance of the nonprofit sector.

If one accepts that diversity, quality for its own sake, and individual growth are substantive components of the nonprofit sector, logic dictates that those who operate within the sector conduct themselves accordingly.

Rational people do not weaken or destroy what is essential to their well-being. But when one looks at some of the day-to-day decisions that are being made or condoned by boards of cultural nonprofits, rationality appears to be in short supply. When the cultural nonprofit aggressively touts itself to the local community as a heavy player in the tourism business, what happens to the "quality component" that justifies the non-profit sector? Can a cultural organization really focus on quality when it has placed itself in a position where drawing capacity alone determines its fate? And how many cultural nonprofits dive enthusiastically into cause-related marketing partnerships with commercial organizations or package solicitations for corporate sponsorships that are music to marketing department ears? So much for the argument that nonprofits in order to encourage quality need to be free from traditional marketplace pressures.

Rare is the nonprofit board that does not seek more government grants or other government subsidies. But how does this affect the diversity that comes from the sector's freedom from government fiscal control? In the recent and vitriolic debate over government funding for the arts, spawned by government grants supporting several highly controversial art exhibitions, millions of dollars were spent arguing the pros and cons of government support for the arts. What should be more disturbing than the debate itself is the fact that amid all the controversy the nonprofit sector did not take the opportunity to underscore the importance of strengthening incentives for nongovernmental forms of support so that the sector could more effectively carry out its role as the means for diverse expression.

Other examples of apparent myopia in nonprofit board rooms come to mind: the growing dependence on entrepreneurial ventures, more talk of power coalitions within the sector itself to maximize clout (so much for fostering individual initiative), and the ever-increasing attention given to means rather than to chartered missions.[9] None of these or earlier mentioned activities is wrong per se for a cultural nonprofit, and clearly some interaction with the for-profit and government sectors is appropriate. The main problem is perspective. When a breadth of vision is lacking, a breadth afforded by a substantive understanding of the nonprofit sector, there is no context to guide daily decisions nor is there incentive to think seriously of the long-term effects of cumulative actions. Management becomes a rollercoaster ride with outside forces setting the pace and with survival at any cost the prime objective. What survives, however, may no

longer be supportable. But if those charged with governing cultural non-profits educated themselves more thoughtfully about the nature of the sector itself, the needed perspective should emerge. Guidelines would be available for making judgments so that cumulative daily decisions did not erode the foundations of the sector, and, equally important, grass-roots attention might be given to fostering support for public education and public policies that assure the continued health of the sector. Simply put, prudent nonprofit governance entails the avoidance of actions that debilitate the sector and involves the promotion of positive means to enhance the sector's effectiveness. And all of this must start with a clear understanding of why we as a people support a nonprofit sector.

Trusteeship

When asked, members of nonprofit boards will, as a rule, affirm that they are trustees and that their task is to see that their organizations are administered for the benefit of the public. If pressed further to define the nature of this trusteeship, many are lost for words and jokingly suggest that maybe trusteeship means "trust us." It does not mean "trust us," but one can understand the difficulty in finding a more specific definition. A certain amount of background knowledge is necessary in order to appreciate the rather amorphous mantle of trusteeship presently bestowed on those who govern nonprofit organizations.[10] The following explanation has proven helpful to many.

From the law's point of view, a trust is a fiduciary relationship whereby a party, known as a trustee, holds property that must be administered for the benefit of others, who are known as beneficiaries. In a traditional trust situation the beneficiary is a named individual or group of individuals. For example, when parents die leaving minor children, a trustee may be appointed to handle the family assets for the benefit of the surviving children. The trustee has full control over the trust assets (to spend, sell, trade, buy, mortgage, and so on) but all must be for the purpose of benefiting the beneficiaries. In a nonprofit organization one has a trust-like situation. Here the assets of the organization are controlled by the governing board but the board is under an obligation to exercise its powers only in order to benefit that segment of the public (the beneficiaries) which is to be served. (The charter of the nonprofit establishes who the beneficiaries are and how they are to be helped.)

A trust situation is one in which power can easily be abused. When one has full control over property there is temptation to use that property for personal benefit or to be negligent in its administration. After all, who is watching? The law recognizes this and traditionally has imposed a high standard of conduct on those who act as trustees. The law demands of a trustee a duty of care, a duty of loyalty, and a duty of obedience. A duty of care requires the trustee to adhere to a certain level of diligence when carrying out trust duties. The duty of loyalty requires faithful pursuit of the purposes of the trust rather than pursuit of personal interests or the interests of nonbeneficiaries. The duty of obedience requires fidelity to the terms of the trust.

These three duties have long application in the law to the classic trust situation—one in which the trustee is charged essentially with handling the financial affairs of certain named beneficiaries. In these classic situations, the law tends to be rigid. It requires, for example, that the trustee give personal attention to all aspects of trust administration and demonstrate a high level of performance, and that the trustee be held liable for permitting even apparent conflicts of interest to exist.

If this rigid interpretation of trusteeship were to be applied to the trustees of nonprofit organizations, there would be cause for alarm. The average nonprofit trustee is a volunteer and a busy individual in his or her own right. In addition, governance of a nonprofit organization can be a far more complex task than management of an individual's financial affairs. The law has had to face the issue of interpreting the standard of conduct expected of trustees of nonprofit organizations. A landmark case, known as the *Sibley Hospital* case, illustrates the problem.[11]

Sibley Hospital is a nonprofit corporation organized under the laws of the District of Columbia and managed by an independent board of trustees. In the early 1970s, members of the board were sued personally for allegedly failing to carry out their trust responsibilities. Under the charter the management of the hospital rests with the board of trustees; the board, in turn, has an executive committee, a finance committee, and an investment committee. But for many years the hospital had been run by two officers, the hospital administrator and the treasurer. If the board or one of its committees met at all, it merely rubber-stamped the decisions of these two officers. The hospital also maintained excessively large noninterest-bearing accounts in financial institutions run by certain hospital trustees, had a mortgage held by a syndicate organized by certain hospital trustees, and retained the investment services of a firm con-

trolled by one of the trustees. All of these business arrangements were "fair" in the sense that fees charged and quality of service provided were comparable to those offered by other firms in the community. It was conceded that on the whole the financial affairs of the hospital were not poorly managed.

If the traditional trust standard of conduct were applied to the described set of facts, the defendants would be in serious trouble. Under the rather rigid traditional standard, a trustee must be cautious in delegating away any responsibility, cannot engage in even apparent conflicts of interest, has an affirmative duty to increase trust assets, and generally must meet a high objective standard of attention to trust affairs. The defendants in the case argued, of course, that the traditional trust standard was not an appropriate one for trustees of a nonprofit organization. They pointed to the complexities of hospital administration and insisted that the hospital was more like a for-profit business than a traditional trust, and, hence, the court should apply to them the more relaxed standard of conduct used in the business world. (Generally speaking, directors of for-profit organizations are not held personally liable for mismanagement unless gross negligence or fraud can be established.) The defendants in the *Sibley Hospital* case also argued that when one has assembled a group of busy people to serve on a nonprofit board, it is unrealistic to assume that conflicts of interest will not arise, and they stressed the volunteer nature of board service.

The judge in the case had a difficult decision to make, with little precedent since until this time it was rare for nonprofit trustees to be sued. His decision was anxiously awaited by the nonprofit community, because the standard he set for the hospital board would be readily applicable to the boards of other types of nonprofits. The defendants had put forth strong arguments for a more relaxed standard, but the judge was also cognizant of the "severe obligations" imposed on nonprofit board members. As he explained, such organizations are not closely regulated by any public entity, they are not subject to the scrutiny of stockholders (as is the case in for-profit corporations), and their boards tend to be self-perpetuating. He recognized that if the law did not set a sufficiently high standard for this type of trusteeship, the public would not be adequately protected from abuse. Simply put, a nonprofit trustee, even though a volunteer, has substantial powers and the law should exact commensurate responsibility.

The standard set forth by the judge in the *Sibley Hospital* case is as follows:

- A trustee of a nonprofit organization has an obligation to establish policy and to use due diligence in supervising the actions of officers, employees, or outside experts assigned to carry out policy.
- A trustee is obligated to disclose promptly and fully to fellow board members any conflict of interest situation that may arise and must then absent himself/herself from further discussion or vote on any such matter.
- A trustee must perform his/her duties honestly, in good faith, and with a reasonable amount of diligence and care.

Under the *Sibley Hospital* case, a failure to meet any one of these tests amounts to default by the trustee of his or her fiduciary duty.

Other cases have since been brought against nonprofit trustees for mismanagement, but they are relatively few and in no way indicate a burgeoning field of litigation. It is instructive, however, to study the existing cases in order to give more helpful guidance for those charged with nonprofit governance. Are the courts and law enforcement officials leaning more toward the relaxed business standard when judging nonprofit trustee conduct or are vestiges of the more rigid classic trust standard still in evidence? Put another way, how are the courts interpreting what constitutes "good faith," "diligence," and "care" on the part of nonprofit trustees as individual cases come before them?

If one follows mainly matters dealing with cultural nonprofits, a distinction can be made between cases that concern alleged mismanagement of subsidiary functions—those functions essentially "business-like" in nature—and those that allege mismanagement of a core charitable function of the nonprofit. In other words, when the issue is the nonprofit's performance of its unique service or core activity, some courts and law enforcement officials seem to look for board attention that at least favors the traditional trust standard rather than the more relaxed business standard. In a California case where board members of a museum were charged with mismanagement of core functions the court stated, "Members of the board . . . are undoubtedly fiduciaries, and as such are required to act in the highest good faith toward the beneficiary, i.e. the public."[12]

In a similar vein, a former New York assistant attorney general assigned to regulating charities had these comments on trustee responsibility:

[Trustee] accountability is the principal line of defense against mismanagement and abuse of the public trust. There are no shareholders waiting in the wings, assisted by squads of lawyers ready and anxious to commence a derivative action. The stock will not plummet; the organization will not report a decline in earnings or sales—there is no easy way to measure or control the quality of performance. Simply put, without a clearly defined and meaningful standard of conduct, neither the [trustee] nor the beneficiaries of not-for-profit institutions are adequately protected.[13]

An explanation for this suggested distinction between core and subsidiary functions is not hard to find. Dedication to mission and proper motivation, which are at the core of nonprofit governance, are not readily measured, and stricter standards of conduct in these areas afford extra protection. When it is difficult to measure success, there must be greater reliance on the diligence and integrity of those in control. Insisting that nonprofit board members show personal attention to mission, that they actually set informed policy and exercise prudent oversight, and that they remain very sensitive to conflict of interest situations in core activities (in ways that at least favor the demanding classic trust standard) encourages the diligence and integrity needed to instill public confidence. In contrast, in some subsidiary areas of management where activity is similar to that in for-profit organizations and, hence, measurable by marketplace standards, the more relaxed business standard may well be defensible.

A need to make distinctions is recognized in the Revised Model Nonprofit Corporation Act. While the act specifically states that directors of nonprofit organizations are not to be deemed classic trustees, it goes on to say, "A director shall discharge his or her duty as a director, including his or her duties as a member of a committee . . . with the care an ordinarily prudent person in a like position would exercise under similar circumstances."[14]

The use of such phrases as "in a like position" and "under similar circumstances" indicates that a trustee is expected to look at the realities of a particular situation and weigh these in light of the nonprofit status of the organization and the mission of the organization. Procedures or results that may be appropriate in one instance may not be justifiable in another. A few examples may help illustrate this point.

Example 1. A museum board has before it two issues. One is the awarding of a contract to put a new roof on the museum building; the other is a proposed new exhibition. Both matters involve conflicts of interest on the

part of board members. One of the firms bidding on the roofing job is partially owned by a board member, who has disclosed this fact to his colleagues and will take no part in the discussion or vote on the awarding of the contract. The proposed exhibition deals with an artist who is beginning to attract more attention. A board member owns an extensive collection of the artist's works. This is known to everyone in the museum and if the exhibition takes place, a good number of the works owned by the board member will be on display. It is understood that the board member will not take part in the discussion or vote on the proposed exhibition.

The distinguishing feature here is the close relationship of one project to the museum's mission. Part of the museum's mission is to select and mount exhibitions, based on sound scholarship, that will serve to educate the public. Measuring the quality of the museum's performance in this area is difficult and the public's confidence in what the museum produces will be directly related to the museum's image for integrity. It is fair to say that the board should err on the side of extreme caution when deciding the exhibition question. The board may be able to justify to itself that the exhibition can be presented objectively, but can it respond effectively if the public is skeptical? If it cannot, a prudent person may conclude that even this apparent conflict must be avoided because the potential injury to the mission of the museum is too great. In contrast, the roofing project may not present the same potential for harm. Bids can be objectively weighed, the matter at issue does not bear directly on the museum's mission, and public inquiry, if it occurs, can be answered simply and effectively. Here a prudent person may have no trouble voting to award the contract to the trustee's company because figures clearly show that the company presented the most favorable bid.

Example 2. Exceptional Art, a nonprofit devoted to fostering the artistic talents of individuals with disabilities, decides to engage in a major fund-raising campaign. The board interviews several professional fund-raising firms and selects one with a proven record for raising large sums through mass mailing campaigns. The firm will receive a percent of the gross amount contributed plus expenses. In order to coordinate the effort, Exceptional Art hires an additional staff person. The board receives periodic reports on the structure of the campaign and its progress. Expenses are mounting but the fund-raising firm assures the board that its campaigns always meet or exceed targeted goals. In time Exceptional Art reaches its goal but when fees, expenses, and the salary of the additional

employee are tallied, the balance sheet shows that only 9 percent of the money raised will actually go toward core programs of the organization. Some of the board members are concerned about how this figure will look on the annual Internal Revenue Service (IRS) return and what will happen if the results are reported in the press. Other members of the board calm their fears, pointing out that the 9 percent of gross is at least some money and that with a little creative (and technically legal) accounting the IRS report can show a higher percent of proceeds attributed to core purposes. Are the board members acting prudently? If this were a sales promotion matter before a for-profit board few, if any, might be concerned. Any profit would be considered better than none, and creative accounting would be of little consequence. But here the activity is central to the nonprofit because the organization depends on donor support. Evidence that few contributions actually advanced the mission of the organization, and efforts to conceal this, can only seriously undermine public confidence in the overall integrity of the organization. It can be persuasively argued that these board members have not exercised sufficient care in carrying out their responsibilities.

Effective governance of a nonprofit depends not so much on management technique as it does on sensitivity to one's responsibility to see that the organization serves its public thoughtfully and with integrity. This does not rule out innovation, but it does mean that the prudent nonprofit trustee always bears in mind the importance of being accountable, the importance of acting so as to merit confidence, and the importance of always weighing long-term effects on mission. If one grasps these concepts, much falls into place and the three legal duties of care, loyalty, and obedience can be interpreted with some degree of assurance.

Conclusion

Considering its importance in our everyday lives, the nonprofit sector should not be taken for granted. A special responsibility to protect the sector and enhance its effectiveness falls on those who have agreed to serve as trustees on nonprofits boards. Their decisions should be informed by an understanding of why our country sustains this third sector and by an appreciation of what is expected of them as trustees. Understanding why we have a nonprofit sector gives trustees important perspective as they make decisions that cumulatively shape the non-

profit sector. Likewise, understanding the nature of trusteeship is important to the nonprofit sector because the sector's fate rests on the caliber of trustee service. Trustees should take the time to educate themselves on these two topics, and they would do well to review this information periodically in order to encourage effective governance. This last suggestion is prompted by the judge's decision in the earlier described *Sibley Hospital* case. After handing down his decision in the case the judge did not levy fines against the individual defendants, because, as he explained, this was a case of first impressions—it was the first time the court had issued an opinion on this aspect of trustee responsibility. However, the judge did require that for the next five years the hospital board read the court's decision to remind each member of his or her responsibilities. This simple technique—a periodic review of trustee responsibility—seems well worth the effort.

2 ❖ *Why Ethics?*

With stories of real or apparent abuse of power routinely appearing in the news we, as a people, are rediscovering ethics, or at least we are talking more about the subject. Nonprofit boards as well are being exposed to their share of lectures and debates. There seem to be two ways the subject of ethics is usually presented to nonprofits:[1] (1) the "pious" approach, and (2) the "split-the-hair" approach.

The pious approach is filled with wonderful language about service to society and about pleasing everyone. It is usually well received by an audience, but few guidelines on how all of this can be achieved are presented. One must hope that everyone is feeling warm, wonderful, and open to compromise when a problem arises.

The split-the-hair approach invariably involves lawyers. Each issue is dissected to make sure that everything is measured and all blood is extracted. For many in the audience, this comes across as a confrontational approach, extremely complicated, and one bound to discourage high motivation.

Neither of the approaches appears to be very successful, so a middle-of-the-road presentation, one that acknowledges the law but relies ultimately on an informed personal commitment, may be in order. One must at least acknowledge the law, because it is impossible to appreciate and interpret an ethical code without reference to legal standards. Ethical

16

standards and legal standards constantly interact, and understanding this interaction provides a realistic framework for decisionmaking. It is necessary, therefore, to begin with some lawyer-like noises, but these can be balanced with practical observations and even some common sense.

First, an ethical standard for a profession[2] must be distinguished from a legal standard. An ethical code sets forth conduct that a profession considers essential in order to uphold the integrity of the profession. Codes of ethics are based on commitments to public service and personal accountability. Quite frequently codes of ethics have no enforcement mechanism. They depend on self-education, self-motivation, and peer pressure for their promulgation. And even in those situations where a profession undertakes to police its own code, enforcement cannot be effective without a consistent and voluntary commitment from a sizable portion of the profession.

When we speak of a "legal standard," we have a more mundane test. The purpose of the law is to require conduct that allows us to live in society without undue harassment. The law is not designed to make us honorable, only bearable. The law, as a rule, sets a lower standard than that required by ethical codes, but the legal standard has clout. If one falls below the legal standard, the subsequent exposure to civil or criminal liability usually commands attention.

When trying to establish or interpret an ethical code it is essential to know first what the law may require of the profession. What does the law say about the minimum standard of conduct expected of one who practices that profession? Knowing the minimum (legal) standard, one can make more realistic judgments about what should be addressed in an ethical code and how the code should be implemented. Also, as will be seen, ethical standards can in time raise legal standards or, possibly, lower them. This is very important. If a profession does not police itself, the law allows the profession to sink quite low before liability is imposed. If the profession actively promulgates a high ethical standard the law raises its expectations of the profession and lends its enforcement power to insist on this higher standard. Understanding the difference between law and ethics enables those in a profession to exert effective pressure.

As explained in the first chapter, the law imposes three duties on nonprofit trustees, those of care, loyalty, and obedience. At the very least these duties require the following:

- that trustees establish policy for the organization in an informed manner—policy designed to further the mission of the organization;
- that trustees use due diligence in exercising oversight with regard to policy implementation;
- that trustees avoid conflict of interest situations by following prudent disclosure procedures; and
- that trustees perform their duties honestly, in good faith, and with a reasonable amount of diligence and care.

There have been so few court decisions interpreting these duties with regard to the activities of cultural nonprofits, however, that one can make only educated guesses on how these general duties should be translated with regard to practical situations.

If one knows at least this much about the legal standard, it becomes clear that nonprofit trustees have only a vaguely drawn line of liability, which increases their vulnerability. But the purpose of a professional code of ethics is to flesh out these legal generalities with more definitive guidance tailored to fit situations that normally arise for those in the profession. And the guidance is offered in order to accomplish two goals: to encourage conduct that clearly meets or exceeds legal standards, and to encourage conduct that merits public confidence.

When one stops to ponder the goals of a professional code and applies this professional code to the cultural nonprofit, the subject of ethics takes on some very practical ramifications. For one thing, adherence to a professional code of ethics by a nonprofit board is a massive step toward prudent risk management. Such adherence all but guarantees protection from lawsuits that question the caliber of board performance. A professional code of ethics represents the consensus of the profession as to what constitutes prudent conduct. The legal standard of conduct for nonprofit trustees requires the court to judge a defendant's conduct in light of what would be deemed ordinarily prudent conduct within the profession. Accordingly, by adherence to a professional code the nonprofit trustee has ready and waiting a substantial defense to most allegations of improper governance. In many respects, an ethical code provides more protection than a directors and officers liability insurance policy, because adherence to the code should serve to ward off even the threat of a lawsuit.

Another practical consideration is the element of confidence building. Professional codes pay particular attention to public perceptions and,

hence, they encourage policies and practices that are designed to preserve the integrity of the board and individual officers. The effectiveness of a nonprofit is directly related to the public's perception of the integrity of the organization. Hence, for the nonprofit, ethical standards play an important role in accomplishing mission.

A third practical consideration is that adherence to ethical guidelines helps a board maintain effective control. Ethical codes usually require boards to establish ethical standards within their organizations. If a serious ethical (rather than legal) matter arises in an organization that has not implemented its own code of ethics as a condition of service, the governing board usually looks the other way. This occurs because the board, when faced with the crisis, realizes that if the ethical issue is pressed, one of the first questions asked will be whether there is a promulgated code of ethics within the organization. (When there are no established ethical standards it is very difficult, if not impossible, to resolve effectively a charge of unethical conduct.) If there is no promulgated code, the spotlight is on the board for its failure to establish standards. Realizing too late its lack of foresight, the typical board turns away from the problem, hoping to spare itself embarrassment. In effect, by failing to implement a code of ethics the board abdicates its ability to remedy improper (but not necessarily illegal) behavior.

Another practical consideration—one mentioned earlier—is that an ethical code can effect a court's interpretation of the legal standard. If a court is called upon to decide if a person has acted in good faith in carrying out professional responsibilities, appropriate evidence includes the professional code of ethics and, equally important, whether that code is generally followed by the profession. The court wants to know how the average person in the profession handles such a situation. If the matter is covered in the code of ethics and is generally followed, the court would reason that anyone giving "good faith attention" to his or her professional responsibilities would know of the code provision and abide by it. If, on the other hand, the code does not address the issue or if the code does address it but it is easily established that the provision is given lip service only, the court can reason that one could act in good faith and not follow the provision. Thus the profession, through its actual conduct, can determine to some degree how the legal standard will be interpreted. In other words, to a considerable extent the fate of a profession is in its own hands.

These very practical considerations make it difficult to condone lethar-

gy regarding ethics on the part of nonprofit boards. Ethical standards can become the beacon for prudent governance, but boards have to take affirmative steps to make this happen. In one effective approach, the profession first articulates a code that sets forth general principles. These principles are then utilized by the board of each nonprofit within the profession to write a code of ethics for its particular organization.[3] This second step, each organization promulgating its own code, is important. The process serves first to educate, because everyone involved in the organization must digest and debate the professional principles in order to craft the organization's internal policy. The process also empowers because once the internal policy is in place the governing board can effectively monitor performance. Without this second step—individual adaption by each organization—few professional codes gain much stature; they are froth but not substance.[4]

Some additional observations support the wisdom of establishing and maintaining ethical standards. We appear to be experiencing a nationwide loss of confidence in the nonprofit sector. There are those who argue that nonprofits are running too close to that minimum legal standard and that it is only a matter of time before laws will be made even more restrictive and benefits traditionally available to nonprofits further curtailed. They point out that with the pressures of the times, nonprofits appear too willing to let the end justify the means. In other words, if there is money to be made, assets to be acquired, or publicity to be obtained, nonprofits are rationalizing that all means are acceptable because, "after all, we are doing it for the public." Such an approach is the antithesis of prudent trusteeship. The prudent trustee looks carefully at the long-term effects of decisions and the prudent trustee recognizes the importance of never compromising integrity.

Consider these situations.

The tax laws, both federal and state, directly affect nonprofits. The public fosters the creation and maintenance of nonprofit organizations through tax structures that exempt these organizations from various taxes and that encourage individuals to contribute support through charitable contributions. One would think that a prudent trustee would be terribly concerned with maintaining the integrity of tax systems designed to support trust activities. But how many nonprofits have participated over the years in activity that violated the spirit, if not the letter, of tax laws? And how many times have we seen the tax laws changed to the detriment of charities as a result?

Postal laws favor charitable organizations. They permit these organizations under certain conditions to use the mail at greatly reduced rates. Currently the U.S. Postal Service is investigating mailings by charitable organizations because of evidence that postal regulations are being abused with regard to income-producing activities. One would think that prudent trustees would not want to jeopardize favorable postal regulations.

Fund-raising practices of many charities are now a serious concern of many state attorneys general. There is big money in fund raising, not just the funds that ultimately go toward the charitable work, but, more often these days, the funds that end up in the pockets of fund raisers, marketing specialists, and so on. If abuses in this area exist, and it appears they do, they could not thrive if charities were really exercising prudence when they contract for fund-raising assistance.

There is much turmoil in the country about the issue of cultural diversity, which should concern nonprofits because of their public missions. How many have truly informed themselves on the questions involved (not including knee-jerk reactions) and how many have engaged in active dialogue with colleagues in search of sensible solutions?

Each of these examples covers conduct on the part of nonprofits that may not be illegal, that is, it is not of a nature that can be easily proven to fall below the minimum applicable legal standard. But in all these examples there are serious ethical issues because the activities described threaten to undermine the integrity of the nonprofit sector and weaken public confidence. Accordingly, if nonprofit trustees consistently looked to professional ethical codes for guidance, debilitating problems could be avoided and the public would be less inclined to seek curtailment of benefits traditionally available to the nonprofit sector.

The nonprofit sector is fragile. Government, of course, is essential and as a capitalistic society the for-profit sector is secure. But the third sector, the nonprofit sector, is not understood by most, and thus it is vulnerable to hasty attack and pragmatic solutions. The sector is limping now and in good measure its future depends on the quality of governance demonstrated by nonprofit trustees. If trustees cannot steer a steady course, one that preserves the foundations of the sector, we could effectively lose a system that profoundly affects the quality of our lives. Why ethics? The answer is obvious when one looks thoughtfully at what is at stake. Will ethical standards be utilized? The answer depends on whether nonprofit trustees can marshal the level of personal commitment needed to perform their duties in an informed and mature manner.

3 ❖ *Steering a Prudent Course*

The nonprofit or third sector of our society is a relatively uncharted area.[1] Just how independent it should be and how it should relate to the marketplace are questions that grow increasingly troublesome as our society becomes more complex. And questions of where to draw the lines for the sector rarely arise in a neutral atmosphere. Too often they are prompted by perceived abuses in the nonprofit sector or they appear when a public initiative collides with the nonprofit sector's expectation of independence. In either case, nonprofits usually find themselves on the defensive and not well prepared to speak on their own behalf. There are lessons to be learned from all of this. Over the years, the tax mechanism has been looked to as the chief means for shaping, or attempting to shape, the nonprofit sector. It has provided the battleground for clashes in public opinion. By reviewing, even in a most cursory way, what has happened in this arena, nonprofits can become more sensitive to core tensions that continue to play important roles in shaping their fate, and thus become better prepared to steer a prudent course.

As we know, cultural nonprofits occupy a favored position in our tax structure. "Charity" status provides a dual sustenance inasmuch as it substantially renders the organization exempt from taxation and provides strong tax incentives for donations to the organization. On the other hand, this privileged status also is a basis for oversight by the taxing

authority. Just how the government should control a charity through the tax power is a subject of continuing debate.

In the early 1900s, when our income tax system was taking root, it was acknowledged that charitable organizations were beneficial to the country and that the tax structure should foster rather than inhibit their growth. Charities had played a dominant role in our country's growth. True to their pioneering spirit, our forebears looked first to their community, not to government, for basic social services. Innumerable voluntary organizations sprang up to satisfy community needs and became accepted as part of the American way of life. A major study on philanthropy, commonly known as the "Filer Report," describes this phenomenon as a reflection of "a national belief in the philosophy of pluralism and in the profound importance to society of individual initiative."[2] In order to foster these perceived public benefits of pluralism and self-help, the early tax codes protected and encouraged charities by granting tax-exempt status and devising the charitable contribution deduction.

In the first half of the century, there was relatively little debate about exempt status for nonprofits. In the second half of the century, with the rise of a more enlightened social conscience in this country, pressures arose to enlarge government's control over many portions of society that until then had been considered "private." The government committed huge sums of money to health, education, welfare, and cultural programs, and the funding link was seized upon as a way of effecting social change. Organizations that received government grants or other forms of "federal financial assistance" under such programs were required to conform to a variety of government-imposed restrictions as a condition for the aid. It became a fact of life that government money or other forms of government aid would come with innumerable strings. Nonprofits that elected to seek government grants or contracts understood this.

There were then those who argued that the tax exemption and the tax deduction enjoyed by charities could not be distinguished from grants—that all in effect were the equivalent of government subsidies. They reasoned that the tax exemption and tax deduction for charities were sums actually owed the government (that is, they were within the tax base), but instead of collecting them and returning them by the grant process, the government allotted them to charities through the tax-exemption procedures. Under this approach charities were viewed not as "self-help" segments of society that responded directly to private beneficence but as recipients of public funds.

Others argued with equal vigor against this "public support" theory. It was their contention that the rationale for tax exemption should be that revenue and property associated with a charity were assets voluntarily committed to public purposes and, hence, not appropriately part of the tax base. (Taxes are levied to obtain funds to further public purposes. Why tax assets already committed to public purposes?) Accordingly, as long as an organization could meet the definition of a charity given in the tax code, that it was an entity "organized and operated exclusively for . . . educational purposes,"[3] it was assured the favored tax-exempt status by virtue of its public purpose. Under this approach, favored tax status is not an indirect government grant.

An immediate reaction may be to relegate to academia the debate over these differing characterizations of a tax exemption or charitable deduction, but the stakes are much too high. One should look first at the logical consequences of these theories and then at what has in fact been happening.

If a tax exemption is considered to be just what its name implies, a determination that this type of property or revenue is not subject to tax (that is, it is not within the tax base), then the only legitimate interest of the taxing authority is to see that the tax exemption is honestly obtained and maintained. Oversight requirements imposed by the taxing authority essentially amount to recordkeeping and reporting requirements in order to demonstrate true charity status. On the other hand, if the tax exemption for charities is viewed as an efficient way of returning to a charity its tax payment in the form of a government grant (that is, public largess) the mandate of the supervising government authority is far more pervasive and the charity's entitlement to independent status is far more tenuous. Under this theory tax oversight could take on the additional dimensions of requiring charities to adhere to standards, programs, and procedures designed to further social and economic goals that are deemed appropriate for recipients of public largess. Accordingly, when one embraces this theory wholeheartedly, government control over all charities, merely by virtue of their tax-exempt status, could extend into such diverse areas as program content, governance standards, and access to services.

Each of the described theories, if followed logically, gives clear but very different dimensions to the nonprofit sector. One emphasizes the sector's independence, the other makes it very dependent on the will of the majority. Which theory accurately reflects our national policy? Histo-

ry provides no definitive answer. There was no clear articulation of un-
derlying policy on this when early tax codes were written and over the
years we have developed checkerboard tax codes, with amendments,
that respond pragmatically to the crisis of the moment. It may not be far
off the mark to say, therefore, that the described theories explaining tax-
exempt status have to date played no overt role in resolving the bound-
aries of the nonprofit sector. They are, however, pointing to where the
nonprofit sector may find itself if it continues to ignore what is happen-
ing. The practice of turning automatically to the tax code to fix what
seems to be wrong at the moment, and not confronting at the same time
the issue of the nature of the nonprofit sector, reinforces the "public sup-
port" concept. The practice also places nonprofits in a poor position to
challenge the assertion that government has broad control because too
often it is alleged nonprofit misconduct that prompts a confrontation in
the first place. Each episode usually leaves the sector weaker. There is no
reason to believe this pattern will change as long as there is no strong
and consistent voice from a broad cross section of the nonprofit sector
itself.

It is time to pay serious attention to the situation, and cultural non-
profits should grapple first with aspects most pertinent to them. If the tax
codes continue to be the major instrument for shaping the nonprofit sec-
tor (and there is little reason to expect change here), and if tax questions
regarding nonprofits are largely determined by events, not theory (which
history seems to demonstrate), then it behooves cultural nonprofits to
think about "managing" so that future events work toward a more stable
environment for nonprofits. ("Managing" is used here to mean setting a
goal and then taking realistic measures to gain acceptance of the goal.) In
the context of what cultural nonprofits can do, consider the following.

Setting a goal. Tax codes are too labyrinthine at this point to expect that
an acceptable all-purpose theory could be found in the near future to
simplify their relationship to cultural nonprofits. Nor are cultural non-
profits sufficiently confident of their own position at this time to encour-
age negotiations of such import. A more realistic approach would be for
cultural nonprofits to articulate characteristics of their operations that
must be preserved if they are to function effectively. (These characteris-
tics, if thoughtfully drafted, would be in harmony with the central argu-
ments used to justify the nonprofit sector as a whole.)[4] The promulgation
and protection of these characteristics would be the immediate overall
goal of cultural nonprofits as they respond to proposed changes in tax

codes or as cultural nonprofits offer their own solutions to tax-related problems. In time a more coherent picture of cultural nonprofits should emerge for policymakers and for the general public.

Gaining acceptance. History shows that many tax-code crises of importance to cultural nonprofits arise because of nonprofit activities that disturb substantial portions of the public. By looking carefully at the kinds of activities that cause these reactions, cultural nonprofits may be able to avoid unnecessary confrontations. Consider some fairly recent activities that have initiated demands for reform through the tax mechanism:

- The persistent unrelated business income debate made more intense in recent years as nonprofits become more entrepreneurial;
- Charges of unfair competition from small businesses; the issue raised is whether nonprofits should have the advantage of tax exemptions when the services or products they provide are in competition with for-profit concerns;
- The rush to embrace cause-related marketing with arrangements looking less like business supporting charity and more like charity endorsing business;
- The growing acceptance of corporate sponsorship that comes with more and more marketing strings;
- The rampant exchanging and selling of mailing lists in order to produce income;
- Evidence of collusion with donors to misuse the charitable deduction such as back-dating gifts, encouraging inflated valuations, failing to apply gifts to exempt purposes;
- Appearances of substantial income with little evidence of "doing good," situations that have encouraged communities to rethink criteria for property tax exemption and have caused the IRS to explore its ability to withdraw exempt status;
- Widespread failure of nonprofits to file required IRS reporting forms.

This list alone sends strong messages as to what types of activities are perceived by the public to be "uncharitable" (not worthy of tax-exempt status). Cultural nonprofits need to listen to these messages because they are evidence of disillusionment on the part of the public. A disillusioned public is much more inclined to go along with broad curtailment of the nonprofit sector rather than sympathize with arguments for strengthening the sector. One cannot argue for independence and for financial and

moral support on the one hand and, on the other, fail to impose self-limitations. Independence and support must be earned and conscientiously guarded. It follows, therefore, that in order to gain acceptance of their goals, cultural nonprofits should heed past messages from the public and plan future actions accordingly. But this takes concerted action. Staff of professional organizations can do little unless strong voices within the profession speak out and prominent cultural organizations are brave enough to set a good example. The word "brave" is used deliberately. Prudence and forthrightness (characteristics essential for a healthy nonprofit sector) are not currently in vogue.

What actions might be targeted for immediate review? Here are a few suggestions that each cultural nonprofit may want to consider.

- Openness should be substituted for secrecy. Unless there is a clear right of privacy to be protected (and legal advice should be sought in advance to identify this) the rule should be disclosure.
- Bending the law should be resisted. It is sensible to have a strict internal policy here, because it is so easy to justify exceptions with the rationale that "it is all for a good cause."
- When revenue-producing activities are at issue, go back to the mission of the organization and examine objectively how the revenue-producing activity over the long run will affect mission. (See chapter 11, "Lending for Profit.")
- What is really a quid pro quo arrangement should not be represented as a gift. Philanthropy, in the true sense of the word, is the foundation of our nonprofit sector and nonprofits should foster, not weaken, true giving.
- Where the public may be misinformed about nonprofit activity, prompt efforts should be made to educate.

Essentially "managing" is nothing more than facing reality and thinking through long-term consequences. Reality is the fact that the shape of the nonprofit sector, whether it evolves through tax policy or by other means, will continue to be drawn sporadically; what emerges will depend on the public's current perception of the sector and whether the public values what it sees. The nonprofit sector will always be colliding with government over revenue, and at times, because of its diversity, it will irritate segments of the public. Broad public support for the sector must be firmly grounded in order to withstand these inherent tensions. This kind of support cannot be left to public relations experts or to lobby-

ing efforts alone. The public needs visible and immediate evidence that the sector works and that it deserves secure status. Nonprofit trustees play a pivotal role in deciding at the grass-roots level what activities will be carried on by their organizations, and how. They have the ability to monitor closely relations with the public. The actions or inactions of trustees can dramatically affect perceptions. If these numerous opportunities to make a difference are used by trustees in an informed manner, public support for the sector will be there. By steering prudent courses within their own organizations, based on lessons learned from history, trustees can assure a steady course for the nonprofit sector itself.

4 ❖ The Education of Nonprofit Boards

Effective Training

Most material designed to instruct nonprofit boards on their responsibilities is generic in nature, covering principles that are applicable to a wide range of boards. This in understandable, because the logical place to begin is with the broad picture. But too often structured board education stops here. The assumption appears to be that nonprofit boards, despite their ever-changing membership, are able to digest and apply sectorwide principles to their particular situations in relatively short time periods. This assumption ignores the distinctive nature of the nonprofit sector. If one looks closely at the sector, it becomes apparent that structured board education should cover not only generic principles but also certain fundamental applications of these principles to the nonprofit activity at issue.

Unlike the for-profit sector, which has profit as a common goal, as well as established methods for creating and measuring that profit, entities within the nonprofit sector pursue individual goals. These goals are described in their respective charters or enabling documents. Because of the characteristic diversity of the sector, there are no established paths for achieving success, and even "success" cannot be measured in traditional ways. Each nonprofit entity must plot its own course within the confines

of a many-faceted sector and, hopefully, do so in a manner that maintains the integrity of the sector. This is a tall order, especially when one considers that typically volunteer board members come to their positions with limited knowledge of the nonprofit sector and even less acquaintance with the specialized governance concerns of their own organizations. Yet, board members are expected to function immediately. If they are to make prudent decisions, it stands to reason that they need more than generic principles; they need also an immediate overview of essential governance information relevant to organizations within their subdivision of the sector. This need is met effectively only when structured board education continues into a practical application stage that places board members in a position where informed decisionmaking is truly possible. This second step in education—from generic principles to practical application—is rarely met by the academic world alone. Those with practical experience in the various subdivisions of the nonprofit sector need to participate in the preparation of effective guidance.[1]

Making It Applicable

The application portion of board education should cover the following points:

- The development (or reaffirmation) of the mission statement for the organization;
- The establishment (or reaffirmation) of policy statements that articulate how the organization carries out its mission;
- The execution (or reaffirmation) of clear delegations of authority;
- The establishment (or reaffirmation) of processes for making important decisions.

When board education regularly covers these additional points the opportunity for quality governance substantially improves.

MISSION STATEMENT

Attention to the first point, the articulation or reaffirmation of a mission statement, requires a board to look to its founding documents to assure that the organization has an agreed-upon purpose and that the purpose

is in accord with legal constraints. Such an examination also focuses attention on the beneficiaries to be served, a matter of prime importance, and raises, rather naturally, a discussion of whether the mission statement is realistic in light of resources available to the organization. In the process of examining the mission statement board members are guided through essential information that too often remains buried until the organization founders.

POLICY STATEMENTS

The second point, the articulation of how the organization carries out the mission, requires the board to establish or reaffirm general policies for the administration of the organization. Here the board must apply in a structural way general governance principles to its particular responsibilities. But policy cannot be evaluated in a vacuum. First, a board must familiarize itself with practices in similar organizations and with current issues of importance to such organizations. All of this should then be discussed in light of sectorwide concerns. Only at this point can the board intelligently craft or review policies for achieving the organization's mission. This process provides the board with a firm base for approaching other governance issues and impresses upon the board the importance of keeping abreast of what is going on in the sector as a whole. Too many boards are expected to assume their responsibilities for setting policy and exercising oversight without the benefit of such a bedrock review. The classic results are shallow decisionmaking, and reactive rather than innovative governance.

DELEGATIONS OF AUTHORITY

A chronic problem in nonprofit organizations is confusion regarding areas of responsibility. Boards often drift into administration, the staff makes policy or, even worse, neither board nor staff makes decisions and things "just happen." The root cause can be failure to address policymaking in a formal way—one cannot delegate what is not articulated. When, however, policy is in place (a matter addressed in the prior step) there can (and should) be clear delegations of responsibility for implementing policy. When there are express delegations of responsibility, there can then be effective oversight by the board. Oversight is an essential board

function, and when it cannot be carried out the board loses control. Regular board education requiring the review of delegations of responsibility primes the board for its oversight duties.

PROCESS

The final point concerns processes for making important decisions. With a mission statement, general policies, and delegations of authority in place, a steady stream of other important matters in need of board attention always remains. Experience normally demonstrates that many of these matters fall within identifiable categories. By addressing early the issue of process for handling each category of questions, a board greatly lessens its chance for error because it establishes the essentials for prudent exercise of its authority. The law does not demand that a board always make the "right" decision, it only requires that the board not abuse its discretion. Discretion is abused when a decision is made without first gathering relevant information or when a decision is made that cannot reasonably be supported by the assembled information. Accordingly, in order to avoid liability for mismanagement (the abuse of discretion), a board wants to be able to show with regard to its decisionmaking that:

- Adequate information regarding the matter at issue was presented to the board;
- The matter was discussed and voted upon;
- The decision can be supported by the information presented (i.e., reasonable people could come to that conclusion based on the information presented).

When this sequence is understood by the board and an appropriate "process" is in place for decisionmaking, the board has a recipe for success. The importance of process is not a difficult concept to explain and adapt in board education, and it is necessary information for prudent governance.

An Illustration

Consider the following hypothetical situation. It is one readily recognized by those in the museum world, and it demonstrates what too often happens when board education is limited to sectorwide generalities.

The board of the Greenwich Time Museum has received exciting news. Mr. X, a local supporter, has written to the museum, offering his extensive and valuable collection of clocks. There are conditions, however. Mr. X requires that the collection be exhibited as a whole and that the collection be retained in its entirety in perpetuity. The gift offer, which has just been received, is announced at a board meeting, and there is an immediate motion that the offer be accepted with enthusiasm. It is pointed out that the collection is worth millions of dollars, and its acquisition will generate enormous publicity for the museum. The director of the museum suggests that action be delayed until the professional staff is consulted, but this is voted down. There is fear that any evidence of lack of enthusiasm might cause Mr. X to approach another museum. The board votes to accept the offer of the gift.

The board of the Greenwich Time Museum considers itself well trained and rather sophisticated. Its membership has been carefully selected to reflect diversity of talents and background, it has an education program that brings in speakers on board liability, fund raising, and public relations, and there is no question that the museum is flourishing. When news drifts back to the board that many museum staff members are greatly disturbed by the board's decision, there is bewilderment. What could be wrong?

If the board had been educated regarding the actual application of governance principles, it might have reacted differently to Mr. X's offer. These steps would have been covered in such education.

1. When the museum's mission statement was examined (as well as the underlying founding documents) there would have been a discussion of the various functions of a museum—collecting, preserving, and presenting—and how each of these functions supports the educational purpose of a museum. The relative cost of each function would have been explored, as well as the need to focus collecting so that demands do not exceed resources. Attention also would have been given to the beneficiaries to be served, and the importance of keeping their interests paramount.

2. When the issue of policies was addressed, the board would have been introduced to professional guidelines that stress the importance of having a written policy on collecting—one that states the museum's philosophy regarding the acquisition, management, and disposal of collection objects. These professional guidelines caution against restricted gifts because restricted gifts diminish the museum's scholarly control over its

collections (a serious problem in an educational organization), and, over time, can place maintenance demands on museum resources that cannot be justified. Both of these drawbacks work to the detriment of the public to be served. This caution would have been discussed in at least a general way as the Greenwich board considered the collecting policy for its museum.

3. When delegations of authority were addressed, certainly the area of collection acquisitions would have been a major concern. Even though the board retained final decisionmaking authority on acquisitions, it would be clear, when vision was not clouded by a dangled gift, that power to recommend acquisitions should be vested in the professional staff. To decide otherwise would be in conflict with the educational nature of the museum. Accordingly, as part of its education process, board members would have affirmed the primacy of the professional staff in this regard.

4. When reviewing "process," the board would have been impressed with the importance of gathering full information before major decisions were made. It would have had the opportunity to approve or reaffirm procedures that required full presentations by staff on the merits of proposed acquisitions.

The reaction of the Greenwich Time Museum board to Mr. X's proposed gift was not an unusual one for a group that had never been encouraged to look closely at the organization it was governing. Our culture equates success with popularity and wealth, and one is not encouraged to worry today about what may happen tomorrow. Against this background, Mr. X's offer looked dazzling. Not having had any substantial introduction to museum operations or the opportunity to ponder the importance of "process" in decisionmaking, the board was caught off guard. It ended up doing what prudent trustees should never do—making an uninformed decision on a matter that will have long-term consequences for the organization.

If, on the other hand, board education had gone beyond generic principles the board would have had at its fingertips:

- A clear vision of the museum's mission.
- An understanding that no gift is free for a museum. Once accepted a gift is an added responsibility.
- A heightened awareness of what it means to make decisions in light of what is best for the public that is to be served.

- Knowledge of professional guidelines that bear on the acquisition of collection objects.
- A recognition of the staff's role in the acquisition process.
- Established procedures designed to promote informed decision-making.

Conclusion

As stressed in earlier chapters, the nonprofit sector is fragile because its ability to function effectively depends heavily on the confidence it can inspire in its integrity. Ultimately, how the sector is perceived depends on the quality of governance demonstrated by individual boards as they guide their respective organizations. But board members usually come to their positions with little training both in issues of crucial importance to the sector as a whole and in those of particular interest to their organizations. Accordingly, it is unrealistic to assume that these board members are prepared to govern well, and, when in fact they fail, the tendency is to look the other way because of their volunteer status. The resulting decline in the standard of performance expected for board service does not bode well for a sector that must maintain the confidence of the public. The sensible solution is to focus on board education and then require more thoughtful governance.

To be effective, board education must be structured so that it covers principles relevant to the sector as a whole and, equally important, the application of those principles to basic governance issues common to the subdivision of the sector at issue. Simply put, it is not enough to bring to board service only a good heart; there must also be an informed mind. Those interested in the nonprofit sector should be working diligently to see that effective training is available and is required for board service.

5 ❖ *What May Lie Ahead*

Henry Hansmann, a noted legal scholar and economist, writes that by the year 2000 we will acknowledge the existence of two nonprofit sectors in this country. One he calls the "philanthropic" nonprofit sector, and here he places organizations dedicated to the poor, to cultural pursuits, and to higher education. The second group, the "commercial" nonprofit sector, is composed of organizations that receive the bulk of their income from the sale of services. In this latter, and larger, group are such organizations as hospitals and other health service organizations, nursing homes, day-care centers, and nonprofit insurance groups. With the acknowledgment of this dichotomy, Hansmann predicts that there will be substantial changes in the law with regard to eligibility for tax exemptions, subsidized postal rates, and other privileges now available to the sector as a whole. He suggests also that there will be renewed attention to the legal standard of conduct expected of those who govern nonprofits.[1]

While legislative changes in these public policy areas may come about by subgroup (i.e., What is appropriate for commercial nonprofits? What is appropriate for philanthropic nonprofits?), strong undercurrents suggest other ways of approaching the allocation of privileges. If public policy crises are looming for nonprofits, we should take a closer look at how cultural nonprofits may fare amid such adjustments.

Hansmann's division of the sector is guided primarily by a source of income test. As a rule, if an organization is supported very heavily by

fees for services, then it falls into the "commercial" nonprofit group—the group he places highly at risk for losing traditional privileges. The "support" test may be a comfortable test for most cultural nonprofits; museums especially may feel relatively safe from public policy changes that radically alter their modes of operation. But when we look at events that have triggered public criticism of nonprofits, the root cause is not fee for service as source of support but "attitude." When nonprofits appear to have lost sight of their public purpose, or appear too entrepreneurial or self-serving, or are unwilling to account for their activities, or merely give lip service to ethical standards, then the public reacts and questions privileged status. This reaction is seen in the controversies over unrelated business income, methods of fund raising, board/staff conflicts of interest, manipulation of tax codes, and the like. The attitude problem is as prevalent in the philanthropic group as in the commercial group. If legislatures attempt to approach reform by looking at "attitude," cultural nonprofits could find themselves in a more vulnerable position. Such an approach might tie privileged status to mandated strict fiduciary standards of conduct, full disclosure of activities, narrower limitations on activities that may be considered "related" to the organization's mission, and proof of meeting legislated annual "public service" requirements. In other words, under this approach, to qualify for nonprofit status an organization would have to conform to more demanding criteria. Legislation of this type would be difficult to draft, and more difficult to implement, but it has the potential for great public appeal.

There is a certain amount of common sense behind the described "attitude" test for determining nonprofit status. Such a test reinforces the avowed purposes of the sector and helps to delineate the sector. The attitude test allows any organization devoted to a public purpose to qualify for nonprofit status, regardless of its source of support, as long as the organization maintains high fiduciary standards, focuses on its mission, and does not become too distracted by auxiliary activities. On the other hand, an organization funded solely by donations could lose its nonprofit status if it failed some aspect of the attitude test. Applying an attitude test gives us a nonprofit sector that still offers many alternatives, has defined boundaries, and has less trouble maintaining the confidence of the public. Appropriate methods for supporting the sector would also become more focused, with greater emphasis on the importance of philanthropy, in the true sense of that word. But it bears repeating that efforts to legislate in these areas could result in undue political interference in

the activities of nonprofits and greatly increased record and reporting requirements for nonprofits. Self-regulation is by far preferable, but self-education requires massive dedication by those who govern nonprofits. Trustee attitude must change first.

The preceding chapters stress to trustees of cultural nonprofits the importance of attitude. Trustees are urged to educate themselves and to accept voluntarily a responsibility to keep their organizations on a course that is compatible with the justifications given for the nonprofit sector. With a major reshuffling of the nonprofit sector predicted for the near future, such voluntary action makes good sense. It demonstrates that the sector can play a substantial role in guiding itself to a stronger and more defensible position and that draconian reform measures are not necessary. The sector should aim to be a partner in any reform, not a recalcitrant subject. Trustees of cultural nonprofits have an opportunity to lead the way.

But no discussion of what may be ahead for cultural nonprofits can avoid mentioning one more issue—that of money. Most cultural nonprofits, and certainly museums, are struggling to stay solvent. There is understandable frustration when these very organizations are criticized by some for being too aggressive in seeking support from the marketplace and from government. "Be realistic," most nonprofit managers will reply to these critics. "The days of the wealthy patrons are gone and we must look for support wherever we can." While it is conceded that times have changed, the issue of support must be considered in light of the role of the nonprofit sector. To do otherwise is to doom the sector to ineffectiveness.

Earlier chapters in this book have discussed the justifications for our nonprofit sector and the importance of nonprofits showing restraint in their interactions with government and the marketplace. Practical decisions concerning restraint are made in light of the need to preserve independence and to focus energies on mission. The chapters have also mentioned our country's history of volunteerism—the willingness of individuals over the years to give of themselves to benefit society. It is this spirit of volunteerism, whether manifested through donation of assets, time, or other support, which has nurtured our nonprofit sector. When considered thoughtfully, it is only this spirit that can continue to sustain the sector. Most support for the nonprofit sector must come directly from the people. People must continue to value what the sector does and be willing to give time, money, and their vote for substantial support or else

there is no reason to continue the sector. A public not committed to a nonprofit sector is a public that considers itself adequately served by government and the marketplace. There is then no need for a third sector.

If this argument has merit—that a vital nonprofit sector must draw most of its support from individual contributions—then those interested in the nonprofit sector should be putting much effort into revitalizing our country's spirit of volunteerism and its commitment to philanthropy. This cannot be accomplished through traditional marketing and public relations techniques. While thoughtful speeches, scholarly articles, and formal programs of instruction will help toward these ends, strong public support cannot be expected until words are reinforced with the nonprofits' conduct. Thus, we are back to the need for each nonprofit to examine carefully the quality of its governance and the image it projects to its constituency and community. This type of effort requires informed personal involvement by each member of a governing board. Only when such leadership becomes the rule in nonprofits can we hope for the committed public that is needed to undergird the sector. It is Mr. Goodman's lesson all over again, as recounted in the preface: "Change of any consequence is accomplished by many small steps in the right direction." The nonprofit sector is presently dissipating its energies. If it is to survive as a meaningful force in our society, it needs a lot of Mr. Goodmans (or should I say Goodpersons) to get back on course and to maintain a steady pace.

Part Two

❖ ❖ ❖

Applying
Theory
to
Practice

6 ❖ Controlled Collecting

Drafting a Collection Management Policy

Undisciplined collecting can create serious administrative, legal, and ethical problems for a museum, but many museums claim there is never enough time to address the situation properly. Everyday demands consume the working hours, they insist, and diverting attention to drafting collection policy is a luxury they cannot yet afford. Let me bring you a message from museums that have learned the hard way—never collect without firm policies in place.

> Where did this come from?
> Do we own it? Is it on loan?
> Are we free to reproduce this?
> Can we dispose of it?
> But we have no more room!
> Please, don't let them see the storage area!

If any of this sounds familiar, the museum is already sinking and there is not a moment to waste. If, on the other hand, none of these problems has yet surfaced, consider your organization fortunate but still in need of preventive care. The right course of action in either case is to develop and enforce a sound collection management policy.

This chapter is copyrighted © 1991 by Children's Museum Network, Inc., and reprinted (with minor changes) from *Hand to Hand*, Linda Edeiken, Editor, vol. 5, no. 4 (Winter 1991–92): 6, 15, with permission of the Children's Museum Network, Inc.

A collection management policy is a detailed written statement that explains what, why, and how a museum collects, and it articulates that museum's professional standards regarding objects left in its care. Collecting cannot be approached in a haphazard manner; it is at the core of a museum's educational mandate and must be carried on with a clear purpose and articulated guidelines. Those guidelines should assure that careful judgments are being made not only with regard to acquisitions but also with regard to the subsequent use and management of objects. In order to approach collecting intelligently, therefore, a museum must have a clear mission statement, and it must be able to address in an informed way both the immediate and long-term effects of its collecting activity. This is a tall order for a busy organization, but it is essential that it be addressed as early as possible. Drafting a collection management policy brings a museum through the steps that are necessary to achieve control over collecting. While the process can be painful, the rewards are enormous. When a policy is in place, both board and staff have clear direction and increased confidence. This in turn enhances their ability to move with assurance and to avoid, for themselves and their successors, the countless legal and ethical problems that result from undisciplined collecting.

Several general points should be borne in mind when collecting policies are being drafted. First, recognize that for a museum nothing is free. Every time a museum accepts an object into a collection, it makes a commitment of time and money to manage that object effectively. Merely storing and keeping track of an object is costly. Because collecting represents a long-term allocation of museum resources, collecting goals must be weighed in light of their impact on the museum's ability to carry out other functions that may be part of its mission, such as exhibition, research, and educational outreach. The best time to ward off overextension of museum resources is at the accession stage. Collecting goals should be realistic. In recent years, major collecting organizations have faced potential disaster because of years of indiscriminate collecting. None of these organizations had taken the time to address the very obvious fact that every collection object costs money.

Second, a museum may decide to maintain more than one type of collection, and each type of collection may require individual attention as a collection policy is being drafted. The central collection is usually called the "permanent collection." Here the museum has made a commitment to build, improve, and maintain indefinitely a mission-driven collection

for study, research, and exhibition. But a museum (such as a children's museum) might decide to have instead, or in addition, a "school" or "teaching" collection—one intended for "hands on" use in educational programs. Other auxiliary collections are possible: study collections, archival collections, "prop" collections (objects used as background material in exhibition), and so on. It is important to describe in the collection policy each type of collection being gathered and, when there is more than one type of collection, to distinguish in the policy when guidelines may vary from one type to the next.

Finally, recognize that no collection management policy is ever set in stone. Once a policy has been adopted it should be viewed as an ever-maturing document. It should be reviewed and debated periodically to be sure that it is functioning well and that it is current. Some museums find it useful to write into the policy itself a requirement for periodic review.

Contents of a Policy

Issues that should be addressed when drafting or reviewing a collection policy include the following.

1. Statement of Purpose
Have a clear, sensible mission statement. Before writing it consider:
a. All relevant legal documents, such as the museum's charter, bylaws, and founder's gift instrument. One must work within any legal restrictions, so be sure all essential documents are carefully reviewed from the very beginning.
b. The mission statement should be consistent with the capabilities of the organization. Be sensible. The ultimate goal is to end up with a mission statement, collecting activities, and programing that are consistent and that reflect realistic assessments of a museum's capabilities in light of its resources.

2. Acquisition of Items
a. Define what type or types of collections the museum maintains. (If there is more than one type, address procedural differences, as appropriate, throughout the policy.)
b. Establish internal procedures for setting collecting goals and monitoring adherence to these goals.
c. Caution that objects should not be accepted if there are inadequate

provisions for caring for them or for utilizing them in the foreseeable future.

d. Avoid the temptation to accept items of doubtful provenance. In the policy, specify who within the museum bears the burden of deciding whether provenance is satisfactory, what criteria are to be followed, and what records are to be made.

e. Understand and clarify in the policy the difference between accepting items for accessioning and accepting them for the purpose of sale or exchange. The distinction can be important to the donor for federal income tax consequences.

f. Have a thoughtfully considered policy regarding the acceptance of restricted gifts. Specify who makes the final decisions in this area. It is wise to require that these decisions be in writing.[1]

g. Provide guidance with regard to the handling of rights (*droit moral*, copyright, trademark) that may be associated with an object.

h. Establish rules with regard to recordkeeping. Every accession (in fact, every item that comes in, whether it is to be accessioned or not) should be recorded in some way as soon as possible. Each accession should be fully documented.

i. Specify the museum's policy regarding authenticating objects for the public and providing appraisals. (First get competent advice regarding potential legal liability, tax code provisions, and so on.)

j. If the museum collects contemporary objects and there could be potential problems with donors—for example, regarding use of the museum's name in advertising—provide guidance on how these problems are to be avoided.

3. Deaccessioning[2]

a. When can a museum deaccession?

As a general rule, if objects are no longer relevant and useful to the purposes and activities of the museum, they may be considered for deaccessioning. Likewise, if objects cannot be preserved properly or used in the foreseeable future, deaccessioning may be considered. Tied in with these considerations may be a need to improve or strengthen another area of the collection in order to further the goals of the museum. Deaccessioning in itself is not wrong or illegal. It usually is the manner in which it is done that causes concern.

b. How should the museum deaccession?

It is important to have a definite deaccessioning procedure. Normally,

the appropriate curator institutes the process, recommending action to a review group and/or an appropriate museum official. At this stage, it should be established that there are no legal restrictions on disposal of the particular item, and any "moral" or "political" considerations should be set forth clearly for the deciding authority. Very often, the deaccession process will vary depending on the value of the object under considera-tion. For example, under some circumstances, outside opinions and/or appraisals may be prudent. Final decisions on deaccessioning are left to the governing board of the museum, but in larger organizations there can be delegated authority to staff to approve relatively minor deaccessions. Complete written records should be made of every deaccession process.

c. Manner of disposal

In what manner should an object be disposed of? Much will depend on the type of object in question and the particular circumstances in-volved. The following alternatives should be weighed with legal and eth-ical ramifications in mind.

- Should only the interests of the museum be considered? (In other words, should the museum seek only the best trade or price?)
- Should efforts be made to keep the object in the community if it has significant local or historic interest?
- Should preference be given to keeping the object in the public do-main? In other words, should private collectors be bypassed in favor of scholarly or cultural organizations that will continue to make the object available to the public?
- If there is to be a sale, should it be by public auction or private sale?

Your policy statement should reflect your organization's procedures for addressing such alternatives in light of its particular mission.

d. Use of proceeds

Proceeds received from deaccessions are usually dedicated to replen-ishing the collection. Consult codes of ethics promulgated within the mu-seum profession on this important issue.[3]

4. Loans
 a. Specify to whom loans will be made and who has the authority to approve outgoing loans.
 b. Specify when loans can be requested and who has the authority to approve incoming loans.

 c. Establish provenance standards for incoming loans.

 d. If there are potential problems regarding (1) misuse of the muse-um's name by lenders or (2) appearances of conflict of interest, pro-vide guidance on how these problems are to be avoided.

 e. Establish time limitations for incoming and outgoing loans. This is crucial for effective monitoring.

 f. Delegate responsibility for establishing internal procedures for pro-cessing and following through on loans.

5. Objects Placed in the Custody of the Museum

It is preferable for a museum to record in some predetermined manner and within a reasonable time every object that is placed in its care. Very often this requires a registration method for objects other than loans that are left temporarily in the custody of the museum for such purposes as attribution, identification, or study. The registration method should be designed to encourage prompt review of these objects in order to ensure expeditious handling. If any ambiguity exists, it may be best to clarify who has authority to accept objects placed in the custody of the museum and under what circumstances these objects can be accepted.

6. Care of the Collections

 a. Conservation of collection objects and, in particular, preventive con-servation measures are continuing responsibilities. There should be a delegation of responsibility to appropriate staff members to moni-tor conservation needs, and it should be clear who has final authori-ty to approve conservation recommendations.

 b. Appropriate attention should be given to the packing and shipping of collection objects moving in or out of the museum. Specify who bears the responsibility for monitoring this.

 c. Who is responsible for governing access to the collection? To collec-tion records? Have written guidelines that take into consideration any relevant statutes regarding access to public records. It is pru-dent to encourage openness.

7. Inventories

 a. There should be periodic inventories of the museum's collections. Specify how and when these are done.

 b. Specify what procedure is to be followed if a collection object ap-pears to be missing.

8. Insurance
 a. Specify whether the museum's own collection is to be insured while on premises.
 b. Establish guidelines for insuring incoming loans.
 c. Establish guidelines for insuring outgoing loans.
 d. Specify who has the authority to contract for collection insurance and any procedure for deviating from general rules regarding such insurance.

General Comments

A museum's collection management policy should be approved by its governing body; it should be in writing; it should be required reading for all curatorial and administrative staff; and, of course, it should be enforced.

Very often donors and prospective donors should be made aware of the collection management policy. It is much easier to explain to a donor why something cannot be done if one can quote a definite museum policy on the subject. Also, if there is public inquiry as to why an object was accepted or disposed of by the museum, the answer can be given with confidence. Some may not agree with the museum's decision, but if there is documented evidence that a prudent, established policy was followed, museum officials should not fear public scrutiny.[4]

7 ❖ *Deaccessioning*

The American Perspective

Perhaps I should begin by noting that I have never been able to find the word "deaccession" in my dictionary. The fact that those who bless new words have never seen fit to recognize the term does not bother many in the United States. We have been engaged in "deaccessioning" for years and if there has been debate—and there has been—it has not been over terminology but over the practice that the term describes.[1]

Let me define what I mean by deaccessioning: It is the permanent removal of an object that was once accessioned into a museum collection. Accordingly, the term does not apply when an object is placed on loan by a museum (there is no permanent removal), nor does it apply if the object in question was never accessioned. For example, if a museum acquires an object but never accessions it, because it is not deemed of collection quality, the disposal of that object is not a deaccession. There was never an intellectual judgment made that the object was worthy of indefinite preservation and, therefore, removal of the object raises less formidable hurdles.

Also, I use the term "deaccession" to cover the entire process of removal. In other words, for me, deaccessioning encompasses two major

This chapter is copyrighted © 1991 by Butterworth-Heinemann Ltd. It was first published in *Museum Management and Curatorship*, Vol 10, No 3, September 1991, 99–107, and is reprinted here with minor changes with the permission of Butterworth-Heinemann, Oxford, UK. It was written for an international audience.

questions: (1) Should this object be removed? and (2) If so, what is the appropriate method of disposal? I make this clarification merely because some limit the term to just the first issue—the decision to remove—and consider the method of disposal an administrative detail. From my experience it is more prudent to consider all aspects of a proposed removal before any decisions are made. Sometimes the method of disposal can raise more difficult questions than the issue of whether the object should go.

One more prefatory comment is in order. When discussing deaccessioning we must bear in mind both legal and ethical standards. As explained in chapter 2, the law sets a relatively low standard, but falling below that standard exposes one to liability. A professional ethical code, on the other hand, sets higher standards and, as a rule, failure to abide by this higher standard does not expose one to liability. This distinction between law and ethics is very important to bear in mind when we look at the history of deaccessioning in the United States. Very little law in the United States inhibits deaccessioning and a tremendous variety of museums are governed mainly by independent boards composed of private citizens. Accordingly, we have had all sorts of museums experimenting with deaccessioning under a wide variety of circumstances. And everyone comments on the ethics of each particular situation with little law defining what is actually enforceable. We have handled a large number of such situations in the United States, so it is worthwhile to take a closer look at how we have fared.

In the United States most museums are not controlled by the government. They are what we call nonprofit organizations, organizations incorporated to serve a public purpose but run by boards of private citizens. Support comes through private donations, grants, and some revenue-producing activities. It is estimated that well over 90 percent of the objects in U.S. museums were donated.

The nonprofit sector is deeply rooted in the American tradition, and one of the reasons we sustain this sector is to provide diversity. Anyone in the United States can start a museum for any purpose as long as the purpose falls within our broad definition of "service to the public." We have museums in this nonprofit sector of every size and shape. For example, the Smithsonian Institution is not a government agency. It owes its existence to the bequest of an Englishman, James Smithson, who left his fortune to start, in the United States, an institution "for the increase and diffusion of knowledge." The Smithsonian is chartered as a nonprof-

it organization and is governed by an independent board of regents. The Metropolitan Museum of Art in New York is an independently managed nonprofit organization, as are the majority of the almost 8,000 museums listed in our professional museum directory.

Under our laws, a nonprofit organization has a broad range of powers. One is the ability to dispose of assets under the supervision of its governing board. Thus, any museum organized as a nonprofit has an inherent right to deaccession material unless its charter specifically limits this right. (It is possible for the creator of a museum to restrict the ability to remove objects as, for example, the Freer Gallery of Art in Washington or the Gardner Museum in Boston. In such cases, under the terms of the donors' gifts no object can be removed from the collections. These instructions reflect the wishes of private parties; they do not reflect public policy.) What all this means is that the decision whether or not to engage in deaccessioning is pretty much left to a museum's governing board acting in light of its own particular circumstances.

Added to this is the factor that the United States, with very limited exception, has never seen fit to restrict the movement of cultural objects located within its borders.[2] In fact, cultural objects can leave the country more freely than they can enter.

What we have then is no centralized policy regarding collecting or collections and a government that plays no discernible role in shaping a national cultural policy. What is collected and what is disposed of is usually left in the hands of those who are interested in a particular museum.

But all is not *laissez-faire*. Perhaps to fill a void, the museum profession in the United States frequently discusses ethics and public accountability. Several of our major professional organizations promulgate codes of ethics and each code has something to say about deaccessioning. The codes recognize deaccessioning as a valid practice but set down guidelines for implementation. For example, the code long promulgated by the American Association of Museums makes the following points:

- Every museum should have a public statement regarding its policy on deaccessioning.
- When considering disposal, the museum must weigh carefully the interests of the public that it serves.
- When disposing of an object, the museum should give due consideration to the museum community in general as well as to the wishes and financial needs of the institution itself.

- While the governing board bears the ultimate responsibility for a deaccession decision, great weight should be given to the recommendation of the curatorial staff regarding the pertinence of the object to the mission of the museum.[3]

The code promulgated by the Association of Art Museum Directors stresses the following points:

- Deaccessioning should be related to policy, not to the exigencies of the moment.
- Procedures for deaccessioning should be at least as rigorous as for the purchase of major works of art.
- While final decisions rest with the governing board of the museum, full justification for a disposal should be provided by the director and the responsible curator.
- Funds obtained through disposal must be used to replenish the collection.[4]

A careful reading of each code shows that both professional organizations require a museum to have a policy regarding deaccessioning, both place final decisionmaking responsibility with the governing board (as the case law in the United States requires), and both require that the board pay attention to curatorial opinion. In other respects, there are different emphases. The art museum association addresses the use of proceeds from deaccessions and insists that these proceeds be used to replenish the collections. The American Association of Museums, which represents all types of museums, has been slower to take such a definitive stand. Historically its code has stressed considering the needs of the museum community generally when one is contemplating deaccessioning. In other words, there is less focus on dollar return with more emphasis on trying to place the unwanted object with another collecting organization. These differences in the codes of ethics themselves highlight the fact that, even in a country where deaccessioning is generally accepted, views differ on its implementation, and differences frequently can be associated with discipline. For example, art museums are quite comfortable with sales in the marketplace, but there is great pressure to require that sale proceeds be used only to replenish the collections. History museums seem more concerned with finding an appropriate new home for a piece, and less stress is put on the matter of what is done with any proceeds that may accrue. Anthropology museums and natural

science museums tend to favor only exchanges with other collecting organizations. These differences can be explained in part by the fact that until recently only art brought substantial prices in the marketplace. With this change—because now there seems to be a market for most anything—and with the very high sale prices we have seen over the last few years, history museums as well as natural science museums are being forced to grapple with the lure of the marketplace. If I were listing recent developments in the United States that are affecting deaccessioning this might be the first one:

> Development 1. The very active and lucrative market for not only art but other collectibles, which has put added pressure not only on art museums but on all types of museums.

Other developments have been equally if not more responsible for renewed attention to deaccessioning. One is a tax reform act passed in the United States in 1986 that makes it less attractive at times for individuals to donate objects to museum collections. As I mentioned earlier, museums in the United States depend almost exclusively on donations to form their collections. With donations down, collections will not grow unless museums can buy in the marketplace—buy, in many cases, the very works that would-be donors are now selling. But where is the money to come from, especially with prices escalating? A logical solution for many is to look for objects to deaccession and sell in order to raise purchase money. The second development then is:

> Development 2. A change in the United States tax law that discourages donations of objects to museums and forces museums to consider buying.

However, more profound and pervasive developments exist. Over the last decade or so the museum community in the United States has begun to examine itself more carefully, in part due to more public interest in museums. As people become more educated and more affluent, they are demanding more from museums and they are questioning the quality of governance in museums. At the same time, more professionally trained people are being attracted to museum work. In an effort to respond to the greater demands on museums, these people are examining in a comprehensive way how their museums operate. Too often what they are finding are disorganized collections, poor documentation, and horrendous storage conditions. A natural response is to reexamine the collect-

ing practices of a museum so that there is some assurance the museum will collect wisely and that objects, once acquired, can be maintained, conserved, and used effectively. Accordingly, a growing number of museums in the United States have refocused their collecting activity and are seriously concerned about proper maintenance and conservation of their collections. Because of this, I can add to my list two other developments that are affecting deaccession activity. These developments are not usually highlighted by the press when a deaccession story makes the newspapers, but they are of fundamental importance. The developments are:

Development 3. Many museums have more carefully focused their collecting and now find themselves with objects that are extraneous to their missions.

Development 4. Because of heightened concern for quality storage and conservation, museums are questioning the validity of retaining objects that are not clearly furthering the goals of their museums.

Because of all the above-described developments, we are seeing more deaccessioning activity in the United States and, as might be expected, renewed debate on the practice. Most of the newspaper stories and magazine articles feature major art museum deaccessions, because these are always more dramatic and often involve the disposal of a work or works in order to acquire immediately a preferred replacement. This allows everyone the opportunity to play critic on the merits of the particular exchange and some, in their zeal, call for the outlawing of all deaccessioning. I don't believe it likely that the United States in the foreseeable future will consider seriously any legislation that would ban deaccessioning, a move that would be at odds with our concept of a museum and with our whole tradition of leaving cultural development in the hands of the people rather than the government.

On the first point—our concept of a museum—we view museums essentially as educational organizations with responsibilities to collect wisely, maintain prudently, and encourage public use and enjoyment. Collecting in an educational organization is not a mechanical process. It is a combination of intelligent selection and periodic reevaluation. What serious educator would ever take the position that what is deemed "right" today should never be subject to review? But this attitude is inherent in a general prohibition against deaccessioning. How can a muse-

um present itself as an educational organization and yet relinquish a continuing responsibility to review critically its progress in achieving its particular goals? Accordingly, in the United States the prevailing view is that if museums want to be considered educational organizations, they must be free to deaccession.

The second reason for arguing that the United States would never seriously consider outlawing deaccessioning is our tradition of leaving cultural development in the hands of the people—as evidenced by our nonprofit sector. This system, which encourages great diversity, has served us rather well. We have museums that never dispose of anything, others that are freewheeling, and every shade in between. Each can survive as long as enough people are willing to support it. By encouraging diversity, we encourage the direct participation of many in shaping a cultural heritage. A ban on deaccessioning, which would seriously inhibit the present system, just does not make sense.

While I would argue that the last thing the United States needs or wants is any legislation inhibiting deaccessioning, I will readily admit that our museum community is not without fault in this area. The weak spot is not the general rules we have developed for deaccessioning, it is a failure to promulgate these rules as aggressively as we should. If more time and effort were spent within the profession educating with regard to these general rules the few problems we have with deaccessioning would probably disappear.

Our general rules are all drawn from our major codes of ethics and they reflect our very American view that each museum is responsible for its own destiny. Our rules give wide discretion to those in authority within a museum, but they also require that those in authority answer directly to the people they serve and on whom they depend for support. The general rules on deaccessioning are essentially these:

1. Deaccessioning should never be addressed in isolation. It is dependent on a clear articulation of a museum's collecting goals and prudent acquisition procedures. In other words, deaccessioning is not a method for curing sloppiness in accessioning. A first consideration, therefore, is to have strict acquisition guidelines in place.

2. Collections should be reviewed periodically for relevance, condition, and quality. When this is done routinely, more objective opinions result. There is no urgency to remove, and there is time to reflect on initial judgments.

3. There should be written policies and procedures on deaccessioning.

These should stress thoughtful review, clear delegation of responsibility, careful recordkeeping, and public disclosure. The policies and procedures should address:

reasons that may justify removal;

the importance of clarifying the museum's unrestricted title to an object before it is considered for removal;

the role of professional staff in the process;

when outside opinions are to be sought;

appropriate methods of disposal that may be considered;

who has final responsibility for deciding whether an object is to be removed;

who has final responsibility for deciding the method of disposal;

who is responsible for keeping records of the process;

who is responsible for providing information to the public on a planned disposal;

when and how notification of deaccessioning is given to donors of objects;

the importance of avoiding even apparent conflicts of interest in the deaccessioning process.

A museum that has such written policies and procedures—and follows them carefully when deaccession situations arise—will probably make sound decisions and will maintain public confidence, because in the very process of preparing its deaccession policies and procedures the museum will have reexamined its mission, clarified its collecting goals, and pondered the long-term effects of its actions. Also, the museum will be acutely aware that the burden of justifying deaccessioning decisions rests with it. After all this preparation, the museum is truly ready to take on individual cases and, as decisions are made, the museum will be able to convey a sense of purpose and thoughtful adherence to articulated goals. This is the essence of good governance.

I must mention that I am always a bit perplexed by the amount of controversy we see on the subject of deaccessioning as compared with general apathy on the issues of mindless collecting or collecting with negligible documentation. Is the public better served by an undisciplined or poorly documented collection? I would suggest that if there is persistent agonizing over deaccessioning, the museum profession should look more deeply. Those who cannot come to terms with deaccessioning may be avoiding other areas of collection management. When you look at the

total collection management picture within a museum and demand that all facets be reviewed and controlled in light of the museum's mission, the matter of deaccessioning falls into perspective. It becomes a small part of an integrated plan and, as such, it can be handled with confidence and in a way that inspires confidence.

If there are lessons to be learned from studying deaccessioning in the United States, they are as follows:

- In order to justify deaccessioning a museum must first be able to demonstrate that it has control over its collections. Control means that there is a collecting plan that is in accord with the mission of the museum, and the plan is religiously followed.
- The museum must be able to demonstrate that its collections are periodically and objectively reviewed for adherence to collecting goals.
- The museum must have written procedures for considering proposed deaccessions, which stress full discussion, clear delegation of decisionmaking authority, and complete recordkeeping.

If these lessons are followed, one does not have to worry about deaccessioning being used as a quick and shallow solution to immediate problems. By the time a museum has taken all the required steps and is at a point where deaccessioning can be considered, it will have educated itself. What decisions are then made should be relatively thoughtful ones supported by articulated policies. This approach offers the public the greatest protection, because it demands that the museum profession understand and practice the full scope of its responsibilities.

Epilogue

In May 1991, the board of directors of the American Association of Museums adopted a new code of ethics. The new code requires each museum, as a condition of membership, to adopt its own code of ethics, applying the association's code to its institutional setting. The purpose of this provision is to strengthen self-regulation through self-education. The new association code adds yet another element to its deaccessioning guidelines. This new element, which echoes an earlier provision in the code of the Association of Art Museum Directors, reads: "Use of proceeds from the sale of collection materials are restricted to the acquisition of collections."

pretations. In these particular transactions, no detailed records were created as to why the exchanges were made and how value was determined at the time of exchange.

2. The guns in question were now scattered all over the country and the cost of legal action to seek their return would be prohibitive.

3. It would be difficult to prove in court that the director and the volunteer gun consultant acted without authority, because no supervisor ever questioned the activity.

4. It would be difficult to prove in court that the director and the volunteer gun consultant acted contrary to expected standards, because there was no articulated code of conduct in place in the museum which addressed the activity in question.

The story could be considered a classic. One can point to many incidents where collecting organizations have found themselves embarrassed and frustrated when irregularities come to the attention of the public.[5] Too often these organizations end up burying their heads in the sand, hoping the adverse publicity will die down. And why? Such organizations usually elect silence when they realize that their failure to manage collecting responsibilities aggressively has backed them into indefensible positions. Permit me to elaborate.

Any lawyer who has worked for any period of time with a collecting organization soon realizes that if that organization calls upon its legal advisor only after there has been publicity about alleged irregularities, the battle is already all but lost. The law tells us that collecting organizations have an obligation to take affirmative steps to establish internal collecting policies. A collecting organization that has not done this is immediately on the defensive when problems arise. Let us look more closely at what the law appears to say.

Most libraries, universities, museums, and historical societies in this country are classified as nonprofit educational organizations. They are created in order to serve a public purpose, but typically are not part of government. They are managed by independent boards of trustees and make up part of what we sometimes refer to as the third sector.[6] Historically, those who served on boards of nonprofit organizations were rarely challenged on their quality of governance, but this is changing. As the public becomes more educated and more affluent, organizations such as libraries, museums, and historical societies take on a greater importance for the average person, and, quite naturally, a greater interest develops in

established internal procedures for reaching the board. The director made no secret of what he was doing, and he appeared to have no self-serving motives. Internal documents described these trading activities. His immediate supervisors were not disturbed by the activity, and no library board member ever raised a question. It was not until the newspaper stories began (prompted by dealers and gun collectors who wondered why certain rare guns were on the market) that state officials started to pay attention. There was an investigation,[1] and the museum director was fired.

The director did not go away quietly; instead, as a state employee, he demanded a hearing on his dismissal. Under state procedure, the case was referred to an arbitrator. After a hearing, the arbitrator ordered that the director be reinstated on the ground that, from the evidence presented, it must be inferred that the library board approved of what had been done.[2] In other words, it was found that the director acted with implied authority. The arbitrator based this conclusion on the following points:

1. During the investigation of the director's conduct, no library board member or supervisor of the director came forward to testify personally on the merits of the case against the director. This failure to testify was interpreted to favor the director.
2. There were no internal policies that made it clear what procedures were to be followed by museum staff when questions arose concerning the management of the collections. When such procedures are lacking, ordinarily blame cannot be placed on staff.
3. There were opportunities for library board members and other officials to know what was going on, and there was no evidence that they ever questioned the director. Only when their own reputations were on the line because of the subsequent publicity was attention paid to the matter.

Meanwhile, the state's attorney general had been asked to determine whether the state could take any legal action to obtain the return of the guns to the museum or whether the state could obtain any money damages to compensate for the loss of the prized objects from the collection.[3] The attorney general concluded that there was no effective way for the state to seek redress.[4] Among the reasons given were the following:

1. It would be difficult to prove in court the actual dollar loss to the state because the "value" of a historic object is open to many inter-

8 ❖ *Exercising Oversight*

Here is a cautionary tale, and it is not pure fiction.

The newspapers in a certain city published a series of articles questioning the removal of numerous valuable objects from the state museum's collection. The newspaper reports, which proved to be essentially correct, described the situation as follows.

The state in question is famous for the role it played in the early development and manufacture of firearms. The state museum had acquired an extensive collection of guns recording this history, and the collection was nationally and internationally known. The director of the museum was not an expert on guns. Over the years, however, on the advice of an outside consultant—a noted gun dealer—he arranged for the removal and exchange of several groups of guns from the museum's collection. Most of the disposals were handled by the consultant, who had ingratiated himself by serving in a volunteer capacity at the museum.

Under state law, no objects were to be deaccessioned (permanently removed) from the museum collection without the approval of the state library board, which was responsible for the governance of the museum. It appeared that the director was aware of this statute, but there were no

This chapter is copyrighted © 1990, The University of Houston, and was first published in *Forged Documents: Proceedings of the 1989 Houston Conference,* ed. P. Bozeman (New Castle, Del.: Oak Knoll Press, 1990). It is reproduced here with minor changes with the permission of the University of Houston and Oak Knoll Press.

When the 1991 code was promulgated, many members raised issue with the new provisions concerning deaccessioning and the need for conforming institutional codes. In order to give due consideration to these concerns, the association's board of directors postponed full implementation of the code and appointed an ethics commission to study the situation. As of 1993, a new provision regarding use of deaccession proceeds was proposed and approved. The new provision is a bit broader than the first published version and it recognizes that from discipline to discipline there are legitimate reasons why practices may vary with regard to use of deaccession proceeds. The 1993 version of the provision reads as follows:

> Proceeds from the sale of non-living collections are to be used consistent with the established standards of the museum's discipline, but in no event shall they be used for anything other than acquisition or direct care of collections.

Meanwhile, in 1992, the American Association for State and Local History (an organization comprised of individuals, agencies, and organizations engaged in the practice of history), approved a Statement of Professional Ethics. The Statement of Professional Ethics takes this position on the matter of deaccessioning:

> Collections shall not be deaccessioned or disposed of in order to provide financial support for institutional operations, facilities maintenance, or any reason other than the preservation or acquisition of collections.

The careful wording of the sentence demonstrates the willingness of those interested in history collections to view expenditures for direct preventive conservation measures and conservation treatment as appropriate uses of deaccession proceeds. The justification is that an object saved is, in fact, as much of a public benefit as an object acquired.

In February 1992, the Association of Art Museum Directors ratified a new version of "Professional Practices in Art Museums," reaffirming that association's commitment to a strict policy limiting the use of proceeds from deaccessioning to acquisition of new works of art. It also added a section making an art museum director (and his or her museum) subject to discipline by the association for violation of this tenant.

Finally, in 1993 the U.S. tax code was amended to remove the earlier mentioned 1986 provision that inhibited donation of objects to museum collections.

how well these organizations are run. As a result of this increased interest, we have seen over the last few decades more legal actions questioning the quality of board governance. These cases have been of particular interest to lawyers who advise nonprofits because they raised questions not yet answered by the courts. Our system of justice relies heavily on precedent (i.e., how was an earlier, similar case decided by the court?), but if there is little or no precedent on a particular issue, a lawyer can make only educated guesses when advising a client on potential liability. Now that we have had a few cases bearing on board governance, it is prudent to analyze them carefully.

An issue of major importance to nonprofits is the rule of thumb courts will apply when judging the conduct of members of nonprofit boards. Will these individuals be judged by the same standard applied to the for-profit (i.e., business) world or will they be judged by a higher standard because of the nature of their quasi-public responsibilities? The standard the law applies to the for-profit world is quite low, as anyone reading the newspaper these days knows. Members of governing boards of for-profit organizations are not held personally liable unless it can be proven that they are guilty of gross negligence or fraud. Gross negligence amounts to all but willful neglect or misconduct so, in reality, board members of business organizations have considerable latitude before they are personally accountable. There are those who argue that the business standard is not appropriate for nonprofit organizations because nonprofit organizations are created to benefit the public, they must maintain high standards of integrity in order to serve the public effectively, and managers of nonprofits are subject to little oversight. For these reasons, many insist that a higher standard of accountability for nonprofit boards is essential in order to encourage faithful attention to duties.[7]

When one reads carefully the series of cases that concern the standard of care imposed on those charged with governing nonprofit organizations, one finds a discernible tendency on the part of both state attorneys general and judges to expect a bit more from board members of nonprofits. While cumulatively these cases do not provide definitive guidance, a cautious interpretation of them suggests the following conclusions:[8]

- Trustees of nonprofit organizations have an obligation to establish policy and to use due diligence in overseeing the implementation of that policy by staff.
- Trustees must be conscious of conflict of interest situations and

should establish policies and procedures that prevent instances of real or apparent abuse of power.

- Trustees must perform their duties honestly, in good faith, and with a reasonable amount of diligence and care.

If these legal warnings are taken seriously, the board of any collecting organization should have in place policies that govern the acquisition, utilization, care, and disposition of collection material; they should actively promulgate codes of conduct for themselves, staff members, and volunteers; and they should be diligent in exercising oversight. These are not terribly demanding standards. The law does not require that boards always be right; it merely expects that boards will honestly address policy questions and will act in a reasonably prudent manner when issues of consequence arise. If a board has neglected the policymaking role and/or its oversight role, the board itself is vulnerable when any activities of the organization are publicly questioned. As in the story that began this discussion, if there is public inquiry, the board, by virtue of its failure to exercise oversight, may be found to have given implied authority to staff to engage in questionable activity, or investigators could probe more deeply and charge the board itself with avoiding its responsibilities. Faced with these alternatives, a delinquent board usually does nothing of consequence, hoping to avoid at all costs an objective evaluation of the alleged wrongdoing.

Upon closer examination, one can see how careful governance within a collecting organization can inhibit the perpetuation of theft, fraud, or misuse of collection objects. The prudent governing board of a collecting organization has in place policies and procedures that provide guidance on at least the following points:[9]

- There is an articulated scope of collecting. No organization can collect everything, so the prudent board sets collecting limits that reflect staff expertise and the capability of the organization to manage the material in a reasonable manner.
- Criteria are established for judging the suitability of objects offered, for determining the quality of the provenance of the objects offered, and for judging the ability of the organization to acquire good title.[10]
- Standards are set regarding the documentation needed to support an acquisition and the documentation records to be maintained.
- Rules are made regarding the deaccessioning of objects from the collections. These procedures require stringent internal review, outside

opinions where appropriate, and complete recordkeeping.

- Guidance is given on the process used to determine an appropriate method of disposal (by exchange, sale, gift) and appropriate transferees (other educational organizations, commercial organizations, individuals, and so on).
- Standards are set concerning access to collection objects (balancing security and conservation concerns with legitimate public needs), the maintenance of inventory control, and the importance of prompt action when objects appear to be missing or subjected to abuse, or appear to be fakes or forgeries.[11]
- Authority is clearly delegated with regard to who is to make certain decisions concerning collection management and what written records are to be made of their decisions.
- A code of conduct is articulated for officials, staff, and volunteers which resonates to current professional ethical codes.[12]

When such policies and procedures are in place, the organization is encouraged to handle matters of consequence in a timely manner. For example, even modest efforts to check the authenticity and adequacy of title of objects offered to the collections can uncover irregularities before the trail turns cold. This was demonstrated in a 1989 case concerning four sixth-century Byzantine mosaics that appeared on the European market and were purchased by an American dealer for resale.[13] When the works were offered to the Getty Museum, a curator, suspecting the mosaics were from Cyprus, inquired of experts from that country. The mosaics were, in fact, national treasures that had been stolen a number of years earlier from a Cypriot church. The Cypriot government successfully sued the American dealer in a U.S. court and obtained the return of the mosaics. If dealers and donors know that libraries, museums, and historical societies routinely ask searching questions, regardless of whether an item is a gift or purchase, more caution will be encouraged all along the line.

The same salutary effects occur when a collecting organization is capable of spotting missing objects in a timely manner and reports the missing objects promptly to authorities.[14] Not long ago, the Baltimore Museum of Art recovered missing objects and helped solve a series of museum thefts because it promptly advertised its loss to authorities and dealers. Similarly, the National Archives and the Library of Congress were able to prosecute successfully thefts of historic documents from

their collections because they were able to establish the losses and took timely action.[15] Advertising a loss of an original also makes it harder to market fakes drawn from the original. (I might add here that recent cases described in note 11 indicate that collecting organizations that fail to report thefts in a timely manner and fail to keep searching for lost material may have difficulty claiming their losses after a period of time if the material eventually comes into the possession of good faith purchasers. In other words, the law in some states is beginning to place a burden on those who lose property to take reasonable action if they want to be able to reclaim the property.)

It is recognized that frequently, even after investigation, definitive answers on authenticity and title are not available at the time an object is offered. Assuming the collecting organization makes a good faith judgment that it can acquire such an object of doubtful provenance, there is a continuing scholarly obligation to review periodically relevant evidence as it becomes available. When the organization's policies and procedures encourage such periodic review and establish what actions are to be taken if fraud is suspected, the chances are infinitely better that constructive steps will be taken.

My message, then, is quite simple—any collecting organization that seriously wants to check theft, forgery, and misuse of collection objects has to start with itself. It has to establish and follow sensible collection management policies and procedures that require the organization to make informed decisions regarding a broad range of collection issues. Collecting organizations are frequently an important link in illegal activity involving cultural material, and, if they neglect to use that link consistently and aggressively to impede illegality, they are often powerless to take action when a case really strikes home.

I should caution that if one only takes steps that are required by the law when dealing with possible theft or fraud, not much will change. As explained in chapter 2, much questionable conduct can escape the arm of the law.[16] What prompts us to strive for loftier goals is a personal moral code evidenced by our acceptance of relevant professional codes of ethics.[17] A professional code asks more of us than the law demands. When an organization seriously promulgates a professional code of ethics, it becomes very difficult for theft, fraud, and misrepresentation to go undetected for long. When a collecting organization adopts such a code and reminds its board, staff, and volunteers to read the code at least

once a year, instances of board inertia, staff confusion, and unresolved conflicts of interest should be rare.

In summary, if collecting organizations seriously want to do something about theft, fraud, and misrepresentation of valuable materials, they must:

- Establish in advance strict internal policies and procedures governing the acquisition, use, and disposal of collection objects.
- Delegate responsibility clearly and insist on complete and accurate recordkeeping.
- Promulgate for governing boards, staff, and volunteers internal standards of conduct that are consistent with relevant professional codes of ethics.

9 ❖ The Myopic Board

The United Way and United Cancer Council Cases

Lawyers find themselves saying over and over again, "But you don't understand," as they try to explain to critics the fine points of what to them are crucial distinctions. Distinctions are very important in the law because we look to the law for a set of consistently interpreted standards that give stability to our society. Considering the complex situations that are the norm these days, consistent interpretation requires a lot of hair splitting—the hair splitting that now characterizes the legal profession.

Sometimes lawyers get so caught up in minutia, however—in interpreting a phrase in a regulation—they miss the "big picture." It is important to step back periodically and look at the big picture, and this is especially true for the lawyer with a continuing relationship with a corporate client. Here a lawyer's job is not just to do battle when there is litigation; it is, more important, to help the client avoid unnecessary litigation so that the organization can pursue its work without costly distraction. When there are lawsuits or threatened lawsuits in an activity of interest to a nonprofit client—a client very vulnerable to public cen-

This chapter is based on a talk, "The United Way and the United Cancer Council Cases," given at the annual American Law Institute–American Bar Association seminar, "Legal Problems of Museum Administration," in Philadelphia, March 1993. Copyright to the transcript of the talk © 1993 is held by the American Law Institute. This edited version is published with the concurrence of the American Law Institute–American Bar Association Committee on Continuing Professional Education.

sure—and the public seems genuinely concerned about that activity, it is time for the lawyer to be sure that the root problem is identified. The immediate threat in a particular legal controversy may only be a symptom of a deeper problem that should have the attention of all nonprofits now—long before a crisis situation leads to harsh court decisions or more restrictive laws. Lawyers and their nonprofit clients should recognize that it is just as essential to focus on the big picture and listen to the public's underlying concerns about a current controversy as it is to dissect the legal technicalities. Studying the big picture invariably identifies trends in nonprofit governance that are eroding public confidence. The trends need attention more than technicalities do. Two situations that illustrate this are the United Way controversy and the United Cancer Council case.

In 1992, just about every newspaper was carrying stories on the then president of United Way of America. United Way is one of the largest charities in the United States and its president was accused of being grossly overpaid, of conducting business in a lavish style, and of favoring family and friends in managing the charity's assets. The president resigned, a major internal investigation followed, and lawyers for the United Way and the ex-president began a long battle over blame and monies due. The IRS, the FBI, and several state attorneys general initiated investigations on the United Way matter. The reputation of the charity suffered greatly and contributions declined.

At the same time, the United Cancer Council, a charity based in Indianapolis, was also having problems with the IRS. The IRS had revoked the exempt status of the organization after monitoring a five-year contract for fund raising that the United Cancer Council had with Watson/Hughey, a fund-raising firm. The IRS said that under the contract over 90 percent of the contributions collected, contributions that constituted the gross income of the charity, ended up in the coffers of Watson/Hughey or were paid out for associated fund-raising expenses, and that the Cancer Council spent very little on its core work. On the basis of these facts, the IRS claimed that the council's main focus was no longer charitable—that it had failed what is sometimes called the "commensurate test" (it did not carry on charitable work commensurate in scope with its resources). In the alternative, the IRS argued that the council was really operating for the benefit of Watson/Hughey and hence was actually operating for private benefit, not for a public purpose. The Cancer Council took the matter to court and a battle loomed over

whether the IRS could sustain its charges and demonstrate authority to withhold tax-exempt status.

Both situations attracted the attention of nonprofits and their lawyers, and reactions were mixed. Some claimed that regulatory authorities were trying to exert too much arbitrary control over nonprofit activities; others limited their energies to dissecting statutes and regulations to determine who might prevail in court. At this point, the only certainties were that a lot of time and money would be spent on arguments and that no matter who won in either incident, the nonprofit sector would suffer. Clearly it was time to ask: What are the messages here for the nonprofit sector? What can be learned from these two situations that may save nonprofits grief later on?

Several major questions raised by these two cases affect all nonprofits:

- With regard to governance, what level of oversight should be expected of the governing board? Put another way, the question might be, At what point might a board be considered negligent because it did not take timely action to remedy a governance problem?
- With regard to accountability, how much internal information should nonprofits willingly disclose?
- With regard to seeking income, how closely can nonprofits safely pattern themselves after the commercial world? For purposes of convenience, I will refer to this last issue as the issue of "commercialism."

Let us look at each of these.

Board Governance

The role of the board in a nonprofit organization is set forth in statutes and by case law but only in broad terms. We can say, with some surety, that the board is supposed "to govern" but for nonprofits we have little case law fleshing out that term. In other words, we have few examples of situations where courts have had to rule on whether a particular nonprofit board's conduct actually met this responsibility "to govern"—a responsibility that usually includes policymaking and oversight. "Oversight" we will define as the periodic monitoring of those charged with the administration of the organization. Lacking clear case examples of

what is encompassed in the responsibility "to govern," the tendency among nonprofit boards is to be reactive, not proactive, or, equally unfortunate, boards claim they are paying attention but lack a sense of perspective. It is easier for boards to drift along without too much thought until a crisis occurs. The boards in both the United Way controversy and the United Cancer Council case appear to exemplify this approach.

When the executive director of an organization is a strong personality who prefers to set the pace, a board often allows itself to be led, which is what happened within the United Way. The ex-president of United Way had established himself as a forceful and effective leader. It is conceded that he had expanded the national office of the United Way so that it provided many more services to local units. In the eyes of most, he was enormously successful—if the measures of success are visibility, activity, and growth. But no one was watching the president closely in other areas. His claimed business expenses were running very high, his salary and benefits package was escalating, and upon his recommendation various activities of his office were spun off as separate entities that provided employment for his son and close friends and additional perks for himself. It was not until newspapers began to publish stories on the president's management style that the board took notice. To its credit, the board took action when national attention was focused on the United Way, but by this time great damage had been done to the organization's reputation. Why, one can legitimately ask, hadn't the board been paying closer attention? What does "to govern" mean if it does not include at least periodically checking on the performance of the organization's chief executive officer? Or had the board been generally aware of the president's style but was not disturbed by it? Did the board think that only visibility, activity, and growth were elements of performance worth monitoring?

With regard to this last question the makeup of the United Way board is relevant. Before the crisis, the governing board of the national office was composed of thirty-seven members, mostly individuals who held prestigious positions in the business world. The national office of United Way acts, essentially, as a coordinating and leadership organization for the many hundreds of local United Way agencies throughout the country, but these local agencies had no meaningful representation on the national board. This has changed since the management crisis. The national board has now been expanded to include a sizable number of members drawn from the local units. Maybe this tells us something about the

range of expertise that is needed on a board if there is to be effective monitoring of staff and more sensitivity as to how beneficiaries and the general public will view the activities of the organization. If at least some board members have personal knowledge of the core work of the organization, a board should be able to monitor far more effectively the overall performance of the chief administrator of the organization, especially with regard to adherence to mission and professional standards, essential considerations for a nonprofit.

The issue of board oversight certainly looms in the United Cancer Council case. In that case, the situation that sparked all of the council's present problems was a five-year fund-raising contract with the firm of Watson/Hughey. The contract began in 1984 when the council had a very small income and was facing a deficit. It hired Watson/Hughey because that firm offered an arrangement with little risk to the council. According to the contract, the firm, using the council's name, conducted direct mail solicitations for funds using a sweepstakes format. The mailing lists developed from these solicitations became the joint property of the council and Watson/Hughey, but with the ability to sell or rent these lists chiefly resting with Watson/Hughey. The council received whatever was left from contributions after costs were deducted, which included Watson/Hughey's healthy fees.

After the council had operated for five years under this contract, the IRS revoked its tax-exempt status, claiming that as much as 96 percent of the money received from contributions was being spent in truth on fund-raising costs—with a lion's share of the costs going into the coffers of Watson/Hughey. When the case went to court, a lot of time was spent, naturally, arguing whether the IRS had presented the right theory and statutory authority for revoking the council's tax-exempt status. A long, costly battle with lots of hair splitting was inevitable, because the IRS had to anchor its case firmly on an appropriate section of the IRS code.

But, one could ask, isn't this really a question of board responsibility and shouldn't it be litigated as such rather than as a violation of the Internal Revenue Code? In other words, is the standard of conduct expected of a nonprofit board no higher than its ability to avoid liability under the IRS code? (To answer this question, see chapter 1, "On Trusteeship.") Where was the Cancer Council's board over the years when figures showed relatively small proceeds from fund raising coming to that organization for its core work, and a tremendous portion of contributions flowing to expenses to the benefit of Watson/Hughey? Also during this

time, Watson/Hughey was the subject of some very bad press because of investigations and litigation brought by various state attorneys general questioning the truthfulness of Watson/Hughey fund-raising tactics. Over that five-year period, where was the Cancer Council's board? Did it fail to look seriously at the situation? If so, that certainly seems like a failure to exercise oversight. If it did evaluate the arrangement and decide that any money, no matter how obtained and no matter what the appearance may be, was acceptable activity, is this a level of board performance the nonprofit sector can tolerate?

A very real issue then from both the United Way controversy and the Cancer Council case, and an issue that goes beyond the technicalities of the IRS code or bean-counting of perks granted to staff, is this: Shouldn't boards of trustees be paying far more attention to informed oversight, and, to facilitate this, shouldn't there be some people on each board with personal knowledge of what is involved in carrying out the mission of that organization? Informed oversight means knowing what is going on in the organization, and weighing all-important decisions in light of the organization's mission. It also means being aware of major issues that are confronting the nonprofit sector, keeping abreast of the big picture. This last part bears on the all-important matter of being sensitive to how the public may be perceiving your activity.

Accountability

With regard to the second question—that of accountability—the United Way situation highlights the issue of salary disclosure. In the press, much was being made of the president's salary of well over $300,000 per year plus generous benefits. When the press took an active interest in seeking salary figures from other nonprofits for comparison purposes, many nonprofits refused to give the information or set up barriers to disclosure. During this same period, the *NonProfit Times*, a periodical serving the nonprofit sector, described in an editorial a survey it had recently conducted among its subscribers on the issue of nonprofits releasing information on salaries.[1] It can be assumed that most persons subscribing to the periodical consider themselves familiar with the nonprofit sector, and the question asked of them was essentially this: "Should a nonprofit organization release the salaries of top officers in a routine financial disclosure?" According to the editorial, over half said no, with some saying

they would give out this information only if forced to do so. Remember, this is the nonprofit sector speaking.

Why the reluctance to give out salary information? The IRS 990 Form, required annually of most nonprofits, has asked for some time for the five highest salaries paid by the nonprofit, and, by law, a copy of the 990 should be on file in the office of a nonprofit for anyone to see. This requirement certainly puts nonprofits on notice that the public expects the information to be available. In fact, few people search out such information, but this may change. As an offshoot of the United Way crisis, a bill almost became federal law in 1992 requiring nonprofits to state on all fund solicitations that a copy of the nonprofit's IRS 990 Form was available upon request. It is said that similar bills will be introduced in later sessions of Congress,[2] and several states have already taken steps to force, within their jurisdictions, more attention to such financial disclosures by nonprofits. In response to these legislative rumblings, the IRS expanded its questions on employee compensation in the Form 990 required to be filed after January 1993. Questions must now be answered on the income received not only from the reporting organization, but also from any subsidiaries of the reporting organization. This is to cover a growing practice of clouding total income received by top nonprofit officials by allowing payments from various sources. More mandatory accountability appears to be the wave of the future for nonprofits, which is the second major lesson we can glean from these events. A continued reluctance to be forthright in giving information or resorting to creative accounting to disguise actual salary can only encourage drastic legislation, prompted by public outrage, on the issue of openness and accountability.

Commercialism

This leads into our third question—commercialism. I'm using the term "commercialism" to cover a number of situations where nonprofits are being urged to take or are actually taking their leads from the for-profit sector. Very frequently, these situations raise questions about "appropriateness," with some arguing that a nonprofit's commercial-like activity is totally out of line, while others applaud it as foresighted. The United Way and United Cancer Council cases offer some examples. For instance, we can look at: (a) the matter of determining compensation of staff, and (b) the matter of business arrangements with other organizations.

SETTING COMPENSATION FOR STAFF

One can find widely different views regarding salaries that are appropriate for officers of nonprofits. In the earlier mentioned editorial from the *NonProfit Times*,[3] this opinion appears.

> Nonprofits seem embarrassed to reveal officers' salaries. Comparisons to talent in . . . [for-profit organizations] are given short shrift because of the idea that nonprofit managers are—or should be—more interested in altruism than in competitive salaries . . . Nonsense . . . Nonprofits should expect the best . . . [and] have to pay for it. It's in nonprofits' interest to communicate this to the public.[4]

But, in that same editorial, it was explained that since 1989 the newspaper had been conducting studies on public perceptions about nonprofit salaries, studies polling the public at large. In these studies, consistent opposition appeared at all levels (whether those polled were grouped by income, education, or any other category) to nonprofits paying six-figure salaries. Evidence of this general public reaction was echoed in numerous other news reports and polls prompted by the United Way controversy and its focus on executive compensation. The public appears to have much more modest views regarding appropriate salaries for nonprofit officers, and the significant decline in recent contributions to the United Way is viewed as evidence that the public is unwilling to accept the proposition that altruism need not be a factor in selecting and compensating nonprofit leaders. Without doubt, public reaction harkens back to the arguments used to justify maintenance of our nonprofit sector. Can a sector that depends on volunteerism and promises adherence to mission (not preoccupation with the bottom line) argue logically that its officers should be evaluated and compensated by standards developed by the for-profit sector?

State attorneys general are now heavily involved in the issue of nonprofit compensation. As representatives of the public in monitoring the conduct of charitable organizations, they are responding to public pressure. At the 1992 annual conference of the National Association of State Charity Officials (with members largely drawn from offices of attorneys general) the topic of nonprofit compensation attracted the most discussion and was characterized as one that needed continued close attention. This quotation from a talk given in October 1992 by the attorney general of Massachusetts to a group of nonprofits in that state illustrates the viewpoint of one active attorney general's office.

From the point of view of my office, the amount of compensation and the process used to set it . . . [are] important in order to evaluate "reasonableness" . . . [and to indicate] whether the board is meeting its fiduciary responsibility to carefully manage . . . [the organization's] assets . . . All charities must realize that in order to retain credibility within their constituencies they must be able to openly obtain an understanding in that constituency that the compensations that they are paying are reasonable and appropriate.[5]

When one reviews these comments on the matter of executive compensation, it can be concluded that, as far as the public is concerned, in the nonprofit world staff compensation is not just a matter for casual negotiation between board and chief executive officers with an eye toward the business sector. The overriding issue is whether the compensation agreed upon falls within limits found acceptable by a public that expects executives to evidence altruism and personal commitment to the work of the organization. In other words, the public, with good reason, demands that nonprofits use a different yardstick when measuring executive qualifications and compensation.

This matter of public opinion regarding salaries should be distinguished from what might be required of the IRS if it were to bring an action to revoke the tax-exempt status of a charity because the salaries paid officers were so out of line that they amounted to "private inurement" (compensation exceeding services). By the time the IRS has the facts to challenge tax-exempt status, a drastic remedy, one can be sure that there is already public outrage, a loss of confidence in the nonprofit sector, and talk of more restrictive legislation. When setting executive compensation, a nonprofit board that is in touch with its public should rarely have to worry about exceeding limits that might trigger IRS attention. The public will sound any needed warning.

BUSINESS ARRANGEMENTS WITH OTHER ORGANIZATIONS

In the Cancer Council case, the issue of commercialism arises in the question whether the council's contract with Watson/Hughey was really a joint venture designed to enrich a for-profit organization at the expense of the nonprofit. If the Cancer Council had been a for-profit organization and it entered into such an agreement with Watson/Hughey, no one would have gotten excited. As long as the council made some money, the contract would have been considered a reasonable business judgment. But can nonprofits take the same approach—that the only real issue is

whether they make some money—or do they have to be concerned with something more? Do they have to be able to convince the public that business arrangements do not unduly favor private parties—in other words, that the nonprofit is not using its favored position in such a way that the chief beneficiaries are third parties rather than the members of the public the nonprofit is supposed to serve? This appears to be an important element of the IRS's concern—the belief that a nonprofit cannot just look at the bottom line of a business transaction and ask, "Will we make a dollar?" It has to go a step further and ask, "Who in this case is primarily benefiting from our nonprofit status? Is it a private party? Have we substantially turned the focus of our activity to a commercial purpose?" Some may argue that decisions of this nature should not be left to the IRS, especially if there is a lack of legislative guidance in this area, but it is hard to argue with any credibility that there is not cause for alarm. The IRS's position resonates to public uneasiness about the direction of some nonprofits and a belief that nonprofits should have some different considerations than those facing for-profit organizations when it comes to entering business arrangements. How, one might ask, has the situation reached this point with so many nonprofit boards still oblivious to the fact that they—for want of clear thinking—have created the problem?

Another message we can draw from the United Way controversy and the United Cancer case then is this—before going down a commercial world path, a nonprofit should keep its eye on its mission, should be ready to explain openly what it is doing, and should be reasonably assured that its constituency will find its actions appropriate for an organization devoted to such a mission.

Conclusions

All of the overriding messages that we have drawn from these cases:

- apparent general dissatisfaction with the level of board oversight,
- pressure for more openness on the part of nonprofits,
- adverse reactions to aspects of commercialism by nonprofits,

all of these give strong warnings that nonprofits should start defining more thoughtfully their responsibilities.[6] If nonprofits fail to heed the warnings, fail to listen to public reactions, and instead continue to test

the limits of what the law may presently allow, they can expect some angry backlash in the form of harsh court opinions or new restrictive legislation. This is why it is so important for lawyers who routinely advise nonprofits to step back and look at the big picture. And why it is important also for nonprofits not only to ask their lawyers, "Is it legal?" but to go on to the second important question, "Is it prudent in light of our nonprofit nature?"

10 ❖ Restricted Gifts and Museum Responsibilities

The specter of the "dead hand" fascinates the legal profession. Article upon article has been written about the legality or wisdom of arrangements permitting an individual to control property indefinitely after death (control by the "dead hand").[1] Shades of the "dead hand" hover over many museums in the form of restricted gifts. When a museum accepts an object for its collection, for example, with a condition requiring permanent display or permanent retention, the museum bows to the "dead hand"; it agrees that utilization of the object will be controlled forever by the donor. Can such gifts be justified in light of current concepts of the role of museums? This chapter argues that under today's standards the acceptance of restricted gifts by museums (i.e., the acceptance of control by the "dead hand") appears to be in conflict with the trust responsibilities imposed by law on those who govern museums, and, accordingly, more thought and discussion should be given to the issue by the museum community as a whole.

For purposes of this discussion, a "restricted gift" is defined to mean

This chapter is based on a paper that originally appeared in *The Journal of Arts Management and Law* 18, no. 3 (Fall 1988). The preparation of the paper was supported by a grant from the Program on Non-Profit Organizations, Institution for Social Policy Studies, Yale University. The work appears here slightly revised in order to meld it with other chapters in the book and to update references. It is published with the concurrence of Heldref Publications, publisher of *The Journal of Arts Management and Law*.

an object offered to and accepted by a museum with legally binding conditions that materially affect the object's use or disposition. Not included within the definition are copyright restrictions, statutorily mandated *droit moral*[2] considerations, and promises that do not actually affect use (such as a promise to attribute the gift to the donor).

Historically, restricted gifts, even gifts of modest value, were accepted by museums with faint protest. And, if a major donor came forward seeking to establish a room or other discrete unit within an existing museum, it was even more certain that the option to impose restrictions was viewed as the donor's prerogative.[3] This attitude reflected our country's deeply rooted traditions of recognizing an inalienable right of control over one's property and of encouraging individual initiatives.[4] The right of control was protected even after death. As courts have stated:

> One of the most treasured rights of a free man in a free civilization is the right to dispose of his property at death as he sees fit. No right is more solemnly assured to him by law. This right is so sacred that a testator's directions will be enforced even though repugnant to the general views of society.[5]

In the last decade or two, with growing interest in the role of museums, their obligations to the public, and the collateral responsibilities of museum trustees, a more thoughtful stand is being taken by some museums on the issue of restricted gifts. Uneasiness mounts about binding future administrators and possibly inhibiting scholarly judgments in the years to come. Relatively new codes of ethics and professional guidelines dutifully wave a cautionary flag. For example, the 1986 International Council of Museums' Code of Professional Ethics states:

> Offers [of gifts] that are subject to special conditions may have to be rejected if the conditions proposed are judged to be contrary to the long-term interests of the museum and its public.[6]

Professional Practices in Art Museums, guidelines promulgated by the Association of Art Museum Directors,[7] states:

> Gifts and bequests should be unrestricted whenever possible. The museum should resist accepting special restrictions concerning exhibition or installation. No work should be accepted with a guarantee as to attribution. While circumstances may justify some deviation from policy, variances should be carefully considered and recorded.[8]

In keeping with this spirit of professionalism, many museums have begun to articulate for the first time formal collection management policies. A collection management policy describes in some detail, for the benefit of staff and the general public, how the museum acquires, uses, lends, and disposes of collection objects. The policy is a public document that reflects the considered contemporaneous judgment of the museum regarding its responsibilities for the selection and control of its collections. The policy puts all on notice as to how the museum operates, and, accordingly, it sets a standard of accountability for the museum.[9]

After reading the acquisition sections of numerous collection management policies, it is evident that the typical museum, whether devoted to art, history, or natural history, has a general policy against accepting restricted gifts.[10] However, when museums are faced with offers of very desired objects, while some museums stand firm, others acquiesce to donor demands.[11] This situation leads one to probe the reasons for the articulated general rule and to question whether prudent decisions are being made regarding exceptions to the rule. In order to answer these questions, one must first examine the role of a museum, the legal nature of a museum, and the obligations imposed on those who manage museums.

The Role of a Museum

A museum is a permanent, nonprofit organization, essentially educational and often aesthetic in purpose, which, utilizing professional staff, acquires tangible objects, interprets them, cares for them, and exhibits them to the public on a regular basis.[12] Today, it is common practice to speak of four fundamental museological functions: to collect, to preserve, to present, and to educate.[13] The last, "to educate," is the most recent addition to the list and refers to the structured, public-oriented programs initiated by museums to encourage broader use of collection objects. Its addition to the list might imply that the other museum functions are not educational; this would be a serious, but not uncommon, misconception.[14]

The bedrock of museum activity is thoughtful collecting and preserving, in themselves educational functions. Without this activity, there is nothing "to present," no source material for research, and no focus for outreach programs. In the words of one well-known museum administrator:

> The curatorial role is central; the rest—no matter how important—is still pe-
> ripheral . . . To whatever extent the public would not readily accept this posi-
> tion, then to the same extent have museums thus far failed in clearly
> communicating their basic importance.[15]

The most basic role of the museum, its reason for being, is to collect
objects perceived to be worthy of preservation for study now and for
generations to come. And, in this process, the museum must select
knowledgeably and purposefully, document carefully, research, reevalu-
ate as necessary, and provide for the care and preservation of the objects.

In addition to this core educational role, the museum engages in edu-
cational "outreach" through the presentation of exhibits and other pub-
lic-oriented programs based on its collecting activity, and, perhaps,
contributes to "pure research" through scholarly staff publications. In
every sense, museums are educational organizations.[16]

The Legal Status of a Museum

Museums commonly describe themselves as trust organizations. In legal
terms, a trust is a fiduciary relationship whereby a party, known as a
trustee, holds property that must be administered for the benefit of oth-
ers, who are known as beneficiaries. In a traditional (private) trust the
beneficiary is a named individual or class of individuals. In a charitable
trust the beneficiary is the public or a broad segment of the public, and
the purpose of the trust is to further certain public benefits. Accordingly,
in the following discussion, museums will be referred to as "charitable
organizations," a term designed to stress the public nature of their pur-
poses and beneficiaries and meant to include both incorporated and un-
incorporated entities.[17]

A trust situation is one in which power can easily be abused; having
full control over property, the trustee must be ever vigilant not to use
that property for personal benefit. Traditionally, the law imposes very
high standards on those who act as trustees. Every law student once
learned the late Judge Cardozo's description of trusteeship:

> Many forms of conduct permissible in a workaday world for those acting at
> arm's length, are forbidden to those bound by fiduciary ties. A trustee is held
> to something stricter than the morals of the market place. Not honesty alone,
> but the punctilio of an honor the most sensitive, is then the standard of behav-

ior. As to this there has developed a tradition that is unbending and inveterate. Uncompromising rigidity has been the attitude of courts of equity when petitioned to undermine the rule of undivided loyalty by the "disintegrating erosion" of particular exceptions . . . Only thus has the level of conduct for fiduciaries been kept at a level higher than that trodden by the crowd. It will not consciously be lowered by any judgment of this court.[18]

The most fundamental duties of the trustee are those of care, loyalty, and obedience. Historically, with regard to the private trustee, these duties were interpreted rather rigidly (as Judge Cardozo notes) with a trustee liable for simple negligence, for even appearing to engage in self-dealing or for delegating away any duties.[19] But questions then arose as to whether these demanding standards should be applied to trustees who govern charitable organizations. Those who govern charitable organizations usually serve as volunteers; yet they are faced with many of the same issues that confront for-profit organizations. Accordingly, some argued, a far more relaxed "business" standard of conduct should apply to trustees of charitable organizations. Under the "business" standard, board members are held personally liable for only gross negligence or fraud.

As explained in chapter 1, a landmark case known as the *Sibley Hospital* case gave some guidance on the question of the standard of conduct that should be expected of trustees of charitable organizations.[20] Here the court sought a middle ground, noting the businesslike aspects of governing charitable organizations but also stressing the "severe obligations" imposed on board members of charities because such organizations are not closely monitored by any group or public entity.[21] The court then fashioned a standard of conduct for these trustees which, if anything, falls midway between the traditional trust standard and the for-profit corporate standard. Under the *Sibley Hospital* standard:

- A trustee of the charitable corporation has an obligation to establish policy and to use due diligence in supervising the actions of officers, employees, or outside experts assigned to carry out policy (rather close to the traditional trust standard, which requires the trustee to perform all tasks that can be accomplished within reason).
- A trustee is obliged to disclose promptly and fully to fellow board members any conflict of interest or apparent conflict of interest situation that may arise, and must withdraw from further discussion or any vote on any such matter. (This is less than the traditional trust standard, which requires the avoidance of even apparent conflicts of

interest, but more demanding than the for-profit corporate standard. In noting the "severe obligations" imposed on the board of a charity because of lack of close regulation, the court seems to expect the board to be very conscious of the need to maintain public confidence.)

- A trustee must perform his or her duties honestly, in good faith, and with a reasonable amount of diligence and care. (The traditional trustee must meet a high objective standard. The *Sibley* standard is subjective and, hence, more flexible.)

Under the *Sibley Hospital* case, a failure to meet any one of these tests amounts to default of a trustee's fiduciary duty.[22]

Obligations of Museum Trustees

Cases questioning the performance of museum trustees are relatively rare and, of those that have been initiated, few were ultimately tried on their merits.[23] Nevertheless, there has been sufficient litigation to support certain conclusions concerning a museum trustee's responsibility with regard to collection-related issues. In *Lefkowitz v. The Museum of the American Indian, Heye Foundation*,[24] the attorney general of New York sued certain trustees and officers of the Museum of the American Indian for mismanagement. There were allegations that the trustees failed to oversee the management of the museum's collections, that complete and contemporaneous records of all collection transactions were not maintained, and that evidence of apparent conflicts of interest existed (transactions between trustees and the museum involving collection objects) with no contemporaneous records clearly establishing that these transactions did not violate the trustees' fiduciary duties. The attorney general's complaint did not distinguish between incorporated and nonincorporated museums, and it is based on a standard of conduct that meets if not exceeds the standard set forth in the *Sibley Hospital* case. The defendants in the *Museum of the American Indian* case elected not to go to trial. Instead, they agreed to cooperate in an independent inventory of the museum's collection and in a complete reorganization of the board of trustees. Eventually, the museum adopted a stringent collection management policy written under the guidance of the attorney general,[25] and the case was then dropped. The attorney general had made his point.

Shortly thereafter, the Washington State attorney general sued the

trustees and the former director of the Maryhill Museum for mismanagement.[26] The trustees were charged with failing to set collection policy and to aggressively protect the museum's assets, as well as with permitting transactions between individual trustees and the museum. The last activity was described as self-dealing and a breach of fiduciary duty without reference to the disclosure option set forth in the *Sibley Hospital* case. The Maryhill Museum is a nonprofit corporation, but the attorney general's charges did not distinguish between the charitable corporation and the charitable trust, and the charges consistently set forth a standard usually applied to the traditional trustee. The *Maryhill* case was settled by stipulation when the museum's board agreed to bring suit in its own name against the one individual considered primarily responsible for the alleged poor management. In other words, the board conceded there was valid cause for concern, and it took it upon itself to pursue legal remedies available to trustees.

In the long-fought *Harding Museum* case,[27] trustees of a Chicago museum were charged with mismanagement of the museum's collection. The attorney general of Illinois took the position that museum officials were "common law trustees" and must be held to a high standard of conduct. The same common law trust standard was actually applied by the Connecticut court in *Harris v. Attorney General*,[28] a case concerning the obligation of museum trustees to insure and protect collection objects. Two fairly recent California cases involving museum trustees also rely on traditional trust language. In *Hardman v. Feinstein*,[29] the trustees of the Fine Arts Museum of San Francisco were sued for mismanagement of the collections by a group of local citizens. The suit was dismissed when the plaintiffs were found to lack standing to sue, but it is interesting to note that the complaint filed against the museum trustees reads in part:

> As Trustees, the defendants have a duty to care for, protect, account for, and prudently manage the assets and property of the Fine Arts Museum of San Francisco.
>
> Although legal title to the assets and property of the Fine Arts Museum of San Francisco is in the said Trustees, the Trustees hold the assets and property in trust for the people of San Francisco, and the Trustees are accordingly accountable to the people of San Francisco.[30]

Rowan v. Pasadena Art Museum[31] was actually decided on the merits. In that case, museum trustees had been charged with a variety of actions alleged to amount to mismanagement of the museum collections. In decid-

ing for the defendants, the court, without distinguishing between incorporated or unincorporated form, stated:

> Members of the board of directors of the corporation [the museum] are undoubtedly fiduciaries, and as such are required to act in the highest good faith toward the beneficiary, i.e., the public . . . Acting within their broad discretion, the trustees must assume responsibility for making decisions regarding all of the affairs of the museum.

The *Sibley Hospital* case may well have modified in certain areas the traditional trust standard as it applies to trustees of charitable corporations, but this important distinction must be made. *Sibley* dealt with financial matters, not the performance of the organization's core charitable function. And, even in the area of finances, the *Sibley* court made it clear that trustees must establish policy, oversee the implementation of policy, and generally discharge their duties with "a reasonable amount of diligence and care." In contrast, all the museum cases mentioned concern the management of museum collections, the core charitable obligation of these organizations, and in all of these cases the courts or attorneys general, whether the museums are incorporated or not, use more traditional trust language when describing the standard of care that must be exercised when establishing and implementing collection policies. In other words, when the issue is the charity's performance of its unique service, its "exempt purpose," courts or attorneys general seem to favor traditional trust standards rather than the more relaxed for-profit corporate standards. The explanation may be that quality of service by a nonprofit is not readily measured, and stricter governance standards here afford an extra measure of protection. It can be concluded, therefore, that museum trustees[32] must establish and enforce policy regarding collection activity; when doing so, they must act prudently and "in the highest good faith toward the beneficiary, i.e., the public,"[33] and when in doubt as to the standard that should guide them, they are well advised to look to traditional trust rules.[34]

Justification for Cautioning Against the Acceptance of Restricted Gifts

As previously noted, current guidelines promulgated by the museum community and many individual museum collection management policies discourage the acceptance of restricted gifts. The skeptic might argue

that the simple reason for this approach is that museums do not want to be tied down, and the existence of a general prohibition serves to intimidate the average donor. Upon reflection, there are indeed more profound reasons, rooted in the nature of museums and in the apparent obligations imposed on museum trustees with regard to collections. (As has been discussed, trustee obligations to the collections resonate to a more demanding standard than that applied to the business world.) All of the reasons interrelate, but for purposes of presentation they will be distinguished as follows: (1) adherence to trust purpose argument, (2) conflict of interest argument, and (3) rule of prudence argument.

ADHERENCE TO TRUST PURPOSE ARGUMENT

The museum's role is to educate by selectively collecting and utilizing material objects. The museum's voluntary acceptance of permanent restrictions regarding the content or use of its collections (restrictions that must be adhered to without periodic evaluation of continuing public benefit) strongly suggests a compromise of trust purpose. To be more specific, when objects are accepted for accessioning (inclusion in a museum collection), a good faith judgment must be made that the objects are appropriate for the museum's collection.[35] But museums are established to endure and, because they are educational organizations, they constantly seek improvement. What filled a need in the collection twenty years ago may now be redundant. What is deemed worthy of collection status today may fail to stand the test of time.[36] What was an appropriate object for display for one generation may not be appropriate for the next.[37] What was thought to be an effective method of display at one time may now be outdated.[38] Thus, the very nature of a museum cautions against the making of indefinite commitments.

There exist some legal precedents for arguing that restricted gifts to museums are not compatible with museum functions. In *In Re Hill's Estate*,[39] the terms of a will provided that a trust be created for the establishment of a school for the instruction of medicine. According to the will, instructors were to "use as textbooks and confine the instruction to the propositions, principles, and methods laid down in [certain named textbooks]." The issue before the court was whether this clause was void. The court struck down the clause on the grounds that the restriction would prevent the school's teaching from keeping abreast of the times and such a situation would not be compatible with public policy. Muse-

ums "teach" through objects, through critical collecting, sound research, and exhibition. If a gift to a museum requires the permanent exhibition or even permanent retention of an object, it is essentially the same as requiring a school to teach from specific texts or teach specific things regardless of new data, better source material, or improved teaching methods.

The court in *Central University of Kentucky v. Walters' Executors* was called upon to decide whether an endowment imposed a restriction on the overall management of a university. The court refused to infer any restriction limiting advancement of education.

> The very nature of the enterprise, on the contrary, looked to improvement. It contemplated by every reasonable implication, that new methods, new people, even new ideas would be employed, when approved by the governing body of the institution. A college means, or ought to mean, growth; the elimination of the false; the fostering of the true. As it is expected to be perpetual in its service, it must conform to the changed condition of each new generation, possessing an elasticity of scope and work commensurate with the changing requirements of the times which it serves. For the past to bind it to unchangeableness would be to prevent growth, applying the treatment to the head that the Chinese do to the feet.[40]

The court's statement can be applied to museums with equal validity.

This need to retain flexibility is underscored in *Wilstach Estate*, a case dealing with the interpretation of a trust for the establishment of an art museum. Under the terms of the trust, the testator's art collection was to form the nucleus of an art museum and the collection was "to be kept together and known and designated by the name of 'the W. P. Wilstach Collection.'" At issue was whether the language requiring that the collection be "kept together" permitted the trustees to deaccession (remove) works of art deemed to be no longer worthy of collection status. The court, recognizing the true work of a museum, refused to infer a restriction against change.

> An art museum, if it is to serve the cultural and educational needs of the community, cannot remain static. It must keep abreast of the advances of the times like every other institution whose purpose is to educate and enlighten the community.[41]

CONFLICT OF INTEREST ARGUMENT

Trustees generally are prohibited from engaging in conflicts of interest because of the strict duty of loyalty owed trust beneficiaries. Under case

law, trustees of a museum clearly owe a strong duty of loyalty to that segment of the public which the museum serves.[42] As stated by the court in *Rowan v. Pasadena Art Museum,* trustees "are required to act in the highest good faith toward the beneficiary, i.e., the public."[43] Usually when a conflict of interest is mentioned, it is assumed that the circumstances involve possible personal benefit to trustees. This need not always be the case. There can be a violation of the duty of loyalty when trustees favor third parties over beneficiaries. In a restricted gift situation, the donor essentially requires that museum trustees honor first and always the donor's wishes regardless of the impact on the public beneficiary.[44] The possibility of conflict is real when museum objects are at issue because these objects are the museum's means of education.[45] Along these same lines, consider the many cautions raised in the museum community with regard to corporate support for exhibitions. One is warned to be wary of even the most subtle influence, or appearance of influence, over what is exhibited or how it may be presented, for fear the integrity of the museum may be questioned. Where is this "sensitivity" when objects are donated with binding restrictions concerning their use?[46] A strong argument can be made that the acceptance of a restricted gift by museum trustees creates a conflict of interest, one that places a considerable burden of justification on the board.

> [A trustee] cannot serve two masters, and if he has a conflict between his duty to his [beneficiaries] and his duty to [another], he must resign or seek the direction of the court in advance. The use of his fiduciary position to gain a benefit for a third person . . . constitutes an act of disloyalty.[47]

RULE OF PRUDENCE ARGUMENT

If, as case law suggests, public policy favors the retention of broad discretionary control in the hands of trustees of educational organizations, it follows that such trustees should exercise caution in preserving discretion. The restricted gift not only forecloses a "second look" by the trustees who accepted the restriction, it also removes the matter from review by subsequent trustees. This type of action hardly comports with the standard of prudence required of trustees. In the *Sibley Hospital* case, the court ordered the trustees to establish a financial policy for the hospital and to periodically reexamine financial arrangements to ensure compliance with the policy. "No existing financial relationships should be

continued unless consistent with established policy and found by disinterested members of the Board to be in the Hospital's best interest."[48]

Trustees are cautioned to bear in mind long-term needs as well as immediate gains, explicitly in the area of finances. Under the Uniform Management of Institutional Funds Act, which concerns the management and use of investments held by eleemosynary institutions, boards of charitable organizations, although held to a less demanding "business standard" in the financial arena, are required to consider both long- and short-term goals when making investment decisions. Under current case law,[49] museum boards appear to be held to a standard higher than the "business standard" when setting collection policy. Certainly this translates into a need to be even more wary of seizing immediate gains at the expense of long-term goals when deciding collection questions. Yet, this is the tradeoff made in most restricted gift situations. One suspects that trustees of charities traditionally are more sensitive to money matters and have yet to give full attention to more complex governance questions.[50]

Another variation of the prudent management theme stresses the financial burden assumed by the museum when it commits itself to permanent retention or display. It is quickly apparent to anyone managing museum collections that no gift of an object is free. Every object accessioned into a collection must be carefully documented and recorded, maintained under proper conditions (whether in storage or on display), made accessible to scholars and other interested persons, periodically inventoried, and provided conservation treatment as needed. Every object accepted, therefore, is a commitment of museum resources that can be justified only if the object continues to serve effectively the purposes of the museum. Cost is one reason why museums frequently reevaluate the content and utilization of their collections. In a museum, space and money invariably are at a premium. A museum's acceptance of a restriction that permanently prevents this type of reevaluation strains the concept of prudent management.[51]

Application of the General Rule

In those museums that have a general rule (written or unwritten) prohibiting the acceptance of restricted gifts, several common and predictable responses are given when board or staff members are questioned on the application of the rule.

- Donors who insist on restrictions are relatively rare.
- If the objects in question are only of marginal interest to the museum, there is little trouble, internally, in applying the general rule.
- If the objects in question are of great interest to the museum, there are, as a rule, differing views internally as to how the museum should respond.
- Museums with relatively modest collections are in a more difficult position. They do not receive the range of offers that come to more prestigious organizations, and, hence, they do not have the bargaining power.

Typical comments on the last two situations are:

- If our museum does not take it, the next museum probably will.[52]
- Curators are naturally acquisitive. How can you expect them to turn away a really good object?
- Trustees and directors have to be practical people. They want things to happen during their tenure. Few medals are awarded for refusing gifts "on principle."
- If a donor has been (or may become) a major benefactor to the museum, the museum should meet him or her halfway.
- It is fine for museums with great collections to be sanctimonious on this issue. Anything they really need now is "top-notch," which makes it easier to rationalize the acceptance of restrictions. Where does this leave museums with modest collections? They can have a great need for objects turned away by their grander sister organizations. If need is considered a valid justification by the prestigious museums for accepting restrictions, why should there be a different criterion for the more modest museums?
- In today's market, few art museums can afford to buy anything. Donors know this. Art museums more than ever are at the mercy of donors.[53]

Examples can be given of situations where "need" was used to justify the acceptance of restrictions.

A highly publicized gift was that of the Reves Collection. In negotiations that began in 1982, Wendy Reves, the widow of collector/publisher/author Emery Reves, offered the couple's extensive art collection to the Dallas Museum of Art, but with many strings attached to the gift. The museum had to build a new facility that would re-create a substan-

tial portion of the Reveses' French Riviera villa (a villa with an interesting history of its own) and the art collection had to be displayed permanently in the re-created villa. The art collection was to be installed under the guidance of Wendy Reves, who intended to duplicate as accurately as possible the rooms that then existed in the French Riviera villa. Additional conditions included the following: individual art works could not be separated from the Reves Collection nor installed in other parts of the museum; none of the works could be sold for any reason without Wendy Reves's permission; and works could be loaned on important touring exhibitions but only with Wendy Reves's permission and not for more than three months at a time. Mrs. Reves was quoted as saying that if she couldn't get what she wanted, she wouldn't give.[54]

The museum did not succumb blindly. It recognized that there were problems and long negotiations followed, but the donor's conditions were not altered. This description is given of the reasons which finally persuaded the Board of Trustees to accept the gift.[55]

> [They] stressed the importance of the art collection, especially from the point of view of strengthening existing areas of the museum's own collections. They also described their altogether favorable impressions of Wendy Reves . . . [They] had been struck by her candor and the sincerity of her wish to create a living memorial to honor her late husband, Emery Reves. They recounted some of the more fascinating anecdotes Wendy had told them and reiterated their belief that such a re-creation would be a very popular attraction in Dallas not only because of the art, but also because of the history of . . . [the villa] itself. Everyone agreed that such a bounteous collection, representing as it did, an entire household of paintings, furniture, silver, porcelain, glass, almost ad infinitum, would be a truly remarkable way to launch the Dallas Museum of Art in a new direction, that of decorative arts. Moreover, the educational value of creating a new department could not be overestimated in further stimulating the community's interest in the arts in general, and in the art museum in particular. They predicted that it would increase the number of visitors to the new museum, then under construction.
>
> The response by the trustees was predictable: they were intrigued by the donor's history and overwhelmed by the description and photographs of the villa and its art collection. The consensus was that the director should not hesitate to proceed with the museum's efforts to receive the gift.[56]

The gift became a reality. The director of the museum admitted the restrictions were burdensome, but defended the decision to accept as a

practical one. "We do not have dozens of Renoirs and Cezannes. For us, this is a spectacular addition."[57]

At the time, the Dallas Museum of Art was constructing a new home (the re-created villa was added as a wing to the new building), and there was space to fill. It was frankly admitted that the Reves Collection would benefit the museum in another way. "Donors make gifts to institutions that are financially secure and artistically dynamic. The collection was important not only in what she had, but in what it would attract."[58]

The Reves Collection was valued at approximately $30 million. The museum had to raise $5 million for the wing re-creating the villa, and substantial other costs were incurred for the transportation and installation of the collection itself. The wing opened in 1985. Art critics gave the Reves Collection mixed reviews, and much has been written about the wisdom of the gift.[59]

Another example involves the Mark Rothko Foundation. The foundation, a dream of the late artist, emerged from the tortuous *Matter of Rothko* litigation (1971–77) as an organization dedicated to the preservation, study, and exhibition of Rothko's work. In the early 1980s the foundation initiated a plan to place selected works in major museums in the United States and abroad with stipulations designed to assure the perpetuation of Rothko's place in such institutions. A select and sizable group of paintings was first offered to the National Gallery of Art with the conditions that they never be deaccessioned and that they always be accessible to the public. The National Gallery of Art has a self-imposed policy against deaccessioning (except with regard to certain graphic arts) so the offer, in effect, comported with the gallery's collection policy. The carefully worded written memorial of the gift confirmed that the gallery pledged that "no works will be inaccessible" and that no works (or documentation) would be deaccessioned.[60]

Some twenty-nine major U.S. museums were then offered a Rothko work subject to certain restrictions, one of which reads as follows:

> The works will not be sold or otherwise disposed of except in the form of a gift to the National Gallery of Art, Washington, D.C., or for the purpose of acquiring other works of art by Mark Rothko, provided the proceeds are used exclusively for the acquisition of works of art by Mark Rothko.[61]

The prices for Rothkos were soaring, and all twenty-nine museums had "a need." They accepted the gifts with the restrictions, in effect promis-

ing in perpetuity to give Rothkos a place in their collections. If asked in the abstract whether restrictions should be accepted, without doubt most, if not all, of the museums would have stated that it was not good practice. One can understand the motivation of the Rothko Foundation, but one wonders what would have happened if all twenty-nine museums involved had said they would welcome the gifts but only with the understanding that the works would be retained as long as they were deemed appropriate for their collections.[62]

Examples given so far are those that make headlines, but consider the following situation, which is a classic for the smaller museums. A prospective donor has a collection of objects which is uniquely suited to the museum's collection (the museum is a historic site). The collection is offered on the conditions that it always be displayed and that if it is ever disposed of, it must be returned to the donor or his heirs.[63] As a practical matter, the collection, if received, would go on exhibit indefinitely because it far surpasses much of what the museum now owns. The museum has a policy against accepting restricted gifts. The director and several trustees consider the collection "essential" and do not want to jeopardize the gift. Other trustees are uneasy. At the next board meeting, the director recommends waiving policy and accepting the gift. The gift is accepted because even the most conscientious of the trustees cannot point to unequivocal support from the museum community for adherence to stated policy.

Numerous examples can also be given of situations where donors have maintained that gifts were given because they relied on implication by museums that restrictions would be honored. For instance, in 1985 the Whitney Museum of American Art settled a lawsuit brought by a donor of a collection of Morgan Russell's works. The donor alleged that the Whitney promised to exhibit the works and to publish a catalog on the collection. As part of the settlement, the Whitney relinquished the collection to another museum favored by the donor. In late 1986, it was reported that the Museum of Contemporary Art in Los Angeles was considering the deaccessioning of certain works, to the dismay of their previous owner. The works are part of a major collection purchased at a "bargain price" some years earlier from a collector who is now on the museum's board of trustees. The sale agreement did not stipulate that the collection had to be maintained intact but this, it is claimed, was the understanding of the former owner. Such situations are spawned by the reticence of museums to clearly state and firmly enforce uniform policy.

Resulting publicity only tarnishes the integrity and effectiveness of the museum community.

The Donor's Perspective

Donors who are contemplating restricted gifts to museums, whether *inter vivos*[64] gifts or bequests, anticipate a warm welcome for their largess. If less than this occurs, the general reactions are:

> This is my property, and I have the final say.
>
> I want to be remembered.
>
> I am more familiar with these objects than anyone else, and I know how they should be handled.
>
> Obviously, the museum has no intention of displaying (or keeping) the gift. Why else would it be quibbling with me?
>
> If the restrictions ever become burdensome, do something about it then. Why look for trouble?

The first reaction is typically American. It reflects the country's social and legal traditions. Both the federal constitution and state constitutions protect private property rights from unwarranted interference.[65] This concept of the "sacredness of private property" is seen in our history of philanthropy, which is replete with examples of restricted gifts. It is reflected also in court interpretations of will contests. In such cases, the guiding rule is that the "intent of the testator" must be ascertained and enforced, unless the testator's purpose is demonstrated to be illegal or against public policy.[66] It is understandable, therefore, that the typical donor expects to be able to set his or her own terms when making a gift.

The desire to leave an imprint on society is common, especially among achievers. As one grows older, it becomes painfully clear that what control one has managed to acquire is very fragile. The restricted gift is seen as a method for obtaining what is sometimes referred to as "secular immortality." It is one thing for a museum to recognize and appreciate the donor's state of mind, it is another to let this cloud the museum's responsibilities.

Donors to museums frequently have strong emotional ties to the objects they are giving.[67] It may be that the donor has carefully assembled the objects over the years with considerable expertise,[68] or the objects in question may have a close identification with the donor's family histo-

ry,[69] or the donor (especially when the donation is in the natural history field) may insist on adherence to standards favored by his or her profession, or the gift may be viewed by the donor as a very personal memorial.[70] Each of these situations cannot help but rouse public sympathy. The ultimate question, however, is "How should status in a museum collection be determined?" Is the public better served when objects must stand on their own merit subject to continuing review?

The fourth mentioned donor reaction is common, because most people think in terms of the foreseeable future. They do not share the museum's obligations to keep pace with the advancement of knowledge and to consider the needs of generations to come.[71] The fact that a donor may not appreciate the museum's position does not relieve the museum of an obligation to explain its responsibilities.

The last mentioned response, the "wait and see" argument, requires a brief discussion of *cy pres*. *Cy pres* is a court action in which a petitioner (usually a trustee) seeks to establish that a donor's purpose is impossible or impractical to carry out, and, accordingly, the court is requested to approve a new purpose which falls within the general charitable intent of the donor.[72] In keeping with our tradition of favoring the property rights of an individual, the courts in *cy pres* actions strain to rationalize any approved change as one in accord with the "overall charitable intent of the donor."[73] It is invariably easier to follow the established pattern, no matter how self-serving the reasoning, than it is to break new ground and question forthrightly whether the public good is actually being well served when the "dead hand" controls trustee discretion.[74] In effect, when a museum accepts a restricted gift, it automatically sanctions the donor's action in imposing the restriction. If the restriction eventually inhibits the best use of the material, the museum is faced with the task of proving impossibility or impracticability of performance. Very simply, the museum has locked itself into a difficult position. It cannot, without court approval, put the public interest first because it has committed itself to defending the donor and, when it seeks *cy pres* relief, the museum's credibility may be an issue. After all, it might be asked by both the court and the press, "Did not the museum accept the gift and the strings? If the court releases the museum from its promise, is the court encouraging a lack of candor when dealing with donors?" When viewed objectively, the "wait and see" argument should trouble a conscientious trustee.

A further consideration regarding the practicality of *cy pres* relief, and a very real one, is cost. Legal proceedings are expensive and the average

museum struggles to keep its doors open. When a museum accepts a restricted gift it is, in all probability, "buying" itself a lawsuit if relief is ever needed. Prudent trustees should consider this.

The Trustee's Dilemma

Clearly, today's museum trustees are faced with considerable pressures when there is an offer of a restricted gift.

- Public opinion normally favors the right of the individual to control his/her property.
- Legal precedent favors individual property rights; there is a history of museums accepting restricted gifts.
- An analysis of legal cases involving charitable trustee responsibilities indicates that museum trustees are obliged to set collecting policy, and they are obliged to act "in the highest good faith toward their public."[75]
- Current codes of ethics relating to museum operations (codes doubtlessly influenced by court decisions) caution against the acceptance of restricted gifts.
- Museums are more conscious of their public mission, yet restricted gifts by their very nature require museums over the years to give preference to donors' wishes rather than perceived public benefit.
- If a troubled trustee looks to his or her peers for support, recent situations can be cited where museums have bowed to donor restrictions despite internal policies cautioning against such action.

Should museum trustees be taking a more aggressive stand? Practically, what options are open to them when dealing with a strong-minded donor? It would be infinitely easier for trustees if it could be argued with assurance that, under current law, restricted gifts are in peril of losing charitable status or that the existence of restrictions may result in greatly reduced tax benefits for donors. With this ammunition, trustees could effectively discourage restricted gifts. But can such arguments be made?

ARE RESTRICTED GIFTS "CHARITABLE"?

Under current law, are restricted gifts in peril of losing charitable status? Cases questioning the legality of donors' charitable purposes abound.

Many of the earlier cases struggled with defining what fell within the term "charity" for philanthropic purposes, and breadth of construction prevailed. In order to encourage individual initiative (and the resulting diversity), courts strove to approve any purpose that contributed to the social welfare.[76] In essence, the intent of the donor was enforced as long as the purpose was not clearly illegal. More recent cases, reflecting social change, tend to focus on alleged discriminatory aspects of various charitable trusts (where beneficiaries are defined by race, sex, religion, and so on). These challenges present very difficult problems. There is always strong motivation to strike down particularly offensive discrimination, but often the only tool available is finding "state action"[77] in order to apply constitutional protections.[78] This remedy, if carelessly applied, jeopardizes our system of philanthropy, and, accordingly, courts have been cautious. A well-motivated but poorly reasoned application of the "state action" doctrine sets a precedent for imposing on traditionally private conduct restrictions designed to prevent undue government interference with individual rights. Simply put, the wise court recognizes that the judiciary should be wary of fostering private virtue at the expense of individual freedom.

> May we not in the long run make a greater contribution to liberty by preserving independence for such [private charities] . . . than by imposing on them a rigid and uniform constitutional absolutism—even if in some instances what seems a wrong goes unrighted?[79]
> If a heavier hand is to be applied to charitable trusts, it will be those purposes that are new, imaginative and experimental which will be most seriously affected.[80]

Other avenues of attacking unpopular charities (or unpopular practices of charities) strike at the financial base. These can take the form of: (1) questioning whether the charities fall within the definition of "charitable" for purposes of section 501(c)(3) of the Internal Revenue Code; or (2) championing the argument that the tax-exempt status of a charity is really an indirect form of government financial assistance (with the resulting ability of the government to exert control over the charity's activities through manipulation of the assistance).

The second approach is fraught with the same "slippery slope"[81] perils associated with the "state action" arguments, and, while much debated, it has not gained general acceptance.[82] What progress has been made in correcting perceived abuses in charitable purposes has been accom-

plished through construction of the term "charitable" as used in section 501(c)(3) of the Internal Revenue Code. In the case of *Bob Jones University v. United States*,[83] the issue before the court was whether a university with a racially discriminating policy was eligible for section 501(c)(3) status. It was conceded that the university was "educational" and, hence, fell within one of the charitable purposes listed in section 501(c)(3). The Supreme Court, however, endorsed this interpretation of the statute:

> Underlying all relevant parts of the Code is the intent that entitlement to tax exemption depends on meeting certain common law standards of charity—namely, that an institution seeking tax-exempt status must serve a public purpose and not be contrary to established public policy.[84]

The court went on to caution, however:

> We are bound to approach these questions with full awareness that determinations of public benefit and public policy are sensitive matters with serious implications for the institutions affected: a declaration that a given institution is not "charitable" should be made only where there can be no doubt that the activity involved is contrary to a fundamental public policy.[85]

In other words, charitable status is to be withheld only when the purpose is "so at odds with the common community conscience as to undermine any public benefit that might otherwise be conferred."[86]

Against this background, one can weigh the possible success of a court test of the "legality" of a restricted gift. Would the purpose of the donor satisfy the *Bob Jones University* test? It is quite unlikely in this day and age that the conditions imposed in typical restricted gift situations would be found "so at odds with the common community conscience as to undermine any public benefit that might otherwise be conferred." For the general public, the fact that objects were being given would probably overshadow the professional concerns of the museum. Even the most avid supporters of museums cannot claim that there is strong public sensitivity to the importance of academic freedom for those who use material objects to advance knowledge.[87] It seems reasonable, therefore, to conclude that today a court challenge to the charity status of a restricted gift would have meager chance of success. This situation could change, but much depends on the standards museums set for themselves and enforce.[88]

> Changes in the courts' conceptions of what is charitable are wrought by changes in moral and ethical precepts generally held, or by changes in relative

values assigned to different and sometimes competing and even conflicting interests of society.[89]

MIGHT RESTRICTIONS ON GIFTS RESULT IN REDUCED TAX BENEFITS FOR DONORS?

A gift may be considered "charitable" (because, on the whole, it benefits the public), but conditions imposed by the donor may affect the amount that can be deducted by the donor as a charitable contribution for income tax purposes. Under current Internal Revenue Service (IRS) regulations, when seeking tax benefits for certain charitable contributions, the donor must report to the IRS the terms of any agreement or understanding entered into between the donor and the donee organization that relate to the use, sale, or other disposition of the property. (See IRS Form 8283, "Noncash Charitable Contributions.") IRS Publication 561, "Determining the Value of Donated Property," states, "If you put restrictions on the use of property you donate, the fair market value must reflect that restriction." The publication goes on to caution that when gifts of any consequence are made, the taxpayer must maintain records which include:

> the terms of any agreement or understanding entered into by . . . [the taxpayer] or on . . . [his/her] behalf that relates to the use, sale, or other disposition of the property. This includes, for example, agreements that (a) restrict temporarily or permanently the right of the organization to use or dispose of the property . . . or (c) earmark donated property for a particular use.

Arguably at some point these regulations could raise questions when a restricted gift to a museum is at issue. One could ask:

- Is there to be a new standard for establishing the value for tax purposes of a restricted gift? Might the test become what a museum might pay on the open market for such an object when the object is encumbered by the restriction in question? If so, is there any objective way such a standard could be applied?
- If there is a possibility of reversion to the donor (if restrictions are not adhered to) must an estimated value of this possibility of reverter be deducted in determining tax consequences? But how does one determine when a museum might decide that it will no longer follow restrictions? What if the museum successfully seeks *cy pres?*
- If the restrictions give the donor incidental benefits (such as rights of control), must the value of these benefits be calculated and deducted

in determining tax consequences? If so, how does one place a value on such incidental benefits?[90]

Such speculation raises nightmarish questions for the IRS, donors, and museums, and, as of 1993, the IRS wisely has not subjected museum-restricted gifts to this type of scrutiny.[91] But there may be a message to museums here. Any serious indication that the valuing of restricted gifts for tax purposes may be reexamined is really evidence of a general concern as to the appropriateness of such gifts, that is, whether such gifts fully benefit the public. If the issue actually arises, museums will be called upon to give an opinion on the question of public benefit and discussion will be in the context of possible tax evasion by donors. Prudence suggests that a more thoughtful look by museums at their practices now may do much to prevent this issue from ever reaching serious proportions.

Based on the observations made here, museum trustees hoping to discourage restrictions from donors cannot merely cite court decisions or IRS regulations and warn that the government, on its own initiative, may intercede to question the validity of the gift or its value. Trustees must look further.

What Can Be Done? What Should Be Done?

A trustee's responsibility is not merely to avoid illegality, but to strive affirmatively to further trust purposes. For the museum trustee, this means the establishment of thoughtful, foresighted policies that foster the advancement of the museum's educational work and, equally important, the enforcement of these policies. Establishment of good policies requires that a trustee be well informed; enforcement may well require that a trustee play an active role, both by word and deed, in educating. Clearly this is the situation when it comes to restricted gifts.

The issue of restricted gifts is one of conflicting interests, the interests of the donor versus the interests of the public. Attitudes do not change nor do public sympathies unless there are articulate exponents of causes. On the issue of restricted gifts, donors have the benefit of tradition, but who argues for the public? The trustee who silently votes to acquiesce? The trustee of the competing museum who quietly lets it be known that "restrictions won't be a problem here"? When viewed objectively, such

conduct does not comport with trustee obligations. Consider again the language of Judge Cardozo.

> Uncompromising rigidity has been the attitude of courts of equity when petitioned to undermine the rule of undivided loyalty [the trustee's duty of loyalty to the trust] by the "disintegrating erosion" of particular exceptions... Only thus has the level of conduct of fiduciaries [trustees] been kept at a level higher than that trodden by the crowd.[92]

Trustees have the ability to influence their peers, they have the ability to educate with regard to a museum's obligations, and they have the ability to say "no" in order to lend credibility to their position. What is the basis, then, for condoning in restricted gift cases an exception to the trustee "undivided loyalty" rule, especially if there has been no attempt to educate and no aggressive defense, and when each exception leaves the museum more vulnerable? Can the museum trustee who never ponders these questions and never presses for their discussion among his peers pass even the *Sibley Hospital* test, which requires the trustee to perform his duties honestly, in good faith, and with a reasonable amount of diligence and care?

A challenge to educate and stand firm may appear to some to be a quixotic call to arms, but in reality it is common sense. Charities need the confidence of the public in order to thrive. If they appear duplicitous, uncertain of their roles, or too willing to compromise, their favored position quickly comes under attack.[93] Experience demonstrates that adherence to "principle" (never compromising its public purpose) serves a charity well over the long run.

A strong argument can be made, therefore, that under today's standards, the acceptance of restricted gifts by museums appears to be in conflict with the trust responsibilities of these organizations and the burden for taking a more informed and aggressive stand on the matter falls on museum boards of trustees.[94]

Additional Considerations for Trustees

If a museum hopes to be effective in implementing a policy concerning restricted gifts, it should also have in place a publicized collection management policy, a consensus regarding concessions that could be made to donors, and a method for handling restricted bequests.

COLLECTION MANAGEMENT POLICIES

A donor and the public have the right to know how a museum handles its collection. This is now generally recognized by museums, and the usual method for articulating a museum's standards is through a publicized, comprehensive collection management policy. As earlier explained, that policy specifies what the museum collects, the criteria for evaluating the suitability of an object for the collection, who has the authority to accept objects, what acquisition records must be maintained and by whom, how objects are maintained and utilized, how objects are deaccessioned and the criteria that must be met for deaccessioning, who has the authority to approve a deaccession, what methods of disposal are preferred, and what deaccession records must be maintained and by whom. When a museum has a publicized collection management policy, all donors are on notice of the museum's practices and they have the assurance that decisions concerning collection objects must be made openly and subject to safeguards.[95]

NEGOTIABLE MATTERS

Trustees should review objectively (preferably before an actual case arises) whether certain concessions can be made to donors and, if so, under what circumstances. Several possibilities come to mind.

Will precatory language be accepted? Precatory language expresses a wish rather than a command. It usually is interpreted to impose a moral (rather than a legal) obligation to carry out the donor's desire as long as this is practical. Precatory language can be altered by an internal museum decision rather than by court action. For many, the controversy over the "de Groot Affair" comes immediately to mind,[96] but numerous gifts with precatory language have been managed to the satisfaction of both donor and donee. It is imperative, however, that before precatory language is accepted, it is clearly documented that all parties understand the nature of the commitment, and the museum has made a good-faith judgment that for the foreseeable future the donor's desire appears to be in accord with museum goals. The museum must also recognize that any recommendation in the future that there be a deviation from precatory language requires careful consideration because the museum's integrity is at issue.

Will the museum in some cases accept more stringent internal require-

ments before the donor's request is altered? For example, it may be that under the museum's collection management policy a deaccession must be approved by a majority of the trustees of the museum and the director is charged with deciding whether an object is exhibited and for how long. If a potential donor requests that his or her objects be deaccessioned only by unanimous vote of the trustees or that the objects be removed from exhibit only with the approval of the trustees, will such a request be entertained?

Will the museum accept a binding restriction with a clear and reasonable termination date? An example might be a promise to retain a particular object for at least twenty years (a time reasonably within the tenure of the existing trustees and officials of the museum).

A board might deem such options compatible with its trust obligations, and, hence, open to negotiation. Having established in advance what is negotiable, the board is in a better position to deal forthrightly and fairly with individual requests.

RESTRICTED BEQUESTS

The third consideration is the restricted bequest, where the museum learns of the restriction only upon the death of the benefactor. What to do? Assuming that the conditions are binding and not subject to reasonable interpretation, the only alternative may be to reject the bequest or seek court intervention.[97] If the latter is chosen, it is quite possible that a museum with a thoughtfully written policy can persuade a court to look favorably on reforming the restriction. Case law can be cited to support this suggestion.

In *Howard Savings Institution v. Peep*,[98] a bequest was made to Amherst College for a scholarship fund for "Protestant boys." The board of trustees of the college adopted a resolution stating that acceptance of the bequest would be contrary to the articulated policy of the school and the board declined to accept unless the "Protestant" restriction could be removed. The executor of the estate took the matter to court. The court approved the striking of the restriction and its decision was upheld on appeal. The argument that the college should be denied relief because, by its own action, it was frustrating the donor's intention was rejected. The court distinguished between cases where donees sought alteration of gifts for mere convenience and where changes were sought in order to permit the donees to carry out their designated charitable purposes.

A more recent case offers another example of a sympathetic court when it is clear that the objective is to permit effective museum administration. In *Morgan Guaranty Trust Co. of New York v. President and Fellows of Harvard College*,[99] at issue was the bequest of Scofield Thayer who left certain works of art to the Fogg Art Museum and to the Metropolitan Museum of Art if the museums accepted the works "for permanent exhibition." The museums requested the executor of the estate to petition the court for instructions with regard to the phrase "permanent exhibition." Testimony was introduced describing routine museum practices of changing exhibits, lending works for exhibits, and limiting exhibition periods for certain fragile works for preservation purposes. It was also noted that some of the art in the bequeathed collection was erotic and under museum policy would be available for study only under controlled conditions. The court determined that

> "Permanent exhibition" as used in this will means readily accessible to anyone desiring to examine the art objects under such reasonable rules as the museum may make in respect thereto and not that they shall be continuously exposed to the public view on the walls or in the cases in the museum.
>
> The term "permanent exhibition" does not prohibit loans to other museums.[100]

In both cases, the credibility of the charities was enhanced by their refusal to accept restrictions contrary to their established policies. In both cases, the courts supported conscientious trustee decisions.[101]

Fairness to Donors

And what of the poor donor? If the only option is to give subject to published museum practices, might the genius of a collector be dissipated over the years? Possibly, but on balance it is better to require that museum objects be constantly judged on their worth rather than guarantee status because of the bargaining power of their donors. Quality manages to survive.

Might potential gifts to the public be lost?[102] Possibly, but many donors might find a more forthright stance by museums reassuring. The museum that demonstrates adherence to its publicly stated policies should inspire some confidence not only in its present administration, but also in the quality of governance in the years to come.

Is it fair to insist that a donor trust the judgment of future generations? If the purpose of the gift is the advancement of knowledge, that is a risk one should be required to take. In his 1980 baccalaureate address, President A. Bartlett Giamatti of Yale University spoke on the "independent university." With regard to support, he stressed the need for support "that believes in the competition of ideas and in the need to sustain centers of excellence that can define excellence for themselves."[103] His message has equal validity for museums with regard to gift restrictions.

A final note on the issue of fairness concerns all those donors to museums who gave or who will give without even suggesting restrictions.[104] Are they well served when their more demanding counterparts receive special treatment? Suppose all donors decided to impose restrictions? Upon reflection, a uniform museum policy on gifts, a policy that is promulgated and enforced, benefits everyone. It treats all donors fairly, it protects the interest of the public, and it preserves the integrity of the museum.

Conclusions

Museums as educational organizations have an obligation to maintain an environment that is conducive to the advancement of knowledge, that encourages the competition of ideas. Museums advance knowledge through their collecting activity. The imposition of permanent restrictions on the utilization of collections strikes at the very heart of the museum's educational work. The acceptance of such restrictions by museums is in conflict with basic educational goals.

Museum trustees are responsible for establishing policy regarding the acquisition of collection objects. Case law is quite clear on the point that museum trustees when carrying out their duties in this regard must act prudently and "in the highest good faith" toward the public. This translates into an obligation to protect aggressively the free competition of ideas within the museum. As a practical matter, this affirmative responsibility requires trustees to do more than give "lip service" to a policy discouraging restricted gifts. They must become active advocates, take precautionary steps, and support words with actions.

A special burden falls on trustees of more prestigious museums because their decisions regarding restricted gifts receive greater notoriety.

For practical purposes, these trustees set precedent that ultimately affects all museums.

The issue of restricted gifts is just one example of the many governance issues facing museum trustees (and trustees of other charitable organizations). While general treatises on the ills of the third sector are useful, whether and how the third sector survives will depend on the willingness and ability of charitable trustees to apply conscientiously appropriate governance standards to practical situations. A number of years ago, Daniel Catton Rich, when writing on "Management, Power and Integrity" in art museums,[105] had this to say. His words still ring true not only for museums, but for other charitable organizations as well.

> In general, a museum's integrity is displayed not by its "image" carefully cultivated by a public relations staff, but from the attitude in which the institution takes on the many complex—and often conflicting—problems that beset it. Here probity and consistency are paramount. A museum that veers and dodges like a battleship trying to escape a kamikaze attack, quickly loses public confidence, laying itself open to investigation and greater control by regulating agencies.

And, one might add, laying itself open to greater control by the "dead hand."

11 ❖ *Lending for Profit*

The Barnes Foundation of Merion, Pennsylvania, oversees the Barnes Collection, some 1,000 works of art collected by the late Albert C. Barnes. Under the terms of Dr. Barnes's trust agreement, the collection is to remain "on site" at the Merion location so that it can serve as the means for teaching art appreciation in a manner fostered by Dr. Barnes. The collection contains many masterpieces, and for over sixty years it has remained undisturbed at Merion.

In 1992, the trustees of the Barnes Foundation were faced with the need to undertake major building renovations, for which there were insufficient funds available to meet projected costs. With the active cooperation of some museum professionals, the trustees devised a plan whereby a group of pictures from the collection would tour in Paris and in Tokyo for loan fees amounting to $7 million. Additional millions were expected from auxiliary activities associated with the foreign tour. The plan was presented to the court as an inventive way to "kill two birds with one stone": Money would be available for renovation and the paint-

This chapter is based on a talk of the same title delivered at the American Law Institute–American Bar Association seminar, "Legal Problems of Museum Administration," Philadelphia, March 1993. Copyright to the transcript of the talk © 1993 is held by the American Law Institute. This edited version is published with the concurrence of the American Law Institute–American Bar Association Committee on Continuing Professional Education.

ings that toured, it was argued, would be afforded better care than if they were in storage. The court approved a one-time deviation from the terms of the Barnes trust so that the plan could be implemented.[1]

This incident caused many in the museum profession to take a more active interest in the issue of "lending for profit." The Barnes arrangement was not unique. There were reports that the Museum of Modern Art was sending some of its masterpieces to Bonn and Tokyo for substantial fees. The Whitney Museum of American Art was scheduled to provide a series of large exhibitions from its permanent collection to the San José Museum of Art for a reported $3 million, and the Boston Museum of Fine Arts had a contract with Nagoya, Japan, to establish a branch museum at Nagoya that would draw on Boston's permanent collection in return for sizable payments to Boston. These were just some of the reported ventures in progress.

"Why all the fuss?" some asked. Hadn't the Phillips Collection of Washington, D.C., lent for high fees years ago in order to secure money for capital improvements? Others insisted that such ventures were unethical and that their growing popularity called for forthright debate. The question then is this: "Are there ethical considerations on this issue of lending one's collection in order to make money?"

First, what do we mean by ethical considerations? In one of my graduate classes at the university, we spend a good deal of time talking about the difference between law and ethics, and frequently in an exam I will ask the students to write about this distinction. One student's answer is relevant to the topic before us; the gist was this: "If you have a really bad situation and you can't threaten people with the law, then you tell them they have an ethical problem." In other words, for this student, when all else fails, rattle your ethical sword. If I remember correctly, that student did not get a very good grade—and I hope it will become clearer why as the discussion continues. But, to be sure we are all talking about the same thing, let me define "ethics" for the purposes of this discussion.

The term "ethics" as used here refers to a professional code of conduct—conduct that a profession considers essential in order to uphold the integrity of that particular profession. In essence, such a code of ethics reflects the reasoned group judgment that certain standards of conduct should be followed in order to sustain the effectiveness of the profession. Also, professional codes depend on that group's commitment to public service and personal accountability because normally such codes are promulgated by self-education, self-motivation, and peer pres-

sure. As we talk about ethical considerations, therefore, we will be asking whether there are reasons not mandated by the law, but based on generally accepted professional wisdom, which should cause us to explore more carefully the ramifications of this growing trend to "lend for profit."

As noted, a number of museums are currently engaging in loan ventures that distinguish themselves from prior loan arrangements by the obvious fact that profit is now an all-important motivation. And, of course, we can point to the Barnes arrangement as an attention-grabbing example of this trend. We can place the Barnes in this category not because we view Barnes as a traditional museum (it is primarily a teaching organization), but because the Barnes loan tour could never have happened without the aggressive collaboration of many museum professionals. While Barnes is not an example of a traditional museum lending in order to obtain substantial profit, it is an example of portions of the museum community very visibly endorsing a method of obtaining revenue that has immediate application for traditional museums.

We can agree that museums need money and that even the most carefully managed museums are experiencing difficult times. Harder choices have to be made about where available resources should be allocated, and, at the same time, thought has to be given to the future stability of the organization. In order to make sound choices and to plan realistically, a museum must have a firm grasp of its own mission, and, equally important, should understand the limitations and expectations placed upon nonprofits generally by society. If decisions are not made within these boundaries, then the issue of ethics, as we are defining it, rears its head. If professional responsibilities—that is, ethics—mean anything at all they must at least mean that those charged with guiding a museum have an obligation to inform themselves fully with regard to mission and to public expectations when important matters are at stake. If we do not concede a responsibility to be fully aware of mission and public expectations, then all the glowing language in our professional codes about a museum's "public trust" responsibilities should be stricken.

The mission of a museum will vary depending on its particular charter; defining the mission is always a first order of business. There can be no reasonable articulation of goals or discussion about appropriate means to achieve goals until those in command have a clear and definite understanding of what that particular museum is all about. In a nonprofit organization, the mission is the reason for being, unlike the for-profit organization where the ultimate purpose is making a profit. In a non-

profit organization, therefore, the mission is the first touchstone for testing the appropriateness of any planned activity.

A companion set of considerations includes the limitations and expectations placed on museums generally, by virtue of their nonprofit status. These considerations form the second touchstone for testing appropriateness of activity. If museums value the benefits afforded to them as nonprofit organizations—benefits such as:

exemptions from most income taxes;
exemption from property tax;
the ability to attract gifts because of favorable tax consequences for most donors;
the ability to accept volunteer services;
the availability of favorable postal rates;

then museums should be very conscious of why they have nonprofit status and make policy decisions accordingly in order to avoid activity that undermines the integrity of that status. It is in this area—being able to articulate why they have nonprofit status and using this as a guide in decisionmaking—that many museums and other nonprofits fall short. This area applies to our particular question of whether "lending for profit" may in fact be so shortsighted as to be considered unethical.

Most of us are very aware of the "perks" afforded nonprofits, but if asked to explain why our society has carved out a nonprofit sector and granted it these benefits, a lot of us would begin to shrug our shoulders. If we do not share a common understanding of why we have this separate sector, how can we conduct ourselves intelligently so as to maintain the strength of the sector? The United States is unique in the fact that it supports a very large nonprofit sector. We could end up like most countries—with only two sectors of any consequence, government and business—if those who operate within the nonprofit sector unwittingly lead their sector astray.

Our inability to talk confidently about why we have a nonprofit sector is understandable. I doubt if any of us were ever taught anything about this in our early education, and when we moved into the professional ranks all discussions about this sector revolved around the perks, not the "why." Only recently have we begun to pay attention to the nonprofit sector, in part because of its dramatic growth. Many questions are being asked about why the sector exists, the value of the sector, how the sector conducts itself, and appropriate restraints on the sector. Because the sec-

tor's history is cloudy, how those questions may be resolved depends in good measure on how the public perceives the nonprofit sector today. In other words, the nonprofit sector is under tremendous pressure to justify itself. It needs to ponder its reasons for being and to articulate those reasons, and to demonstrate that its activities are in accord with those reasons.

Why do we have a nonprofit sector? The answer must demonstrate that the nonprofit sector affords society benefits that cannot be obtained from government or from the business sector. If we cannot show any unique benefits flowing to society, then the logical question is why this third sector? If government can supply nonprofit services just as well, why not cut out all the tax and postal benefits for nonprofits and have that money flow directly into the public treasuries? Similarly, if business can do some of nonprofits' work just as well, why should business have to compete with organizations doing the same work but receiving public subsidies? Wouldn't the public be better served by doing away with the subsidized "third" sector and obtaining desired services in a truly competitive marketplace? These questions usually infuriate those working in the nonprofit sector, but it can be said with considerable justification that to date the nonprofit sector has been more emotional than thoughtful in its response to these critical attacks. Unless the nonprofit sector can do better with its answers, and then conduct itself in conformity with these answers, we are facing some very interesting times.

A number of arguments support the nonprofit sector, as explained in chapter 1, but two are particularly relevant to this discussion. One argument is that the sector fosters diversity. In the United States, any group can start a nonprofit organization as long as the purpose of the organization fits within the broad category of "public service" and voluntary support can be obtained. Thus, the nonprofit sector provides a voice for minority groups, for new ideas, for criticism of accepted practices, and for matters that are forbidden to government. If, on the other hand, we had no nonprofit sector and looked only to government for support of cultural endeavors, we would have to confront the reality that a democratic government responds to prevailing majority views. New or unpopular ideas rarely find support when the test is whether the average voter will approve such public expenditures. The nonprofit sector, by not having to depend on the will of the majority, gives us the opportunity for real diversity—a benefit that cannot be duplicated by government itself.

A second argument in support of the nonprofit sector is that the sector

can foster greater quality of service or product. If the ordinary demands of our capitalistic marketplace must be met for all activities, then some endeavors will either fall by the wayside or be compromised. For endeavors of this nature, the nonprofit sector provides a supportive atmosphere. In the nonprofit sector, an organization can be sheltered from taxation, it can attract gifts and grants to keep itself in operation, and it can accept volunteer services and other benefits. All these privileges are there so that the nonprofit can concentrate on its mission, its public purpose, without having to compromise in order to compete in the marketplace or be forced to take on auxiliary activities that distract from mission in order to generate income. Thus, the structure of the nonprofit sector encourages quality for its own sake—the ability to focus on mission—a benefit not found in the for-profit sector.

These two arguments in support of the nonprofit sector are powerful ones, but they do place restraints on the sector. Let us look at the argument that says the nonprofit sector is important because it permits organizations devoted to the public good to operate with protection from the pressures of the marketplace—protection that is important so that mission is always the focus and quality is not compromised. If this is one of the main reasons why a museum has nonprofit status, it follows that those guiding the museum should be painfully aware that the activities of the museum should be conducted so that it is quite evident that the emphasis is on mission—serving its community—and that quality is not, in fact, being interpreted to mean marketability.

It is fair to say that in the last fifteen years or so many of those charged with governing nonprofits are more market-oriented than mission-oriented. They have failed to make choices that demonstrate sensitivity to why they are nonprofits. Mission gets blurred or is so elastic it can be construed to accommodate whatever might be the latest income-producing technique. We have only to look at many of our hospitals and universities—colleagues of ours in the nonprofit sector—for examples. The trend is now more than evident in the museum world.

- Museum shops are larger and larger, with off-site museum shops located in shopping malls.
- Museums have extensive licensing operations to manufacture products bearing the museum's name.
- Some have tie-ins with travel organizations in order to shepherd tour groups to their museums.

- Museums hold blockbuster shows with attendant retail products and special tickets.
- Museums package solicitations for corporate sponsorship that essentially market their "product."
- Museums are encouraged to count, label, and segment their "clients" so that they can target their messages.

So much for the argument that nonprofits, in order to encourage quality, need to be free from traditional marketplace pressures.

If we admit that quality or mission has suffered because of these activities, we should take steps to limit marketplace experiences. If we argue, as many in the museum community will, that quality and mission have not suffered because of the market orientation, then we leave ourselves open to the question of why we need special subsidies to protect us from market pressures.

While we struggle with this dilemma in an effort to answer our current critics, we now enter another market-oriented moneymaker, "lending for profit." It might be a tour of spectacular works for a fee as high as the traffic will bear, or it could be assembling an exhibit "on order" for another organization for a profit motive, or it could be opening and running a brand-new museum for a foreign client for a substantial annual fee. We hasten to point out, however, that these are "win—win" situations. Museums get badly needed money, and their works get greater exposure. Who could complain? But how far can we go and still maintain with any credibility that mission and sensitivity to our status are central factors in our decisionmaking? This brings me back to my student's explanation of "ethics."

That student defined "ethics" as the last resort—the sword you pull out when a crisis is at hand and all else has failed. I like to think of "ethics" (as we are using the term here) as a way of avoiding crises. Ethics should be a profession taking itself seriously in order to maintain public confidence—not testing its credibility to the limits before beating its breast and saying "we have strayed." If we view ethics as a way to prevent serious problems, then, from an ethical standpoint, the profession should be taking a much harder and longer look at this surge of interest in "lending for profit." In the process of this reexamination we could ask this very important question: "In the light of hindsight, what lessons should we have learned from our experiences to date with blockbusters and similar market-oriented ventures?"

Let us look at some comments reported in a 1991 book titled *The Economics of Art Museums*.[2] The book contains a number of essays written by museum professionals, economists, and market specialists. True, the focus is on art museums, but the observations have broad applications.

In one essay, John Walsh, director of the Getty Museum, talks about blockbuster traveling exhibitions and how they have affected the museum audience. He argues that this form of exhibition has caused people to think of art as "an event" and, hence, one is inclined to go to the museum only when there is a show. In the minds of many, he says, a museum without a blockbuster has become a theater with a darkened marquee. All of this, he laments, has turned attention away from a museum's permanent collection, which is really the museum's reason for being.[3]

William Luers, president of the Metropolitan Museum of Art, writes in the book about the Metropolitan's twenty years of experience with blockbusters. He admits to the museum's growing dependency on the revenues such exhibitions produced and that this naturally placed pressures on the professional staff to schedule such traveling exhibitions regularly, "thereby distorting the direction and approach to the mounting of museum exhibitions."[4] Recognizing the problem, the museum, Luer asserts, has taken steps to focus more attention on its central, long-term goals.

James Wood, director of the Art Institute of Chicago, also discusses at some length the increasing emphasis on earned income in museums and explains how, in his opinion, this emphasis generally works against the image of the museum as an educational organization. He questions in particular the ability of U.S. museums to cope with international economic pressures and cites the Japanese custom of paying huge fees for traveling exhibitions. These exhibitions, in turn, are used as marketing opportunities by the Japanese. Wood notes that U.S. museums, as lenders, seem quick to accept Japanese loan fees, but wonders about the next step. Will U.S. museums then adopt the Japanese model of exhibition (using the exhibition to generate profit) and thus undermine their nonprofit status?[5]

The economist Martin Feldstein talks about tradeoffs and the fact that museums are never going to have enough money to pursue a full range of public benefits. He explains that if a museum wants to do more of one thing, then something else must be curtailed. The prudent manager must face these tradeoffs honestly.[6] What Feldstein is saying is that a museum cannot rationalize every venture on the grounds that in some way its public will benefit. Instead, it should analyze objectively how activities

truly essential to its mission will be affected by a proposed new venture, and then make a decision in light of these identified tradeoffs.

These opinions of rather experienced individuals should not come as a surprise. If one reads in any detail the evidence given to support such opinions the problem of eroding the foundations of our nonprofit sector is clearly present as well as these associated tradeoffs:

declining staff morale,
a growing emphasis on quantity, not quality,
an escalation of competitiveness among nonprofits, and
fragmentation of energies.

Also, on the practical side, there looms the question: How does "lending for profit" affect the museum community's long controversy with the accounting profession over the issue of capitalization of collections? The accounting profession, through its Financial Accounting Standards Board, has been seeking to require museums to capitalize collections and show them as assets on balance sheets. After more than two years of effort, the museum community won concessions from the accounting profession with its insistence that collections are not true assets because they are not used for financial gain. Is it a stretch of the imagination to say that "lending for profit" looks very much like utilization of collections for financial gain?

If the museum community is seriously trying to learn from experience, all sorts of red flags should be waving. Instead, some are quick to embrace what appears to be the next popular income-producing vehicle—"loans for profit"—and few voices are saying, "Wait a minute, where are we going?"

- How will all of this affect public perception?
- How will it truly affect our ability to carry out our missions?
- Every museum that lends invariably borrows. Where will we get money to pay borrowing fees when large fees become the norm?
- What strains will be placed on our collections as they become revenue-producing vehicles? Can conservation concerns be objectively weighed when big dollars hang in the balance?
- Will major collectors now expect huge fees to exhibit their objects? In Europe Baron Thyssen, a Swiss citizen, and the Spanish government have already provided a model. The baron leased his massive collection to Spain in 1992 for ten years for approximately $50 million,

plus a museum bearing his name. It is said that there were many museums bidding along with Spain, some even from this side of the Atlantic, but Spain won the round. Should we speculate as to what might happen if other collectors adopt this stance?

A December editorial article in the *Washington Post* quoted from a recent publication of Sen. Daniel Moynihan in which the senator observes that as a people "we are getting used to a lot of behavior that is not good for us."[7] This happens, it is explained, when people are unwilling or unable to confront current problems. To cope, they lower standards and no longer question what was once unacceptable. I think we can see this in the museum community. Rather than address our basic problem—the need to sort out what it means to be a nonprofit so the sector can work toward a surer foundation—rather than do this, "we define our problem down" to merely one of money—if only we had more money, everything would be fine. In doing this, in focusing so much attention on earning income, we are forgetting what we are all about, and every day it seems to bother us less. For want of a better term, I call this a serious ethical problem.

12 ❖ *Poor Sue*

The Realities of Protecting Archeological and Paleontological Artifacts

The Story of Sue

On an August day in 1990, fossil hunters associated with a commercial geological research organization in South Dakota discovered dinosaur bones on the property of Mr. X, a member of the Cheyenne River Sioux Tribe. The hunters notified Mr. X and paid him a fee of $5,000, allegedly for the right to excavate the bones. Upon excavation of the remains and their removal to the research organization's laboratory, it became evident that Sue, as the skeleton was named, was a spectacular find. Word of its recovery was publicized, and paleontologists were invited to come study what was said to be the best *Tyrannosaurus rex* skeleton yet uncovered.

As Sue's fame grew, so did trouble for the owners of the research institution. Mr. X began to doubt whether he really gave permission to remove the skeleton from his property; the Cheyenne River Sioux Tribe asserted an interest; and the federal government in its historic role as trustee for the Indians began investigating its rights in the matter.

Charges and countercharges filled the air. The research institute was condemned and labeled by some as crassly commercial. Equally unflat-

The substance of this essay was first delivered at the American Law Institute–American Bar Association seminar, "Legal Problems of Museum Administration," Philadelphia, March 1993.

tering remarks were made about the motivations of Mr. X, the tribe, and federal officials investigating the matter. Paleontologists split, with some highly critical of any explorations conducted by those outside of academia, while others defended nonacademic and commercial fossil hunters as playing useful roles.

In May 1992, the local U.S. attorney obtained a search warrant against the research institute, claiming theft of government and Indian property; the next day law enforcement officers seized Sue and took her into custody pending a court hearing. The research institute then initiated legal action to regain Sue, and a series of legal skirmishes took place.

In February 1993, a trial court ruled that Sue was federal property held in trust and that no valid sale of Sue could be made without the consent of the government. Accordingly, the court said, there had been no passage of title to the research institute. The judge in reaching his decision had little precedent to guide him, and, quite likely, there will be further litigation before the issues raised are finally resolved.[1] The story is told here, however, not for its ending but as an illustration of the many complex matters that come into play when the subject is protection of resources unique to a country. Museums, as repositories of scarce resources, whether they be fine art, artifacts, or natural resources, are invariably drawn into such controversies, and it is important to appreciate the complexities involved. Looking at the broader developments Sue set in motion illustrates some of these complexities and affords food for thought for all types of museums.

Renewed Debate

The matter of Sue exacerbated a long-simmering debate on whether the government should regulate the disposition of fossils found within the United States. In one camp are those who argue that fossils are an irreplaceable part of our national heritage and must be reserved for scientific and educational purposes. In another camp, others argue, with equal vigor, that restrictions by the federal government will in fact hamper the advancement of knowledge. Those urging more federal protection cite the danger of increasing commercial exploitation of fossils as fossils become more attractive to collectors, with the accompanying uncontrolled excavations. Those opposed to more regulation argue that on the whole fossil dealers and amateur collectors aid the scientific community. It is

through them, they say, that important finds are brought to the attention of scientists and public awareness of the importance of fossils is increased. Clearly, there is a substantial division of opinion within the scholarly community on whether the regulation of fossils is necessary and, if there is regulation, the direction it should take.

Existing Regulations

When evaluating this division of opinion on control of fossils, a sensible starting point is the regulations we may now have. The search can be broken down into situations relative to: (1) public lands owned or controlled by the federal government; (2) lands owned by state governments; (3) lands owned by private individuals; and (4) lands associated with Indian tribes.

PUBLIC LANDS

Presently, no general federal legislation expressly protects fossils found on public lands but, under their specific legislative authorities, some federal agencies do find it compatible with their missions to regulate fossil hunting on lands under their control.

When looking for general statutes that might address protection of fossils, the Antiquities Act of 1906 comes immediately to mind.[2] That statute requires one to obtain permission before excavation or removal of "any historic or prehistoric ruin or monument, or any object of antiquity" located on federally controlled land.[3] The legislative history of the act indicates that Congress was focusing on evidence of human life (i.e., archeological material) when it framed this language, although records show that administratively some agencies used this section of the Antiquities Act as authority to regulate fossil collecting. In 1974, in the case of *United States v. Ben Diaz*, the terms "ruin," "monument," and "object of antiquity," as used in the Antiquities Act, were held to be unconstitutionally vague.[4] The court explained:

> One must be able to know, with reasonable certainty, when he has happened on an area forbidden to his pick and shovel . . . Nowhere here do we find any definition of such terms as "ruin" or "monument" or "object of antiquity" . . . In our judgement the statute, by use of undefined terms of uncommon usage, is fatally vague.[5]

Because of this weakening of an ability to interpret the language of the Antiquities Act broadly, the solicitor's office of the Department of the Interior in 1977 took the position that it was more prudent to construe this section of the Antiquities Act as *excluding* paleontological objects. On the administrative level, however, some federal land managers continue to cite the Antiquities Act as authority to control fossil hunting. There appear to have been no court challenges on the issue of whether fossils are covered by the Antiquities Act.[6]

A second statute of interest is the Archeological Resources Protection Act of 1979 (ARPA),[7] which serves in good measure to clarify federal authority that had been weakened by the *Ben Diaz* case. ARPA covers "archeological resources," which is defined to exclude nonfossilized and fossilized paleontological specimens unless those specimens are found in an archeological context. In other words, ARPA, which in many areas supersedes the Antiquities Act, clearly excludes fossils unless the fossils are part of an archeological find.

Another possible source of statutory authority is federal historic preservation legislation. As a rule, however, these statutes address historic and archeological preservation, again terms usually construed to exclude fossils. The only exception found in preservation statutes is a National Natural Landmarks program that allows sites with outstanding geological features or fossil evidence to be set aside as natural landmarks.[8] This program allows only for site designation, not the general protection of fossils on all public lands.

No other general applicable federal legislation comes to mind except, perhaps, the Materials Act of 1947.[9] This statute gives federal authorities limited power to sell mineral material found on federal lands. It could be considered oblique authority to regulate, in order to designate appropriate material for sale.

This generally covers applicable federal legislation. As one can see, there is currently little strong statutory support for regulation of fossil hunting on public lands. Individual agencies, however, can have in their own charters more specific authority as it relates to the mission of the agency. For example, the U.S. Forest Service, the U.S. Bureau of Land Management, and the U.S. National Park Service can cite in their statutory authority broad mandates to protect lands under their control, which mandates are construed to include the management of fossils. There have been no consistent regulatory practices by such individual agencies, however, and relatively little time and money have been devoted to fossil protection.

It would be fair to say that, except in dedicated national parks or sites, there is little effort to control fossil hunting but, on the other hand, there appears to be no hard data to date that establishes a dramatic increase in reckless excavation of fossils for mercenary purposes.

STATE LAND

Individual states may have legislation regulating state-owned land. These statutes must be read carefully. Some clearly list coverage of paleontological material, others speak in general terms of historical and archeological resources and thus raise the issue of legislative intent regarding the extent of coverage. Generally, these statutes have permitting procedures for state-owned lands with preference given to excavation by scholars. Some state statutes have a *voluntary* permitting procedure for private landowners.[10]

PRIVATE LANDS

Private land is controlled by the individual landowner, and this ownership as a rule extends to fossils on or below ground. A fossil hunter prospecting or excavating on private land must negotiate with the landowner.

INDIAN LANDS

Indian land, which frequently is held in trust by the federal government for tribes or individual members of a tribe, presents a whole range of new problems. It is difficult to generalize where ultimate authority over fossils may rest with regard to land associated with Indian tribes. Perhaps for a while questions concerning Indian land will have to be decided on a case-by-case basis. As illustrated by the "Sue" case, a tribe may seek to assert control over fossils even if they are found on land controlled by an individual member of the tribe. And, even though an individual Indian may negotiate with a third party regarding fossil excavation on land under that Indian's control, the federal government may assert ultimate authority to regulate any such activity, citing its role as trustee of the property. Cases of this nature are going to bring their own unique mix of legal and political issues. Time is needed to sort out these issues.[11]

Baucus Bill

In response to renewed interest in the issue of fossil protection, a bill was introduced in the 1992 session of the U.S. Congress by Sen. Max Baucus of Montana.[12] The bill was titled the Vertebrate Paleontological Resources Protection Act, and, while no definitive action was taken on it in that session, many would like to see a new version of the bill reintroduced. Very briefly, the 1992 proposal did the following:

- It regulated "paleontological resources" located on lands owned or controlled by the federal government. "Paleontological resources" were defined to include significant naturally occurring remains of vertebrates as well as fossilized remains of vertebrates if the remains could be dated to vertebrates living prior to the Holocene epoch.
- Under the bill, permits had to be obtained to excavate or remove paleontological resources located on land owned or controlled by the federal government.
- Permits were to be issued only to "qualified applicants" primarily for purposes of scientific research, public education, or public display.
- Federal land managers had to make decisions regarding the issuance of permits in consultation with paleontologists.
- All such resources removed from public land were to remain the property of the United States and had to be deposited in suitable institutions that had collection management policies meeting professional standards.
- All trafficking in paleontological material illegally removed from federal lands or obtained in violation of any state or local law would become subject to the civil and criminal penalties imposed by this new act.
- The act imposed a series of substantial civil and criminal penalties.

This is only a very general outline of the proposed bill, but it is sufficient to identify some difficult issues raised by this type of legislation. The proposed fossil legislation is closely patterned after ARPA, our major legislation addressing archeological resources. Looking closely at our problems in implementing statutes dealing with archeological materials should make us more cautious about moving swiftly on regulation of fossils.

ISSUE 1

First and foremost, if there is to be fossil legislation, far more thought must be given to the practical problem of identifying what paleontological resources taken from federal land actually merit indefinite retention. Put another way, can scientific significance—the articulated standard—be determined quickly and efficiently? I understand that it is harder to make such a determination within a fairly short period for paleontological material than for archeological material. If we look to our extensive experience in trying to articulate what is scientifically important with regard to archeological material under the Antiquities Act, ARPA, and several other statutes, we have a very depressing picture.

As previously mentioned, the constitutionality of the Antiquities Act was questioned in court because of its vague definition of what it covers. When ARPA was passed in order to cure some of this confusion, the situation did not improve. ARPA uses the term "archeological resources" and attempts to sketch out in broad language what this covers. It was then the task of federal agencies to flesh out this statutory definition in their implementing regulations. Once again, the definition of what should be covered proved to be a stumbling block; anyone experienced in managing collections could see some of the problems. A very inclusive definition, one that would make it easier to enforce the statute, would mean that more material would be collected than could be realistically controlled. Museum collections are costly to maintain and require indefinite scholarly attention if they are to be kept viable as educational resources. Visits to museum storage areas in countries with broad retention policies offer vivid evidence of the futility of undisciplined collecting. On the other hand, a narrow and efficient definition of "archeological resources," one that permits a quick and relatively accurate assessment of scientific importance, is almost impossible to draft because judgments of this nature usually have to be made on a case-by-case basis by highly trained individuals. Federal agencies trying to arrive at regulatory language that was enforceable but not too broad struggled for years, and what resulted has been the subject of much criticism. In a 1987 law review article, a former assistant U.S. attorney with considerable experience in enforcing antiquities legislation had this to say about the government's ability to promulgate effective regulations in the area of archeological protection:

> The best that can be said of the federal archaeological resource regulations is that they are confusing. In fact, they are a horrible hodge-podge, internally inconsistent and incomprehensibly vague...[They] are probably best left untested in the courts.[13]

The message here is clear. For years, the government has been trying to define with clarity the term "archeological resources" in order to have a basis for efficient enforcement of regulatory statutes. It has not yet been able to do so. Can we expect any better track record if there is new legislation to protect "paleontological resources"? Good intentions alone do not make good statutes. The realities of enforcement must be considered as well as the achievement of results that actually benefit society.

ISSUE 2

Experience in archeology shows another serious practical weakness. There has been little effective control over the quality of material retained from regulated federal archeological excavations and even less control over the curation of that material. Federal land managers, the ones on the front line in implementing these statutes, often do not have the time, inclination, or expertise to exercise the necessary oversight. It is hard enough to get an initial informed decision on whether material merits retention. It is harder to follow through over the years to monitor the care given this material. Today, we find that much of our protected archeological material cannot be found and that some of what is being located is useless because of poor quality, poor care, and/or missing documentation.[14] In effect, experience with archeological material has taught us that mandated retention of materials taken from public lands is very difficult and costly to implement effectively.

ISSUE 3

There are other practical problems with the proposed 1992 bill to regulate fossils. The bill had a provision that allowed amateur collectors to retain possession of paleontological resources from public lands if those resources were not of significant scientific value. While the amateur could have possession, title would remain in the federal government. This type of situation begs trouble and even raises some constitutional

questions. Our courts have voiced reluctance to enforce laws of foreign countries that permit private citizens to have indefinite custody of property that the state claims as its own. Such situations can entrap parties who innocently acquire the property from those who merely have custody. This position goes back to our belief that people should have a reasonable way of knowing when they are violating a law.[15] To avoid criticism of this nature, it would be preferable to have the government relinquish all claims to material that is not deemed scientifically significant, but then we are back to the problem of whether decisions regarding significance can be made expeditiously.

ISSUE 4

Another important issue is expense. Until now the federal government has not uniformly funded the curation of archeological material removed from federally controlled lands, even though it claims title to this material. Now that the government is taking more of an interest in locating this material, one can be sure that the payment of curation costs will become a major issue. If the government decides to control paleontological material, it should expect to pay mounting annual sums for the care of the material. This cost, coupled with the knowledge that it will be difficult to control the quality and quantity of material retained, raises serious policy issues.

ISSUE 5

Tied in with the problem of efficient determination of what material should be retained by the government is the matter of fair access. Consider the interests of amateur collectors and of educators who need fossil specimens for teaching purposes. Historically, these groups have had access to most public lands. Their ability to fossil hunt has advanced education and has led to many fruitful collaborations with researchers in academia. The legislation proposed in 1992 drastically restricted access of these individuals to any fossils on federal lands.

ISSUE 6

Finally, associated with the issue of fair access, is the question of the legitimacy of commercial trade in fossils. Many paleontologists wish to

ban commercial trade, finding it destructive to the advancement of knowledge because it encourages unscientific excavation. Others in the profession see a legitimate role for the commercial dealer. This same split of opinion can be seen historically in professions concerned with fine art and anthropological material. We might say to paleontologists: "Welcome to the club, we've been debating this issue of national retention of cultural material versus relatively free trade for decades."

Consider this country's twenty-year dialogue on the UNESCO Convention concerning the import, export, and transfer of cultural property.[16] That international convention, which includes paleontological material, was debated for years in Congress, and then was given only limited implementation in this country.[17] On the whole, we remain a country more sympathetic to the free flow of cultural objects and the knowledge they bring than to fostering policies, both here and abroad, that restrict this flow.

Conclusions

My list of practical issues is discouraging for those who hope for a legislative solution to the protection of fossils, but at least the debate about Sue has raised public awareness. No matter what legislation might be passed in years to come, it will not be very effective unless the public cares sufficiently about the goals to be achieved. Maybe the focus of efforts should first be toward greater public education. With the public more aware of what paleontologists do, there is far more likelihood that interesting specimens will come to the attention of scientists and, as needs arise, that individual donors will come forward to support important projects. These are the methods that have sustained much of what our U.S. museums do, and do quite well. They should work for paleontologists, too.

Readers are reminded that this story of Sue holds lessons not just for paleontologists. Pondering the whole saga can help museums of all types, and their governing boards, play a more intelligent role in national and international efforts to balance the desires of some to control and protect scarce cultural resources with competing desires of others to allow the free flow of such material. When issues are complex, it is difficult to draft regulating laws and treaties, and even harder to enforce them. However, what can be effective over time in avoiding extremes and in

carving out acceptable middle grounds are museums committed to making informed internal decisions regarding acquisition, identification, borrowing, or disposal of such unique materials. Self-imposed internal policies based on knowledge of applicable laws and professional standards, and use of peer consultations when especially difficult situations arise, result in thoughtful attention to individual cases. This process usually leads to the development of relatively balanced standards that in time prove acceptable to most.

13 ❖ *From Card File to Computer*

I am compelled to make a confession before beginning my discussion. It is an embarrassing admission, but it is best to admit it now before the flaw is detected. I am afraid of computers. I still write everything out on yellow pads, and I am terrified when my secretary is ill because I might have to approach all the machinery on her desk. At home, where we have had a computer for some time, my contribution is to look into the study each night before going to bed. If I see a little light, I shout, "Someone left the computer on," hoping that someone will come to the rescue and push the right button.

One might then ask, "What is she doing discussing 'moving people toward change—toward the age of automation' when she herself appears to be at least a decade behind?" I may not know much about computers, but I do believe I know a bit about what should happen in a museum before major expenditures are made for automation.

This chapter was prepared for delivery at the 1990 international meeting of the Museum Documentation Association, held in Cambridge, England. The theme of the meeting was "Staff Development and Training: Meeting the Needs of Museum Documentation." This chapter addresses the subtopic "Moving People Toward Change" and was first published in the proceedings of the *Fourth International Conference of the Museum Documentation Association*, ed. D. A. Roberts (Cambridge, England: The Museum Documentation Association, 1993), 3–8. Copyright © 1993 The Museum Documentation Association. It is reproduced with permission.

The ability to automate information merely exacerbated long-simmering management problems in museums. These problems were just beginning to be addressed some fifteen years ago in the United States and at a pace some might say was painfully slow. Suddenly, we had rapid advancements in computer technology, followed by tremendous pressure to automate everything. Serious management questions were set aside in the rush to automate, because it was easier to believe that computers would solve problems once they were stuffed with information. The quality of information and the accessibility of that information once it was logged onto a system were given too little thought, and many museums ended up with expensive disasters on their hands. They made the mistake of equating frantic activity with progress and learned, to their sorrow, that computers only magnify management errors.

I would like to recount my personal experience with museum documentation issues. Years ago, I happened to be at the right place at the right time to see problems emerge in this area and to view a range of reactions as museums tried to cope. Time has shown that more sophisticated museums were no better at coping with these problems than many of their smaller or less prestigious colleagues. Human nature is human nature, and we learned the hard way that one must never lose sight of the human factor when planning and implementing a documentation system for a museum. I suspect that computers are relatively easy to control as compared with human beings, so I will talk from personal observations about moving people toward change.

In the early 1970s, I worked in the legal office of the Smithsonian Institution. My days were taken up with legal problems far removed from collection issues. On my desk would be questions about the proper management of endowment funds, the liability of the Institution for visitor accidents, the relationship of the Institution to the federal government—all matters shared by large charities in the United States, whether they be museums, universities, or hospitals. In other words, collections raised relatively few legal issues of consequence, and those charged with immediate control over the collections mostly did what they wished.

The Smithsonian is made up of a complex of fourteen collecting organizations. Each has a different focus, each has a unique history, and each has its own director or chief administrative officer. While each unit has a good deal of autonomy, all ultimately report to a Board of Regents, which governs the entire Smithsonian, and to the central administrative staff housed in the original Smithsonian building called the "Castle."

Rarely did I venture from my office in the Castle out into the field to talk with those administering the museums. In time, however, I noticed a growing number of museum staff coming to me with problems related to their collections. Many of these problems required careful review of records, and I saw, first-hand, the range of quality among recordkeeping systems. There appeared to be no uniformity with regard to allocation of responsibility, adequacy of documentation, or security. Museum personnel were asking me whether their museum in fact owned certain objects, whether there were legally binding restrictions on the use of certain collection objects, or what to do about old loans—material that had been on loan for generations with no contact with original lenders or their heirs. These and similar problems had arisen mainly because of faulty recordkeeping systems or inadequate monitoring of records, and they defied quick legal solutions. When a museum is in the position of proving its ownership of an object or proving that it has unrestricted use of an object, it must come forward with convincing evidence. When documentation is inadequate, the evidence is not available, and the museum is then faced with costly uncertainty. It cannot move with confidence to utilize the object fully, yet it usually is bound to maintain and care for the object indefinitely, hoping that legal rights eventually will be resolved. I found myself having to give this message too often to the then-steady stream of museum staff coming to my office.

Why, suddenly, were these problems showing up at my doorstep? At first, I feared it might be a form of flattery. Perhaps I was the first legal counsel to take a serious interest in these documentation problems—I asked so many questions—and maybe these nice people were searching diligently to find unusual cases to satisfy my interest.

Upon closer examination, I noticed that most of the people bringing me these questions were what we call "registrars." Registrars have been around for a long time in U.S. museums and each Smithsonian museum had its own registrar. They are responsible primarily for maintaining collection records within a museum—more precisely, records that deal with the acquisition, legal status, and movement of collection objects. I think it would be fair to say that at that time typical registrars were subservient types. They did what they were told. The ones coming to see me did not fit this mold. They had good academic backgrounds and they were not satisfied just to transcribe. They were rightfully concerned about the quality and adequacy of documentation and about their professional responsibilities. What I was seeing, therefore, was a swell of questions

prompted by a more perceptive group of registrars. These were seeds of internal change planted by a developing professional group.

I learned a good deal from these registrars. Around this time the registrars decided to meet monthly to discuss documentation issues, such as how to solve an existing problem or how to avoid duplicating a problem. I was invited to these meetings frequently, which meant I had to be prepared to offer legal advice on a range of documentation issues. These registrars represented every type of collection—from fine arts to insects—with some collections dating back to the mid-1800s. All of the registrars educated me with real-fact situations, and I applied relevant legal principles in our search for solutions. In our efforts to attack individual problems we were developing some very clear ideas about how records should be kept from a registrar's point of view. This was fine and good, but several other points also became clear.

1. If a registrar was to keep good records, the whole museum had to cooperate. This meant that internal policies had to be established that defined: (a) what constituted adequate documentation; (b) who was responsible for obtaining the required documentation; (c) when this required information was to be delivered to the registrar; (d) who controlled access to this information; and (e) who had the authority to approve deviation from established procedures.

2. Once documentation criteria were established, a lot of skeletons would come out of the closet. The inadequacy of many existing records would be highlighted, which could place in doubt the museum's claim to certain objects or, at the very least, tarnish its reputation.

3. Roles would have to be redefined. Registrars would have to assume more responsibilities and would probably bear the burden of seeing that these documentation standards kept abreast of the times. Others within the museum would have to adjust their roles to accommodate registrarial responsibilities.

4. Conversion to good documentation systems would take considerable time, effort, and money. And, at this point, remember, we were discussing only registrarial records and in-house needs; there was little mention of elaborate automation.

In light of all these subsidiary consequences, the people factor began to loom large. Registrars, no matter how competent and dedicated, could not bring about change all by themselves. And what administrator wants to be told that an indefinite amount of time and money may have to be spent on a project with little visibility which could highlight additional

problems? A good number of staff people would be required to change ingrained habits or to follow procedures they found intrusive to what they considered to be their core work. Obviously, within a museum, there would be terrible pressure to let sleeping dogs lie. But other external events were also affecting our decisions.

1. More people were taking an interest in museum collections. The United States celebrated its bicentennial in 1976 and history was on everyone's mind. There were more researchers at our doors, more requests for loans of museum objects, and more commercial ventures based on collection objects.

2. Environmental issues became important. We had national legislation requiring evaluation of environmental consequences whenever major governmental projects were undertaken, which resulted in heavy demands on natural history museums for access to records and specimens that documented evolutionary processes.

3. Our country was becoming more affluent. People were visiting museums more, were expecting better services, and were interested in learning more about art and artifacts for investment purposes.

4. In the late 1970s, a major revision of our copyright law put at risk museums that failed to document explicitly the status of copyright interests when objects were acquired.

5. More and more legislation, both on the national and local levels, dealt with the right of the public to obtain certain information from public authorities, and another cluster of legislation dealt with the protection of an individual's privacy which forbade public authorities to release certain kinds of information.

6. Because of perceived abuses in the area of charitable gifts, our tax laws became more restrictive and museums were called upon to verify the details of certain charitable contributions.

All of the above placed stress on the ability of museums to respond to information requests, but there was no structure for controlling the situation in an organized way. Different types of information were maintained by different people within a museum, and no one was trained to begin an orderly review of information needs. Few administrators were capable of even digesting the scope of the problem.

Some began touting automation as the savior. It was said that if everything was put on the computer, we could then pull out what information was needed at any particular time. One additional factor pushed the Smithsonian at this point toward automation—its need for a support

facility. With its museums bursting at the seams, the Institution launched a major effort to fund and construct an off-site storage center. To justify the proposed size of the facility, the Institution had to document the size of its collections and their projected growth. Where to begin? Many of the collections had not been inventoried for generations, and few internal policies articulated acquisition criteria; so it was all but impossible to predict probable growth patterns. Nevertheless, in a fragmented way, individual organizations within the Smithsonian began to inventory their collections and to project space needs, and many began to automate their findings. I need not describe the quality of much that was produced.

A proper inventory involves not just a shelf count, but also a matching of records with objects. Invariably, groups of objects without documents and documents without objects will remain. Merely determining what you can identify with certainty takes tremendous outlays of staff time, not to mention the time needed to resolve discrepancies. In addition, other questions had to be faced in the inventory process: How should objects be described? How should groups of objects be counted? How much information should be captured? Questions of this nature were being decided on a unit level with little attempt at uniformity. Also, few, if any, of these collecting organizations had in place strong policies and procedures regulating the acquisition and movement of objects so that automated records, once made, were not kept current. There were no systems for keeping them current. To say that these early efforts to inventory and automate records fell into disarray is a kind description.

Meanwhile, central administrators and funding sources, not intimately familiar with the internal operations of museums, could not understand the delays and mounting expenses. If stores could inventory and automate their stock in a reasonable period of time, why couldn't museums? A related misconception was that the creation of an automated record system was a one-time event with no continuing responsibilities. In fact, what was becoming painfully clear to those closely involved in these early efforts to automate was that Pandora's box had been opened. Every management flaw was coming to light and it was foolhardy to proceed until policies were clarified, roles were redefined, and staff was educated. This would take time. It takes time to sort through complex problems, and it takes time for staff to adjust to changes.

I have focused most of my remarks on what we call registrarial records and have not addressed collection records of particular interest to curators, exhibit designers, educators, or other museum personnel. A natural

question, as one progresses in automating collection information for registrars, is: "What information should be captured and automated for other museum staff?" To make any true progress in answering this question, groups immediately concerned have to go through a process of analysis similar to that undertaken by the registrarial group earlier described. Each group has to examine precisely what it does, evaluate what records it now has, make informed judgments about the categories of information it will need in the foreseeable future, and consider how such information is to be obtained and managed. Each group's findings will undoubtedly impact on others within a museum. Priorities will then have to be established within a museum with regard to what information can realistically be captured in light of competing demands and what adjustments need to be made regarding lines of authority.

Once internal needs were identified, another set of questions arose: "How will one museum's records mesh with those of other museums when they attempt to communicate? Do they think alike? Can they think alike? Some of the more obvious problems in this area will be and are being solved by the initial discussions of professional groups, but now not so obvious problems are coming to light. As our horizons broaden, we find that nationally and culturally we can have different perspectives. What has one meaning for one has a quite different meaning for another, and maybe both views differ from that of a country of origin. How does one approach reconciling conflicting perspectives in the quest to document for a broad audience? How does one develop cataloging systems that will accommodate an ever-growing demand for broader and more in-depth documentation—certainly a recognized problem for history museums as they confront information requirements for research and interpretation. Is there a limit to what we should expect of documentation systems? Clearly, time, common sense, and patience are necessary as we strive for effective communication.

The Smithsonian is still working on its documentation systems, and I am sure it will be doing so indefinitely. We now know that a good documentation system must reflect good management practices, and good management is a never-ending task. We live in a rapidly changing world, and museums are not immune from change. If managers do not respond intelligently to new demands, the quality of documentation systems is ultimately affected. This leads me to underscore what I believe are root problems for many museums.

Current articles on automation of museum records frequently cite two

main causes for failure: (a) poor project management, and (b) lack of understanding of the principles and functions of documentation. I would venture to say that in many situations these are subsidiary problems—not the main ones. If a museum is to have a good documentation system, it must first have in place:

> clearly articulated and prudent internal policies describing what the museum does;
> precise and prudent delegation of responsibilities; and
> informed top-level managers who understand the general scope of documentation demands.

Years ago, museums existed without the need for such internal precision, but those days are gone. When you are the object of increasing public attention, the sensible way to control your destiny (and one too frequently ignored) is to get your house in order. You have to think long and hard about what your responsibilities are and then take steps to be sure your policies and procedures are in accord with those responsibilities. Without this introspection, the organization is adrift. No matter how expert your project managers may be and no matter how well they understand the principles and functions of documentation, you cannot set up a good record system when you do not know what you are or where you are going. Nor will that system happen if top management is not prepared to make hard decisions concerning allocation of museum resources.

As I look back, I cannot be critical of the slow and often disorderly route some have taken to arrive at our present state of knowledge. Such a route is almost a necessity when complex issues are involved and many people are affected. Human nature being what it is, it takes time to move forward as a group.

Lessons learned to date should not be lost, however, when we turn our attention to training staff to meet documentation needs. I would suggest, therefore, that trainers should post certain rules on their walls. The rules are these:

1. Documentation systems must follow good management practices. The cart can never go before the horse. This means that many times education must begin at the top.
2. Documentation systems should be tailored to meet the needs of the individual museum. Training should be geared toward giving staff the tools necessary to develop and oversee their own systems.

3. Once a documentation system is in place, staff must be fully advised of their respective roles in maintaining the system. Roles should be assigned realistically and participants should understand how they relate to the whole. In other words, documentation systems should not be taught in a vacuum.

4. There must be a knowledgeable person or group within every museum assigned to monitor the effectiveness of a documentation system once it is in place. A system is not static, and the person monitoring the system must be broadly trained and must keep abreast of new developments.

5. A documentation system is only as good as those in control. People run systems; systems don't run people. Accordingly, a system should never exceed the capabilities of staff, and, when training, you should be prepared to repeat and repeat and repeat.

6. True progress is made very slowly. Take small steps and be realistic in what you promise to achieve.

7. Always remember that any documentation system ultimately depends on people, and people are infinitely more complex than any computer. When designing, developing, and testing a documentation system, you always judge success by how well the system comports with human nature.

14 ❖ Repatriation and the Law

Several years ago I was asked to explain to an audience within a ten-minute period the legal issues that can arise when requests for repatriation of Native American material are presented to museums. ("Repatriation" was defined to mean the return of human remains or cultural items to Native American individuals or groups establishing close affiliation with such remains or objects.) This was an impossible task. No lawyer can explain even a simple matter in ten minutes. Instead I chose to use my limited time to focus on only two points: (1) Why the law plays such a key and, to some, exasperating role in these discussions on repatriation; and (2) Why in matters of this nature the law is often under-utilized. I believed then that once these two points were understood, there would be a better appreciation of how the law can facilitate rather than impede productive change. I continue to believe these two points, rather than a litany of possible legal problems, are of primary importance; that if interested parties accept the two points the rest will fall into place. Hence this chapter on repatriation is quite brief.

This chapter is based on a talk given in May 1988 at the annual meeting of the American Association of Museums, for a panel titled "Reclaiming the Past: Native Americans and Cultural Preservation." The original text has been revised in order to meld it with other portions of this book.

POINT 1: WHY IS THE LAW IN THE MIDDLE OF ALL THESE DISCUSSIONS?

In the United States, our government is based on law. Law, as set out in our statutes and as interpreted by our court decisions, establishes the rules whereby we interact as a society. The law affects every facet of our lives. A government by law brings stability inasmuch as it provides notice and consistency. All must go back to the same sources to determine what the law is, and these sources are readily available as published statutes, regulations, or court decisions. Our law is not in the head of a ruler nor is it supposed to be dependent on how the majority of the people feel at a particular moment. It is there, in black and white, for all to read. The courts, with their elaborate procedures, are charged with seeing that the law is consistently interpreted.

The law provides stability in another way. It accepts change slowly. By the time statutes have been passed or amended, or court decisions have interpreted statutes and traditional legal principles, much time and talk have elapsed. When change finally comes, we usually have thoroughly explored the pros and cons of the issue; those affected are generally aware of what is happening, and there are no great surprises. The law provides time to ponder and prepare for change.

To many, a rule of law may appear artificial—nothing but wrangling over words or a mechanism for maintaining the status quo. The criticism is not totally unjustified, but over the long haul a rule of law keeps us free. It gives us the stability we need to manage our daily affairs and to plan our futures and, at the same time, it provides a mechanism for change geared to society's ability to manage and accept change. As a society of diverse people, we are never all going to agree on even fundamental issues. The best we can do is openly debate through the legislative process what laws we should have, and then argue on the record in the judicial process as to what those laws mean in certain circumstances. Lawyers, of course, are in the middle because they are trained to understand how the law evolves and the process one goes through to interpret a particular point of law in a given fact situation. Lawyers, if conscientiously doing their jobs, force us to adhere to our system of government based on law.

When we approach a claim for repatriation without first exploring fully what the law may say about such matters as "standing to sue," "bur-

den of proof," allowable defenses, and constitutional protections, we cast aside the anchor in our society. We say, in effect, legal principles apply only when they suit our immediate purposes. But we weaken everyone's freedom when we condone selective application of the law. The preferred approach is to turn first to our anchor, which is the law, to determine what it may say about rights and obligations. There is another benefit. In the process of reviewing the law, we gain a very realistic picture of all the ramifications of an issue. The law gives a history of how society has coped in the past with similar issues; it brings into focus the legal principles that must be reckoned with if we are to have consistency in our rule of law; and it gives a good indication of how amenable society may be to accepting a change in the law and what ripple effect such a change may have. When such a major issue as repatriation is at stake, all the wisdom the law might bring is definitely needed.

POINT 2: WHY IS THE LAW OFTEN UNDERUTILIZED WHEN THE ISSUE IS REPATRIATION?

The system of law in this country is rooted in a white person's culture. It reflects that culture's concepts of one's relationship with a creator, of one's relationship with society, and one's relationship to the environment. Accordingly, "our" laws recognize a separation between religious and secular affairs and give great weight to the right of the individual to own property and to dispose of that property. They recognize other individual rights that cannot be infringed upon by the government, and they also set forth certain procedural rules that are deemed fair in our society.

When the issue is repatriation of Native American material, however, we are forced to deal not just with the white person's system of law, but to respond to other systems of law that frequently are based on fundamentally different concepts of human relationships—systems that do not distinguish between religious and secular matters and where personal property and real property take on completely different values. At present there are over 500 federally recognized Indian tribes, bands, and villages. Each may have its own system of law, many of which are not compatible with the traditional white person's system. Thus, when some Native American claims are presented to museums, they may be based on tribal concepts that are not compatible with Anglo-Saxon law, and, if precedent is to be followed, there are valid and important legal arguments for refuting these claims. (As a rule, foreign claims presented to

U.S. courts that are based on concepts incompatible with our country's system of justice are rejected.)

At this point, many become frustrated with the prevailing legal system. The arguments that the system provides guidance in accord with concepts of justice accepted by the majority and perpetuates the consistency expected of the law pale when viewed against that system's apparent inability to deal sensitively with Native American claims. When this apparent impasse is reached, those who have become disillusioned often seek to cast the law aside as no longer useful. For them the law is a mechanical process that has failed to churn out an acceptable answer. Law and lawyers become obstacles that must be overcome. This reaction seriously hampers true progress. When we look at what repatriation is all about, it becomes clear that the legal traditions of all parties must have a central place in all discussions of a claim. The law is not the problem; the problem is that people fail to utilize fully what the law can offer.

Repatriation claims are rooted in the proposition that there are moral imperatives for all people to recognize that individual groups have an obligation to protect important elements of their culture. Repatriation questions arise only when a clash of cultural values occurs between the party requesting the return of sensitive material and the controlling party. The requesting party has turned to its law to verify the cultural importance of its claim (law mirrors the values of a society) and the controlling party has used its law (as evidence of its cultural values) to determine its response to the request. All that has been established at this point is that there is a true repatriation question and if progress is to be made it must be through negotiation rather than through the adjudicative process.

During negotiation, the crucial issues will involve balancing the importance of differing cultural values. Thus a knowledge of the legal traditions of all parties is essential because, as has been explained, the law of a society embodies values deemed important to that society. Law accurately reflects cultural values. But in repatriation procedures legal precedents are introduced and discussed not to determine who "wins" but as information essential to reaching a solution that does as little violence as possible to the important cultural values of all parties involved. (Recall that repatriation is based on respect for all cultures.) In other words, the law should be used in repatriation negotiations not as a club but as a means of illuminating the cultural values of all parties involved. When used in this way, the law can help bridge the gap between conflict-

ing cultures by identifying reasonable compromises. If the negotiation process is long and difficult, it is not the fault of the law, the process merely reflects the seriousness of the problem.[1]

I hope I have made my two points: the law must play a key role in repatriation issues, and the law is underutilized in these matters if it is viewed only as a club and not as a bridge. If my points are valid, we should be leery of repatriation settlements that do not involve a full examination of legal issues. Such settlements poorly serve everyone because they denigrate the first principle of repatriation—respect for all cultures.

❖ *Appendix A*

Codes of Ethics Relating to the Museum Profession

American Association of Museums (AAM). "Code of Ethics for Museums." Washington, D.C., 1991 (with 1993 amendments).

American Association for State and Local History (AASLH). "Statement of Professional Ethics." Nashville, 1992.

Association of Art Museum Directors (AAMD). "Professional Practices in Art Museums." New York, 1992 .

International Council of Museums (ICOM). "Code of Professional Ethics." Paris, 1986 (reprinted in 1990 with minor editorial changes).

❖ *Appendix B*

International Council of Museums Code of Professional Ethics

The International Council of Museums (ICOM) Code of Professional Ethics is a very detailed code and thus is a good reference both for the neophyte who needs amplification and for the experienced museum professional. The code has two major parts: Institutional Ethics (II) and Professional Conduct (III).

The term "museum professional" is defined broadly in the code. One statement in the "Professional Conduct" portion of the code has particular relevance to the chapters in this book. It reads as follows:

> The museum professional should understand two guiding principles: first, that museums are the object of a public trust whose value to the community is in direct proportion to the quality of service rendered; and, secondly, that intellectual ability and professional knowledge are not, in themselves, sufficient, but must be inspired by a high standard of ethical conduct. (Sec. 5.1)

The code is reproduced here with the permission of ICOM.

I. Preamble
The ICOM Code of Professional Ethics was adopted unanimously by the 15th General Assembly of ICOM meeting in Buenos Aires, Argentina, on 4 November 1986.

It provides a general statement of professional ethics, respect for which is re-

The International Council of Museums Code of Professional Ethics is reprinted with the permission of the International Council of Museums, Paris.

garded as a minimum requirement to practice as a member of the museum pro-
fession. In many cases it will be possible to develop and strengthen the *Code* to
meet particular national or specialized requirements and ICOM wishes to en-
courage this . . .

1. Definitions

1.1. The International Council of Museums (ICOM)

ICOM is defined in Article 1, para. 1 of its *Statutes* as "the international non-
governmental organization of museums and professional museum workers es-
tablished to advance the interests of museology and other disciplines concerned
with museum management and operations."

The objectives of ICOM, as defined in Article 3, para. 1 of its *Statutes*, are:

"(a) To encourage and support the establishment, development and profes-
sional management of museums of all kinds;

(b) To advance knowledge and understanding of the nature, functions and role
of museums in the service of society and of its development;

(c) To organize cooperation and mutual assistance between museums and be-
tween professional museum workers in the different countries;

(d) To represent, support, and advance the interests of professional museum
workers of all kinds;

(e) To advance and disseminate knowledge in museology and other disciplines
concerned with museum management and operations."

1.2. Museum

A museum is defined in Article 2, para. 1 of the *Statutes* of the International
Council of Museums as "a nonprofit making, permanent institution in the service
of society and of its development, and open to the public which acquires, con-
serves, researches, communicates, and exhibits, for purposes of study, education,
and enjoyment, material evidence of people and their environment.

(a) The above definition of a museum shall be applied without limitation aris-
ing from the nature of the governing body, the territorial character, the functional
structure or the orientation of the collections of the institution concerned.

(b) In addition to institutions designated as 'museums' the following qualify as
museums for the purposes of this definition:

(i) natural, archeological, and ethnographic monuments and sites of a museum
nature that acquire, conserve, and communicate material evidence of people and
their environment;

(ii) institutions holding collections of and displaying live specimens of plants
and animals, such as botanical and zoological gardens, aquaria, and vivaria;

(iii) science centers and planetaria;

(iv) conservation institutes and exhibition galleries permanently maintained
by libraries and archive centers;

(v) nature reserves;

(vi) such other institutions as the Executive Council, after seeking the advice of the Advisory Committee, considers as having some or all of the characteristics of a museum, or as supporting museums and professional museum workers through museological research, education or training."

1.3. The Museum Profession

ICOM defines the members of the museum profession, under Article 2, para. 2 of its *Statutes,* as follows: "Professional museum workers include all the personnel of museums or institutions qualifying as museums in accordance with the definition in Article 2, para. 1 *(as detailed under para. 1.2 above),* having received specialized training, or possessing an equivalent practical experience, in any field relevant to the management and operations of a museum, and privately or self-employed persons practicing in one of the museological professions and who respect the *ICOM Code of Professional Ethics.*"

1.4. Governing Body

The government and control of museums in terms of policy, finance, and administration, etc., varies greatly from one country to another and often from one museum to another within a country according to the legal and other national or local provisions of the particular country or institution.

In the case of many national museums the Director, Curator, or other professional head of the museum may be appointed by, and directly responsible to, a Minister or a Government Department, whilst most local government museums are similarly governed and controlled by the appropriate local authority. In many other cases the government and control of the museum is vested in some form of independent body, such as a board of trustees, a society, a nonprofit company, or even an individual.

For the purposes of this *Code* the term "Governing Body" has been used throughout to signify the superior authority concerned with the policy, finance, and administration of the museum. This may be an individual Minister or official, a Ministry, a local authority, a Board of Trustees, a Society, the Director of the museum, or any other individual or body. Directors, Curators, or other professional heads of the museum are responsible for the proper care and management of the museum.

II. Institution Ethics

2. Basic Principles for Museum Governance

2.1. Minimum Standards for Museums

The governing body or other controlling authority of a museum has an ethical duty to maintain, and if possible enhance, all aspects of the museum, its collections, and its services. Above all, it is the responsibility of each governing body to ensure that all of the collections in their care are adequately housed, conserved, and documented.

The minimum standards in terms of finance, premises, staffing, and services

will vary according to the size and responsibilities of each museum. In some countries such minimum standards may be defined by law or other government regulation and in others guidance on and assessment of minimum standards is available in the form of "Museum Accreditation" or similar schemes. Where such guidance is not available locally, it can usually be obtained from appropriate national and international organizations and experts, either directly or through the National Committee or appropriate International Committee of ICOM.

2.2. Constitution

Each museum should have a written constitution or other document setting out clearly its legal status and permanent, nonprofit nature, drawn up in accordance with appropriate national laws in relation to museums, the cultural heritage, and nonprofit institutions. The governing body or other controlling authority of a museum should prepare and publicize a clear statement of the aims, objectives, and policies of the museum, and of the role and composition of the governing body itself.

2.3. Finance

The governing body holds the ultimate financial responsibility for the museum and for the protecting and nurturing of its various assets: the collections and related documentation, the premises, facilities, and equipment, the financial assets, and the staff. It is obliged to develop and define the purposes and related policies of the institution, and to ensure that all of the museum's assets are properly and effectively used for museum purposes. Sufficient funds must be available on a regular basis, either from public or private sources, to enable the governing body to carry out and develop the work of the museum. Proper accounting procedures must be adopted and maintained in accordance with the relevant national laws and professional accountancy standards.

2.4. Premises

The board has specially strong obligations to provide accommodation giving a suitable environment for the physical security and preservation of the collections. Premises must be adequate for the museum to fulfill within its stated policy its basic functions of collection, research, storage, conservation, education, and display, including staff accommodation, and should comply with all appropriate national legislation in relation to public and staff safety. Proper standards of protection should be provided against such hazards as theft, fire, flood, vandalism, and deterioration, throughout the year, day and night. The special needs of disabled people should be provided for, as far as practicable, in planning and managing both buildings and facilities.

2.5. Personnel

The governing body has a special obligation to ensure that the museum has staff sufficient in both number and kind to ensure that the museum is able to meet its responsibilities. The size of the staff, and its nature (whether paid or un-

paid, permanent or temporary), will depend on the size of the museum, its collections, and its responsibilities. However, proper arrangements should be made for the museum to meet its obligations in relation to the care of the collections, public access and services, research, and security.

The governing body has particularly important obligations in relation to the appointment of the director of the museum, and whenever the possibility of terminating the employment of the director arises, to ensure that any such action is taken only in accordance with appropriate procedures under the legal or other constitutional arrangements and policies of the museum, and that any such staff changes are made in a professional and ethical manner, and in accordance with what is judged to be the best interests of the museum, rather than any personal or external factor or prejudice. It should also ensure that the same principles are applied in relation to any appointment, promotion, dismissal, or demotion of the personnel of the museum by the director or any other senior member of staff with staffing responsibilities.

The governing body should recognize the diverse nature of the museum profession, and the wide range of specializations that it now encompasses, including conservator/restorers, scientists, museum education service personnel, registrars and computer specialists, security service managers, etc. It should ensure that the museum both makes appropriate use of such specialists where required and that such specialized personnel are properly recognized as full members of the professional staff in all respects.

Members of the museum profession require appropriate academic, technical, and professional training in order to fulfill their important role in relation to the operation of the museum and the care for the heritage, and the governing body should recognize the need for, and value of, a properly qualified and trained staff, and offer adequate opportunities for further training and retraining in order to maintain an adequate and effective workforce.

A governing body should never require a member of the museum staff to act in a way that could reasonably be judged to conflict with the provisions of this *Code of Ethics,* or any national law or national code of professional ethics.

The Director or other chief professional officer of a museum should be directly responsible to, and have direct access to, the governing body in which trusteeship of the collections is vested.

2.6. Educational and Community Roles of the Museum

By definition a museum is an institution in the service of society and of its development, and is generally open to the public (even though this may be a restricted public in the case of certain very specialized museums, such as certain academic or medical museums, for example).

The museum should take every opportunity to develop its role as an educational resource used by all sections of the population or specialized group that

the museum is intended to serve. Where appropriate in relation to the museum's program and responsibilities, specialist staff with training and skills in museum education are likely to be required for this purpose.

The museum has an important duty to attract new and wider audiences within all levels of the community, locality, or group that the museum aims to serve, and should offer both the general community and specific individuals and groups within it opportunities to become actively involved in the museum and to support its aims and policies.

2.7. Public Access

The general public (or specialized group served, in the case of museums with a limited public role), should have access to the displays during reasonable hours and for regular periods. The museum should also offer the public reasonable access to members of staff by appointment or other arrangement, and full access to information about the collections, subject to any necessary restrictions for reasons of confidentiality or security as discussed in para. 7.3 below.

2.8. Displays, Exhibitions, and Special Activities

Subject to the primary duty of the museum to preserve unimpaired for the future the significant material that comprises the museum collections, it is the responsibility of the museum to use the collections for the creation and dissemination of new knowledge, through research, educational work, permanent displays, temporary exhibitions, and other special activities. These should be in accordance with the stated policy and educational purpose of the museum, and should not compromise either the quality or the proper care of the collections. The museum should seek to ensure that information in displays and exhibitions is honest and objective and does not perpetuate myths or stereotypes.

2.9. Commercial Support and Sponsorship

Where it is the policy of the museum to seek and accept financial or other support from commercial or industrial organizations, or from other outside sources, great care is needed to define clearly the agreed relationship between the museum and the sponsor. Commercial support and sponsorship may involve ethical problems and the museum must ensure that the standards and objectives of the museum are not compromised by such a relationship.

2.10. Museum Shops and Commercial Activities

Museum shops and any other commercial activities of the museum, and any publicity relating to these, should be in accordance with a clear policy, should be relevant to the collections and the basic educational purpose of the museum, and must not compromise the quality of those collections. In the case of the manufacture and sale of replicas, reproductions, or other commercial items adapted from an object in a museum's collection, all aspects of the commercial venture must be carried out in a manner that will not discredit either the integrity of the museum or the intrinsic value of the original object. Great care must be taken to identify permanently such objects for what they are, and to ensure accuracy and high

quality of their manufacture. All items offered for sale should represent good value for money and should comply with all relevant national legislation.

2.11. Legal Obligations

It is an important responsibility of each governing body to ensure that the museum complies fully with all legal obligations, whether in relation to national, regional, or local law, international law, or treaty obligations, and to any legally binding trusts or conditions relating to any aspect of the museum collections or facilities.

3. Acquisitions to Museum Collections

3.1. Collecting Policies

Each museum authority should adopt and publish a written statement of its collecting policy. This policy should be reviewed from time to time, and at least once every five years. Objects acquired should be relevant to the purpose and activities of the museum, and be accompanied by evidence of a valid legal title. Any conditions or limitations relating to an acquisition should be clearly described in an instrument of conveyance or other written documentation. Museums should not, except in very exceptional circumstances, acquire material that the museum is unlikely to be able to catalogue, conserve, store, or exhibit, as appropriate, in a proper manner. Acquisitions outside the current stated policy of the museum should only be made in very exceptional circumstances, and then only after proper consideration by the governing body of the museum itself, having regard to the interests of the objects under consideration, the national or other cultural heritage and the special interests of other museums.

3.2. Acquisition of Illicit Material

The illicit trade in objects destined for public and private collections encourages the destruction of historic sites, local ethnic cultures, theft at both national and international levels, places at risk endangered species of flora and fauna, and contravenes the spirit of national and international patrimony. Museums should recognize the relationship between the marketplace and the initial and often destructive taking of an object for the commercial market, and must recognize that it is highly unethical for a museum to support in any way, whether directly or indirectly, that illicit market.

A museum should not acquire, whether by purchase, gift, bequest, or exchange, any object unless the governing body and responsible officer are satisfied that the museum can acquire a valid title to the specimen or object in question and that in particular it has not been acquired in, or exported from, its country of origin and/or any intermediate country in which it may have been legally owned (including the museum's own country), in violation of that country's laws.

So far as biological and geological material is concerned, a museum should not acquire by any direct or indirect means any specimen that has been collected, sold, or otherwise transferred in contravention of any national or international

wildlife protection or natural history conservation law or treaty of the museum's own country or any other country except with the express consent of an appropriate outside legal or governmental authority.

So far as excavated material is concerned, in addition to the safeguards set out above, the museum should not acquire by purchase objects in any case where the governing body or responsible officer has reasonable cause to believe that their recovery involved the recent unscientific or intentional destruction or damage of ancient monuments or archaeological sites, or involved a failure to disclose the finds to the owner or occupier of the land, or to the proper legal or governmental authorities.

If appropriate and feasible, the same tests as are outlined in the above four paragraphs should be applied in determining whether or not to accept loans for exhibition or other purposes.

3.3. Field Study and Collecting

Museums should assume a position of leadership in the effort to halt the continuing degradation of the world's natural history, archaeological, ethnographic, historic, and artistic resources. Each museum should develop policies that allow it to conduct its activities within appropriate national and international laws and treaty obligations, and with a reasonable certainty that its approach is consistent with the spirit and intent of both national and international efforts to protect and enhance the cultural heritage.

Field exploration, collecting, and excavation by museum workers present ethical problems that are both complex and critical. All planning for field studies and field collecting must be preceded by investigation, disclosure, and consultation with both the proper authorities and any interested museums or academic institutions in the country or area of the proposed study sufficient to ascertain if the proposed activity is both legal and justifiable on academic and scientific grounds. Any field program must be executed in such a way that all participants act legally and responsibly in acquiring specimens and data, and that they discourage by all practical means unethical, illegal, and destructive practices.

3.4. Cooperation between Museums in Collecting Policies

Each museum should recognize the need for cooperation and consultation between all museums with similar or overlapping interests and collecting policies, and should seek to consult with such other institutions both on specific acquisitions where a conflict of interest is thought possible and, more generally, on defining areas of specialization. Museums should respect the boundaries of the recognized collecting areas of other museums and should avoid acquiring material with special local connections or of special local interest from the collecting area of another museum without due notification of intent.

3.5. Conditional Acquisitions and Other Special Factors

Gifts, bequests, and loans should only be accepted if they conform to the stated collecting and exhibition policies of the museum. Offers that are subject to

special conditions may have to be rejected if the conditions proposed are judged to be contrary to the long-term interests of the museum and its public.

3.6. Loans to Museums

Both individual loans of objects and the mounting or borrowing of loan exhibitions can have an important role in enhancing the interest and quality of a museum and its services. However, the ethical principles outlined in paras. 3.1 to 3.5 above must apply to the consideration of proposed loans and loan exhibitions as to the acceptance or rejection of items offered to the permanent collections; loans should not be accepted nor exhibitions mounted if they do not have a valid educational, scientific, or academic purpose.

3.7. Conflicts of Interest

The collecting policy or regulations of the museum should include provisions to ensure that no person involved in the policy or management of the museum, such as a trustee or other member of a governing body, or a member of the museum staff, may compete with the museum for objects or may take advantage of privileged information received because of his or her position, and that should a conflict of interest develop between the needs of the individual and the museum, those of the museum will prevail. Special care is also required in considering any offer of an item either for sale or as a tax-benefit gift, from members of governing bodies, members of staff, or the families or close associates of these.

4. Disposal of Collections

4.1. General Presumption of Permanence of Collections

By definition one of the key functions of almost every kind of museum is to acquire objects and keep them for posterity. Consequently, there must always be a strong presumption against the disposal of specimens to which a museum has assumed formal title. Any form of disposal, whether by donation, exchange, sale, or destruction requires the exercise of a high order of curatorial judgment and should be approved by the governing body only after full expert and legal advice has been taken.

Special considerations may apply in the case of certain kinds of specialized institutions such as "living" or "working" museums, and some teaching and other educational museums, together with museums and other institutions displaying living specimens, such as botanical and zoological gardens and aquaria, which may find it necessary to regard at least part of their collections as "fungible" (i.e., replaceable and renewable). However, even here there is a clear ethical obligation to ensure that the activities of the institution are not detrimental to the long-term survival of examples of the material studied, displayed, or used.

4.2. Legal or Other Powers of Disposal

The laws relating to the protection and permanence of museum collections, and to the power of museums to dispose of items from their collection vary greatly from country to country, and often from one museum to another within the same country. In some cases no disposals of any kind are permitted, except in

the case of items that have been seriously damaged by natural or accidental deterioration. Elsewhere, there may be no explicit restriction on disposals under general law.

Where the museum has legal powers permitting disposals, or has acquired objects subject to conditions of disposal, the legal or other requirements and procedures must be fully complied with. Even where legal powers of disposal exist, a museum may not be completely free to dispose of items acquired; where financial assistance has been obtained from an outside source (e.g., public or private grants, donations from a Friends of the Museum organization, or private benefactor), disposal would normally require the consent of all parties who had contributed to the original purchase.

Where the original acquisition was subject to mandatory restrictions these must be observed unless it can be clearly shown that adherence to such restrictions is impossible or substantially detrimental to the institution. Even in these circumstances the museum can only be relieved from such restrictions through appropriate legal procedures.

4.3. Deaccessioning Policies and Procedures

Where a museum has the necessary legal powers to dispose of an object the decision to sell or to otherwise dispose of material from the collections should only be taken after due consideration, and such material should be offered first, by exchange, gift, or private treaty sale, to other museums before sale by public auction or other means is considered. A decision to dispose of a specimen or work of art, whether by exchange, sale, or destruction (in the case of an item too badly damaged or deteriorated to be restorable) should be the responsibility of the governing body of the museum, not of the curator of the collection concerned acting alone. Full records should be kept of all such decisions and the objects involved, and proper arrangements made for the preservation and/or transfer, as appropriate, of the documentation relating to the object concerned, including photographic records where practicable.

Neither members of staff, nor members of the governing bodies, nor members of their families or close associates, should ever be permitted to purchase objects that have been deaccessioned from a collection. Similarly, no such person should be permitted to appropriate in any other way items from the museum collections, even temporarily, to any personal collection or for any kind of personal use.

4.4. Return and Restitution of Cultural Property

If a museum should come into possession of an object that can be demonstrated to have been exported or otherwise transferred in violation of the principles of the Unesco *Convention on the Means of Prohibiting and Preventing the Illicit Import, Export and Transfer of Ownership of Cultural Property* (1970) and the country of origin seeks its return and demonstrates that it is part of the country's cultural heritage, the museum should, if legally free to do so, take responsible steps to cooperate in the return of the object to the country of origin.

In the case of requests for the return of cultural property to the country of origin, museums should be prepared to initiate dialogues with an open-minded attitude on the basis of scientific and professional principles (in preference to action at a governmental or political level). The possibility of developing bilateral or multilateral cooperation schemes to assist museums in countries which are considered to have lost a significant part of their cultural heritage in the development of adequate museums and museum resources should be explored.

Museums should also respect fully the terms of the *Convention for the Protection of Cultural Property in the Event of Armed Conflict* (The Hague Convention, 1954), and in support of this *Convention,* should in particular abstain from purchasing or otherwise appropriating or acquiring cultural objects from any occupied country, as these will in most cases have been illegally exported or illicitly removed.

4.5. Income from Disposal of Collections

Any moneys received by a governing body from the disposal of specimens or works of art should be applied solely for the purchase of additions to the museum collections.

III. Professional Conduct

5. General Principles

5.1. Ethical Obligations of Members of the Museum Profession

Employment by a museum, whether publicly or privately supported, is a public trust involving great responsibility. In all activities museum employees must act with integrity and in accordance with the most stringent ethical principles as well as the highest standards of objectivity.

An essential element of membership in a profession is the implication of both rights and obligations. Although the conduct of a professional in any area is ordinarily regulated by the basic rules of moral behavior which govern human relationships, every occupation involves standards, as well as particular duties, responsibilities, and opportunities that from time to time create the need for a statement of guiding principles. The museum professional should understand two guiding principles: first, that museums are the object of a public trust whose value to the community is in direct proportion to the quality of service rendered; and, secondly, that intellectual ability and professional knowledge are not, in themselves, sufficient, but must be inspired by a high standard of ethical conduct.

The Director and other professional staff owe their primary professional and academic allegiance to their museum and should at all times act in accordance with the approved policies of the museum. The Director or other principal museum officer should be aware of, and bring to the notice of the governing body of the museum whenever appropriate, the terms of the *ICOM Code of Professional Ethics* and of any relevant national or regional Codes or policy statements on Museum Ethics, and should urge the governing body to comply with these. Members of the museum profession should also comply fully with the *ICOM Code* and

any other Codes or statements on Museum Ethics whenever exercising the functions of the governing body under delegated powers.

5.2. Personal Conduct

Loyalty to colleagues and to the employing museum is an important professional responsibility, but the ultimate loyalty must be to fundamental ethical principles and to the profession as a whole.

Applicants for any professional post should divulge frankly and in confidence all information relevant to the consideration of their applications, and if appointed should recognize that museum work is normally regarded as a full-time vocation. Even where the terms of employment do not prohibit outside employment or business interests, the Director and other senior staff should not undertake other paid employment or accept outside commissions without the express consent of the governing body of the museum. In tendering resignations from their posts, members of the professional staff, and above all the Director, should consider carefully the needs of the museum at the time. A professional person, having recently accepted a new appointment, should consider seriously their professional commitment to their present post before applying for a new post elsewhere.

5.3. Private Interests

While every member of any profession is entitled to a measure of personal independence consistent with professional and staff responsibilities, in the eyes of the pubic no private business or professional interest of a member of the museum profession can be wholly separated from that of the professional's institution or other official affiliation, despite disclaimers that may be offered. Any museum-related activity by the individual may reflect on the institution or be attributed to it. The professional must be concerned not only with the true personal motivations and interests, but also with the way in which such actions might be construed by the outside observer. Museum employees and others in a close relationship with them must not accept gifts, favors, loans, or other dispensations or things of value that may be offered to them in connection with their duties for the museum (see also para. 8.4 below).

6. Personal Responsibility to the Collections

6.1. Acquisitions to Museum Collections

The Director and professional staff should take all possible steps to ensure that a written collecting policy is adopted by the governing body of the museum, and is thereafter reviewed and revised as appropriate at regular intervals. This policy, as formally adopted and revised by the governing body, should form the basis of all professional decisions and recommendations in relation to acquisitions.

Negotiations concerning the acquisition of museum items from members of the general public must be conducted with scrupulous fairness to the seller or donor. No object should be deliberately or misleadingly identified or valued, to the benefit of the museum and to the detriment of the donor, owner, or previous

owners, in order to acquire it for the museum collections nor should be taken nor retained on loan with the deliberate intention of improperly procuring it for the collections.

6.2. Care of Collections

It is an important professional responsibility to ensure that all items accepted temporarily or permanently by the museum are properly and fully documented to facilitate provenance, identification, condition, and treatment. All objects accepted by the museum should be properly conserved, protected, and maintained.

Careful attention should be paid to the means of ensuring the best possible security as a protection against theft in display, working, or storage areas, against accidental damage when handling objects, and against damage or theft in transit. Where it is the national or local policy to use commercial insurance arrangements, the staff should ensure that the insurance coverage is adequate, especially for objects in transit and loan items, or other objects, which are not owned by the museum but which are its current responsibility.

Members of the museum profession should not delegate important curatorial, conservation, or other professional responsibilities to persons who lack the appropriate knowledge and skill, or who are inadequately supervised, in the case of trainees or approved volunteers, where such persons are allowed to assist in the care of collections. There is also a clear duty to consult professional colleagues within or outside the museum if at any time the expertise available in a particular museum or department is insufficient to ensure the welfare of items in the collections under its care.

6.3. Conservation and Restoration of Collections

One of the essential ethical obligations of each member of the museum profession is to ensure the proper care and conservation of both existing and newly acquired collections and individual items for which the member of the profession and the employing institutions are responsible, and to ensure that as far as is reasonable the collections are passed on to future generations in as good and safe a condition as practicable having regard to current knowledge and resources.

In attempting to achieve this high ideal, special attention should be paid to the growing body of knowledge about preventative conservation methods and techniques, including the provision of suitable environmental protection against the known natural or artificial causes of deterioration of museum specimens and works of art.

There are often difficult decisions to be made in relation to the degree of replacement or restoration of lost or damaged parts of a specimen or work of art that may be ethically acceptable in particular circumstances. Such decisions call for proper cooperation between all with a specialized responsibility for the object, including both the curator and the conservator or restorer, and should not be decided unilaterally by one or the other acting alone.

The ethical issues involved in conservation and restoration work of many

kinds are a major study in themselves, and those with special responsibilities in this area, whether as director, curator, conservator, or restorer, have an important responsibility to ensure that they are familiar with these ethical issues, and with appropriate professional opinion, as expressed in some detailed ethical statements and codes produced by the conservator/restorer professional bodies.[1]

6.4. Documentation of Collections

The proper recording and documentation of both new acquisitions and existing collections in accordance with appropriate standards and the internal rules and conventions of the museum is a most important professional responsibility. It is particularly important that such documentation should include details of the source of each object and the conditions of acceptance of it by the museum. In addition specimen data should be kept in a secure environment and be supported by adequate systems providing easy retrieval of the data by both the staff and other *bona fide* users.

6.5. Deaccessioning and Disposals from the Collections

No item from the collections of a museum should be disposed of except in accordance with the ethical principles summarized in the Institution Ethics section of this *Code,* paras. 4.1 to 4.4 above, and the detailed rules and procedures applying in the museum in question.

6.6. Welfare of Live Animals

Where museums and related institutions maintain for exhibition or research purposes live populations of animals, the health and well-being of any such creatures must be a foremost ethical consideration. It is essential that a veterinary surgeon be available for advice and for regular inspection of the animals and their living conditions. The museum should prepare a safety code for the protection of staff and visitors which has been approved by an expert in the veterinary field, and all staff must follow it in detail.

6.7. Human Remains and Material of Ritual Significance

Where a museum maintains and/or is developing collections of human remains and sacred objects these should be securely housed and carefully maintained as archival collections in scholarly institutions, and should always be available to qualified researchers and educators, but not to the morbidly curious. Research on such objects and their housing and care must be accomplished in a manner acceptable not only to fellow professionals but to those of various beliefs, including in particular members of the community, ethnic, or religious groups concerned. Although it is occasionally necessary to use human remains and other sensitive material in interpretive exhibits, this must be done with tact and with respect for the feelings for human dignity held by all peoples.

6.8. Private Collections

The acquiring, collecting, and owning of objects of a kind collected by a museum by a member of the museum profession for a personal collection may not in itself be unethical, and may be regarded as a valuable way of enhancing profes-

sional knowledge and judgment. However, serious dangers are implicit when members of the profession collect for themselves privately objects similar to those which they and others collect for their museums. In particular, no member of the museum profession should compete with their institution either in the acquisition of objects or in any personal collecting activity. Extreme care must be taken to ensure that no conflict of interest arises.

In some countries and many individual museums, members of the museum profession are not permitted to have private collections of any kind, and such rules must be respected. Even where there are no such restrictions, on appointment, a member of the museum profession with a private collection should provide the governing body with a description of it, and a statement of the collecting policy being pursued, and any consequent agreement between the curator and the governing body concerning the private collection must be scrupulously kept. (See also para 8.4 below.)

7. Personal Responsibility to the Public

7.1. Upholding Professional Standards

In the interests of the public as well as the profession, members of the museum profession should observe accepted standards and laws, uphold the dignity and honor of their profession, and accept its self-imposed disciplines. They should do their part to safeguard the public against illegal or unethical professional conduct, and should use appropriate opportunities to inform and educate the public in the aims, purposes, and aspirations of the profession in order to develop a better public understanding of the purposes and responsibilities of museums and of the profession.

7.2. Relations with the General Public

Members of the museum profession should deal with the public efficiently and courteously at all times, and should in particular deal promptly with all correspondence and enquiries. Subject to the requirements of confidentiality in a particular case, they should share their expertise in all professional fields in dealing with enquiries, subject to due acknowledgment, from both the general public and specialist enquirers, allowing *bona fide* researchers properly controlled but, so far as possible, full access to any material or documentation in their care, even when this is the subject of personal research or special field of interest.

7.3. Confidentiality

Members of the museum profession must protect all confidential information relating to the source of material owned by or loaned to the museum, as well as information concerning the security arrangements of the museum, or the security arrangements of private collections or any place visited in the course of official duties. Confidentiality must also be respected in relation to any item brought to the museum for identification and, without specific authority from the owner, information on such an item should not be passed to another museum, to a dealer, or to any other person (subject to any legal obligation to assist the police or other

proper authorities in investigating possible stolen or illicitly acquired or transferred property).

There is a special responsibility to respect the personal confidences contained in oral history or other personal material. Investigators using recording devices such as cameras or tape recorders or the technique of oral interviewing should take special care to protect their data, and persons investigated, photographed, or interviewed should have the right to remain anonymous if they so choose. This right should be respected where it has been specifically promised. Where there is no clear understanding to the contrary, the primary responsibility of the investigator is to ensure that no information is revealed that might harm the informant or his or her community. Subjects under study should understand the capacities of cameras, tape recorders, and other machines used, and should be free to accept or reject their use.

8. Personal Responsibility to Colleagues and the Profession

8.1. Professional Relationships

Relationships between members of the museum profession should always be courteous, both in public and in private. Differences of opinion should not be expressed in a personalized fashion. Notwithstanding this general rule, members of the profession may properly object to proposals or practices which may have a damaging effect on a museum or museums, or the profession.

8.2. Professional Cooperation

Members of the museum profession have an obligation, subject to due acknowledgment, to share their knowledge and experience with their colleagues and with scholars and students in relevant fields. They should show their appreciation and respect to those from whom they have learned and should present without thought of personal gain such advancements in techniques and experience which may be of benefit to others.

The training of personnel in the specialized activities involved in museum work is of great importance in the development of the profession and all should accept responsibility, where appropriate, in the training of colleagues. Members of the profession who in their official appointment have under their direction junior staff, trainees, students, and assistants undertaking formal or informal professional training, should give these the benefit of their experience and knowledge, and should also treat them with the consideration and respect customary among members of the profession.

Members of the profession form working relationships in the course of their duties with numerous other people, both professional and otherwise, within and outside the museum in which they are employed. They are expected to conduct these relationships with courtesy and fair-mindedness and to render their professional services to others efficiently and at a high standard.

8.3. Dealing

No member of the museum profession should participate in any dealing (buy-

ing or selling for profit), in objects similar or related to the objects collected by the employing museum. Dealing by museum employees at any level of responsibility in objects that are collected by any other museum can also present serious problems even if there is no risk of direct conflict with the employing museum, and should be permitted only if, after full disclosure and review by the governing body of the employing museum or designated senior officer, explicit permission is granted, with or without conditions.

Article 7, para. 5 of the ICOM *Statutes* provides that membership in ICOM shall not be available, under any circumstances, to any person or institution that is dealing (buying or selling for profit) in cultural property.

8.4. Other Potential Conflicts of Interest

Generally, members of the museum profession should refrain from all acts or activities which may be construed as a conflict of interest. Museum professionals by virtue of their knowledge, experience, and contacts are frequently offered opportunities, such as advisory and consultancy services, teaching, writing, and broadcasting opportunities, or requests for valuations, in a personal capacity. Even where the national law and the individual's conditions of employment permit such activities, these may appear in the eyes of colleagues, the employing authority, or the general public, to create a conflict of interest. In such situations all legal and employment contract conditions must be scrupulously followed, and in the event of any potential conflict arising or being suggested, the matter should be reported immediately to an appropriate superior officer or the museum governing body, and steps must be taken to eliminate the potential conflict of interest.

Even where the conditions of employment permit any kind of outside activity, and there appears to be no risk of any conflict of interest, great care should be taken to ensure that such outside interests do not interfere in any way with the proper discharge of official duties and responsibilities.

8.5. Authentication, Valuation, and Illicit Material

Members of the museum profession are encouraged to share their professional knowledge and expertise with both professional colleagues and the general public (see para. 7.2 above).

However, written certificates of authenticity or valuation (appraisals) should not be given, and opinions on the monetary value of objects should only be given on official request from other museums or competent legal, government, or other responsible public authorities.

Members of the museum profession should not identify or otherwise authenticate objects where they have reason to believe or suspect that these have been illegally or illicitly acquired, transferred, imported, or exported.

They should recognize that it is highly unethical for museums or the museum profession to support either directly or indirectly the illicit trade in cultural or natural objects (see para. 3.2 above), and under no circumstances should they act

in a way that could be regarded as benefiting such illicit trade in any way, directly or indirectly. Where there is reason to believe or suspect illicit or illegal transfer, import or export, the competent authorities should be notified.

8.6. Unprofessional Conduct

Every member of the museum profession should be conversant with both any national or local laws, and any conditions of employment, concerning corrupt practices, and should at all times avoid situations which could rightly or wrongly be construed as corrupt or improper conduct of any kind. In particular, no museum official should accept any gift, hospitality, or any form of reward from any dealer, auctioneer, or other person as an improper inducement in respect of the purchase or disposal of museum items.

Also, in order to avoid any suspicion of corruption, a museum professional should not recommend any particular dealer, auctioneer, or other person to a member of the public, nor should the official accept any "special price" or discount for personal purchases from any dealer with whom either the professional or employing museum has a professional relationship.

❖ *Notes*

PREFACE

1. From William H. McGuffey's *Newly Revised Eclectic Reader* (1844), as reprinted in *America's Voluntary Spirit*, ed. Brian O'Connell (New York: The Foundation Center, 1983), 59–61.

CHAPTER 1. ON TRUSTEESHIP

1. The nonprofit sector is quite diverse. The major portion of the sector is composed of philanthropic organizations (tax-exempt organizations to which donor contributions are tax deductible). In this group fall such groups as educational, cultural, health, religious, and social welfare organizations. A much smaller group of the nonprofit sector is composed of membership organizations and social groups (organizations that are tax exempt but donations to them are not tax deductible). In this latter group fall labor unions, trade associations, social clubs, and so on. This book concerns the philanthropic portion of the nonprofit sector and, more particularly, the cultural organizations within it.

2. Some nonprofits have boards of directors, others have boards of regents or boards of governors. For purposes of this chapter the terms "board of trustees," "trustees," or "trustee" will be used and should be construed to cover all descriptive titles.

3. Thomas Wolf, *Managing a Nonprofit Organization* (New York: Prentice Hall, 1984, 1990), 5. Reprinted by permission of the publisher Prentice Hall Press/a Division of Simon & Schuster, New York.

4. National Center for Nonprofit Boards, "Teaching about Nonprofit Boards" (Washington, D.C., 1990).

5. Economists have much to say about the nonprofit sector. Their theories, however, might be labeled "bloodless." The unique benefits provided by the nonprofit sector cannot be measured in dollars and cents, and, thus, the economist's picture of the sector is a limited one.

6. For a discussion of the term "charitable" see Clark, "Significant Cases and Trends Impacting the Definition of What Is Charitable," in *Proceedings of New York University's Twenty-first Conference on Tax Planning for 501(c)(3) Organizations* (New York: Matthew Bender and Co., 1993).

7. Douglas, "Political Theories of Nonprofit Organization," in *The Nonprofit Sector: A Research Handbook,* ed. Walter Powell (New Haven: Yale University Press, 1987), 47. Reprinted with permission of Yale University Press.

8. This is not to suggest that nonprofits can ignore efficiency and accountability in conducting their affairs. Both are important elements of prudent nonprofit governance. (See discussion on trusteeship later in this chapter.) The "quality" argument for sustaining the nonprofit sector is made eloquently by Paul DiMaggio in "When the 'Profit' Is Quality," *Museum News* (June 1985): 28 et seq.

9. One writer comments on nonprofit entrepreneurial ventures as follows:

Those who question the traditional tax treatment of tax-exempt organizations and their donors generally do not deny that significant public benefit is derived from these activities. Rather, the difficulties have arisen because of the perception that tax-exempt organizations are engaged in a multitude of practices that differ from their cause mission. The concern is fueled by a subliminal sense that the growth in the size, scope, and success of many tax-exempt institutions is somehow inconsistent with a charitable, educational or religious goal.

Richard Meltzer, "The Long and Winding Tax Road," *Museum News* (September/October 1987): 32, 34. Copyright © 1987, The American Association of Museums. All rights reserved. Reprinted with permission.

10. See also chapter 10, "Restricted Gifts and Museum Responsibilities," for a detailed discussion of the legal standard of conduct imposed on nonprofit trustees.

11. *Stern v. Lucy Webb Hayes National Training School for Deaconesses and Missionaries* (a.k.a. *Sibley Hospital* case) 381 F. Supp. 1003 (D.D.C. 1974), and also 367 F. Supp. 536 (D.D.C. 1973) (order granting plaintiffs standing to sue).

12. *Rowan v. Pasadena Art Museum,* No. C 322817 (Cal. Sup. Ct. L.A. County, Sept. 22, 1981).

13. Abrams, "Regulating Charity: The State's Role," The Record of the Association of the Bar of the City of New York, 481, 486, 1980. Reprinted with permission.

14. The Revised Model Nonprofit Corporation Act is promulgated by the American Bar Association as a model that states may wish to follow when enact-

ing their own state legislation regarding nonprofit organizations. States are free to reject, adopt, or adapt with modifications the model. The quoted section of RMNCA is sec. 8:30.

CHAPTER 2. WHY ETHICS?

1. In these chapters the subject of ethics is limited to mean the principles of conduct deemed appropriate for a particular profession or activity, as opposed to a set of moral values. More specifically, the essays address the principles of conduct deemed appropriate for those charged with governing or managing nonprofit organizations.

2. The term "profession" is used to include any group that is charged with a specific responsibility. For example, the American Association of Museums has promulgated a code of ethics that addresses museum trustee conduct. Such trustees are a "profession" for purposes of their interaction with this particular code.

3. If an organization writes its own code of ethics (based on general professional codes) and makes this code a condition of employment or of service, there is a contractual basis for enforcing the code within that organization. See Appendix A for a list of relevant codes of ethics.

4. It is recognized that in drafting its own organization's code of ethics a board must be guided not only by the general principles promulgated by the profession but also by any specific requirements placed on the organization by its charter or other authorizing documents. Also, when interpreting a code of ethics a board must make an informed decision. In other words, the board must look carefully at the particular situation before it and then weigh these facts in light of the letter and spirit of the code of ethics. Prudent governance is not a mechanical process.

CHAPTER 3. STEERING A PRUDENT COURSE

1. It is stressed again that this discussion focuses on museums and views issues from their perspective. The nonprofit sector is very diverse and museums form only a small fraction of it. It is important, however, for museums to understand their particular problems so that they can play an effective role in articulating issues of importance to them.

2. "Giving in America: Toward a Stronger Voluntary Sector," Commission on Private Philanthropy and Public Needs, Washington, D.C., 1975, p. 9. See also the report of the Commission on Foundations and Private Philanthropy published as "Foundations, Private Giving, and Public Policy" (Chicago: University of Chicago Press, 1970).

3. 26 U.S.C. § 501(c)(3).

4. See discussion of the nonprofit sector in chapter 1, "On Trusteeship." It is assumed that when "essential characteristics" are being selected, these will be tested for compatibility with arguments in support of the nonprofits section.

CHAPTER 4. THE EDUCATION OF NONPROFIT BOARDS

1. Centers for the study of the nonprofit sector are becoming more prevalent in the academic world. There is a place, however, for similar centers that focus on issues of particular concern to major subdivisions within the sector. Each type of center would benefit from the existence of the other by forcing more accurate testing of theory and by encouraging broader participation in the study of the sector as a whole.

CHAPTER 5. WHAT MAY LIE AHEAD

1. Hansmann, "The Two Nonprofit Sectors: Fee for Service Versus Donative Organizations," in *The Future of the Nonprofit Sector,* ed. V. Hodgkinson et al. (San Francisco: Jossey-Bass, 1989).

CHAPTER 6. CONTROLLED COLLECTING

1. See chapter 10, "Restricted Gifts and Museum Responsibilities."
2. See chapter 7, "Deaccessioning: The American Perspective."
3. See Appendix A for a list of codes of ethics.
4. For more complete information on drafting collection management policies, see M. Malaro, *A Legal Primer on Managing Museum Collections* (Washington, D.C.: Smithsonian Institution Press, 1985).

CHAPTER 7. DEACCESSIONING

1. Some claim the word merely demonstrates ignorance of Latin. *Ad cedere* is the Latin for "to cede to" or "accession." *Decedere* is the Latin for "to cede from" or, logically, "decession." Somehow we "deaccession" or "cede from to."
2. The exceptions are mainly archaeological objects removed from federal or Indian lands. Federal statutes control the use of these objects. States may have similar statutes regarding such materials found on state property.
3. American Association of Museums, *Museum Ethics* (Washington, D.C.: American Association of Museums, 1978). See epilogue to this chapter about the 1991 revision.
4. *Professional Practices in Art Museums* (New York: Association of Art Museum Directors, 1981 with amendments as of 1992). See epilogue to this chapter about later refinements.

CHAPTER 8. EXERCISING OVERSIGHT

1. State of Connecticut, Department of Public Safety, Division of State Police: Investigation Report #H85-354514, dated April 23, 1986.
2. *In the Matter of Arbitration between the State of Connecticut and Administrative and Residual Employees Union (P-5). Bargaining Unit: Re David White;* Office of Labor Relations File #16021730076/87 (State of Connecticut).
3. See August 7, 1986, letter to Gov. William O'Neill from Col. Lester Forst,

Commissioner of the Department of Public Safety, and John Kelly, State's Attorney (State of Connecticut).

4. See letter of February 24, 1988, from Atty. Gen. Joseph Lieberman to Gov. William O'Neill with attached investigative report titled "Colt Firearms Collection/Connecticut State Library," dated February 21, 1988.

5. See, for example, the series of articles appearing in the *New York Times* regarding the troubles of the New-York Historical Society, noting especially June and July 1988, and the early portion of 1993. Also, in the late summer and fall of 1987, the *St. Louis Post Dispatch* carried numerous front-page articles on trouble at the Missouri Historical Society. The director of the society was alleged to have taken valuable objects from the collection and to have been involved with the transfer of fakes.

6. The government and the commercial sectors are common to most societies. In the United States, "nonprofits" are so numerous and powerful that they are now referred to as the third sector of our society.

7. In addition to other chapters in this book, see, for example, Fishman, "Standards of Conduct for Directors of Nonprofit Corporations," *Pace Law Review* 7 (1987); Katz, "Museum Trusteeship: The Fiduciary Ethic Applied," *Journal of Arts Management and Law* 16 (Winter 1987). But, for a different point of view, see Marsh, "Governance of Non-Profit Organizations: An Appropriate Standard of Conduct for Trustees of Museums and Other Cultural Institutions," *Dickinson Law Review* 85 (1981).

8. *Stern v. Lucy Webb Hayes National Training School for Deaconesses and Missionaries*, 381 F. Supp. 1003, 1014 (D.D.C. 1974) (see chap. 1, n. 11); *Lefkowitz v. Museum of the American Indian, Heye Foundation*, Index No. 41416/75 (N.Y. Sup. Ct., N.Y. County, June 27, 1975); *State of Washington v. Leppaluoto* (Sup. Ct., State of Washington, Klickitat County, No. 11781, April 5, 1977) (the two preceding cases were eventually settled when the collecting organization agreed to adhere to requirements set down by the attorney general of the state in question); *Rowan v. Pasadena Art Museum*, Case. No. C 322817 (Cal. Sup. Ct., L.A. County, September 22, 1981). It is of interest to note also that, in 1988, the National Charities Information Bureau issued "Standards in Philanthropy" (nine standards by which to measure governance and management of philanthropic organizations). One segment of this document reads as follows: "The board should be an independent volunteer body. It is responsible for policy setting, fiscal guidance, and ongoing governance, and should regularly review the organization's policies, programs, and operations."

9. For a detailed discussion of collection management policies, see Malaro, *A Legal Primer on Managing Museum Collections* (see chap. 6, n. 4).

10. On the issue of acquiring good title, note especially a 1989 court decision involving a claim from the country of Cyprus against a U.S. art dealer. At issue was title to four Byzantine mosaics created in the early sixth century. The mosaics

had found their way into the commercial market and were purchased by an American art dealer. Cyprus, claiming the mosaics were national treasures, sued to recover them. One issue was whether the American dealer could establish that she had purchased the mosaics in good faith. The court found that she was not a good faith purchaser. The court reasoned that, because of the nature of the items offered and the method of offer, a prudent person would have questions about the provenance and hence the burden fell on the dealer to prove she had taken reasonable steps to investigate title. In this case, the dealer could establish that she had made only a few superficial inquiries and even these could not be documented. Also the dealer admitted that she was not an expert on Byzantine mosaics and yet she never consulted an independent expert regarding the offered items. *Autocephalous Greek-Orthodox Church of Cyprus and the Republic of Cyprus v. Goldberg & Feldman Fine Arts*, 717 F. Supp. 1374 (S.D. Ind. 1989), aff'd 917 F.2d 278 (7th Cir. 1990).

11. Some more recent cases are underscoring the importance of reporting thefts to the proper authorities. In some jurisdictions, failure to report a theft may make it more difficult for the original owner to regain the object once it surfaces, on the theory that failure to report the loss caused a statute of limitations to begin to run (see ibid., and *O'Keeffe v. Snyder*, 170 N.J. Super. 75, 405 A.2d 840, 416 A.2d 862, 1980), or on the theory that harm to the subsequent good faith purchaser must be balanced with the lack of activity by the party suffering the loss. See the many hearings on *The Soloman R. Guggenheim Foundation v. Lubell*, 153 A.D. 2d 143, 550 N.Y.S.2d 618 (N.Y. App. Div. 1 Dept. 1990), aff'd 77 N.Y.2d 311, 569 N.E.2d 426 (1991). In the *Lubell* case, the Guggenheim Museum is trying to retrieve from an alleged innocent buyer a painting the museum first suspected as missing in the mid-1960s. While it searched its own premises, it never reported the loss to the proper authorities nor did it take any steps to warn the art trade. The museum first learned of the whereabouts of the work in 1986. It was in the possession of the Lubell family, which had purchased the work in 1967 from a reputable dealer. The museum demanded the return of the work, Lubell refused, and the museum sued. After a series of hearings, the New York courts, as of 1993, had rejected the view that failure to report a loss can trigger a statute of limitations. Instead, New York appears to favor the doctrine of laches as the appropriate approach. Laches is essentially an equitable defense, where one party claims it was harmed by the negligent delay of the other party to assert its rights. The defense of laches requires the court to weigh the circumstances of the individual case. In late 1993, just before a full hearing on the laches defense, parties in the *Lubell* case reached a settlement.

12. Professional codes of ethics that relate to museums, historical societies, and so on, are listed in Appendix A.

13. See the *Cyprus* case described in n. 10 above.

14. An article in *Museum News* ([July/August 1989]: 10–12) describes how

prompt action by the Baltimore Museum of Art helped solve a series of art thefts. When the Baltimore museum discovered that a group of gold pocket watches was missing from its collection, it promptly reported this to law enforcement officials and provided detailed information and photographs of the watches to dealers and auction houses throughout the world. A New York dealer spotted the watches and law enforcement officials were able to apprehend two individuals who were responsible for a series of art robberies. When interviewed, museum officials stressed the importance of advance planning and good communications if a museum hopes to act responsibly when a theft occurs.

15. In 1987, the Library of Congress and the National Archives brought charges against Charles Merrill Mount, an art historian, for stealing rare documents from their collection. Mount was convicted and sentenced to five years in federal prison (see report in *Aviso* published by the American Association of Museums [July 1989]: 2).

16. A recent case that illustrates the difficulty of proving one's claim legally to historic artifacts is *Government of Peru v. Johnson*, 720 F. Supp. 810 (C.D. Cal., 1989) aff'd *Government of Peru v. Wendt*, 933 F.2d 1013 (9th Cir. 1991). In this case, Peru tried to establish its ownership of eighty-nine artifacts which it claimed were stolen from a Peruvian site. The defendant argued that he was a good faith purchaser. The court stated, "The plaintiff must overcome legal and factual burdens that are heavy indeed before the court can justly order the subject items to be removed from the defendant's possession and turned over to the plaintiff. The trial of this action has shown that the plaintiff simply cannot meet these burdens."

17. See list of ethical codes in Appendix A.

CHAPTER 9. THE MYOPIC BOARD

1. *NonProfit Times* 6, no. 12 (December 1992): 3.

2. As of Spring 1993 at least one such bill had been introduced into the 1993 legislative session, S. 565, "The Truth in Tax-Exempt Giving Act."

3. See n. 1, above.

4. Ibid. Reprinted with permission.

5. Address of Atty. Gen. Scott Harshbarger before the Massachusetts Hospital Association, October 27, 1992.

6. Refer back to the chapters in Part 1 with regard to defining responsibilities.

CHAPTER 10. RESTRICTED GIFTS AND MUSEUM RESPONSIBILITIES

1. The classic article in the field is Scott, "Education and the Dead Hand," *Harvard Law Review* 34 (November 1920): 1, but just as eloquent is John Stuart Mill's 1833 essay on "The Right and Wrong of State Interference with Corporation and Church Property," *Dissertations and Discussions*, vol. 1 (Boston: Little, Brown, 1864).

2. A number of states have enacted *droit moral*–type legislation—legislation that permits the artist or the artist's estate to assert some control over the subsequent use of his or her work. In 1990, a federal statute was passed, the Visual Artists Rights Act (Title VI and VII of H.R. 5316, signed into law on December 1, 1990). The federal statute grants visual artists certain rights of attribution and integrity. When copyright and/or *droit moral* considerations are applicable to a gift situation, a whole new range of issues comes into play, issues that the author makes no attempt to discuss in this chapter. It should be noted, however, that copyright and *droit moral* protection are of limited duration.

3. This chapter does not address specifically the museum that is created and, usually, funded by one individual for the sole purpose of "showcasing" the donor's possessions, such as the Isabella Stewart Gardner Museum (Boston), and Hillwood Museum (Washington, D.C.). Rather it concerns the established museum which is offered a restricted gift. The observations made in this chapter are applicable to all types of objects donated to museums: paintings, natural history specimens, and historic artifacts.

4. Di Clerico (in *"Cy Pres*: A Proposal for Change," *Boston University Law Review* 47 [1967]: 153, 167) notes: "Such an emphasis on intent [the intent of the donor] could be expected in an era [1850–1920] which placed a premium on 'rugged American individualism.' "

5. *In re Girard's Estate*, 386 Pa. 548, 127 A.2d 287, 288 (1956), rev'd by *Commonwealth of Pennsylvania v. Board of Directors*, 353 U.S. 230 (1957), rehearing den'd *Commonwealth of Pennsylvania v. Board of Directors of City Trusts of the City of Philadelphia*, 353 U.S. 989 (1957).

6. ICOM Code of Professional Ethics (1986) ICOM, Maison de l'Unesco, 1 rue Miollis 75732 Paris Cedex 15, France, Sec. 3.5.

7. *Professional Practices in Art Museums* (New York: Association of Art Museum Directors, 1981 with amendments as of 1992).

8. Ibid., 4. This statement in the 1992 code uses somewhat stronger language than that appearing in the 1981 version of the code.

9. See chapter 6, "Controlled Collecting: Drafting a Collection Management Policy." See also the International Council of Museums' Code of Professional Ethics (1986), secs. 3.1 and 6.1; chapter 3 of Malaro, *A Legal Primer on Managing Museum Collections* (see chap. 6, n. 4); and Alan D. Ullberg and Patricia Ullberg, *Museum Trusteeship* (Washington, D.C.: American Association of Museums, 1981). As of 1984, the Accreditation Commission of the American Association of Museums (AAM) considers a written collection management policy an essential for a museum seeking accreditation.

10. The author reviewed numerous collection management policies produced by a wide variety of museums.

11. Those museums that "stand firm," and there are many, rarely receive much publicity. Invariably, the spectacular "exceptions" attract the attention and this

makes it more difficult for all. With regard to statistics on restricted gifts, see n. 104 below.

12. See the definition used in the Museum Services Act (20 U.S.C. § 968(4), *Code of Federal Regulations,* vol. 45, pt. 1180). In its 1989 data report, the American Association of Museums lists more than 8,100 museums in the United States; over one-half of these are historical museums, and over one-half of all museums have annual budgets below $100,000.

13. It should be noted that some organizations, for example, science and technology museums, may not collect in the traditional sense, but these organizations do qualify as "museums" under the definition currently in use.

14. There is much debate in the museum community as to the emphasis a museum should place on structural educational programs, the forms the programs should take, and who should control this activity (curator or museum educator). The debate is not over *whether* the museum should educate but over *how* the museum should educate.

15. S. Weil, *Beauty and the Beasts: On Museums, Art, the Law and the Market* (Washington, D.C.: Smithsonian Institution Press, 1983), 53. Quoted with permission.

16. It would be difficult today to find a museum charter that did not describe the organization as educational. Also, the Internal Revenue Service has consistently recognized museums as educational organizations for purposes of qualifying for tax-exempt status under sec. 501(c)(3) of the Internal Revenue Code.

17. Whether a charity is incorporated or not can be an important consideration in certain circumstances. However, as will be seen, it does not appear to be a relevant distinction when the issue is a museum's collecting policy.

18. *Meinhard v. Salmon,* 249 N.Y. 458, 164 N.E. 545 (1928).

19. A. W. Scott, *The Law of Trusts,* 3d ed. (Boston: Little, Brown, 1967, supp. 1982), sec. 170 (hereafter *Scott on Trusts,* 3d ed.); *Restatement of the Law (second) Trusts* (St. Paul, Minn.: American Law Institute Publishers, 1959), sec. 170 (hereafter *Restatement (second) of Trusts*).

20. See chap. 1, n. 11. For a more recent general discussion of board liability, see D. Kurtz, *Board Liability: Guide for Nonprofit Directors* (Mt. Kisco, N.Y.: Moyer Bell Ltd., 1988).

21. In the District of Columbia, where the hospital is located, there is no attorney general's office. The traditional oversight powers of a state attorney general are probably lodged in the Office of the Corporation Counsel for the District of Columbia. As a practical matter, there was in the District no aggressive oversight of charitable organizations, a rather typical situation in many states. According to testimony by O. Donaldson Chapoton, deputy assistant secretary for the U.S. Department of Treasury, before the U.S. House of Representatives' Ways and Means Subcommittee on Oversight (June 22, 1987), the IRS is the central organization in the United States for ensuring that nonprofit organizations are accountable for

the benefits of tax exemption. For areas not presently covered by the tax law, he suggests mandatory fuller public disclosure by nonprofits.

22. In the *Sibley Hospital* case, the defendants were found guilty of failing to supervise the management of the hospital's investments. Because it was a case of first impression, the court did not impose a monetary fine, but it did require that annually for the next five years the board, as a group, read the court's decision so as to remind each member of his responsibilities. For further analysis of the *Sibley Hospital* case, see Mace, "Standards of Care for Trustees," *Harvard Business Review* (Jan.–Feb. 1976): 14. Note: "The Fiduciary Duties of Loyalty and Care Associated with the Directors and Trustees of Charitable Organizations," *Virginia Law Review* 64 (April 1978): 449.

23. See Marsh, "Governance of Non-Profit Organizations," 607 (see chap. 8, n. 7); Malaro, *A Legal Primer on Managing Museum Collections;* and Ullberg and Ullberg, *Museum Trusteeship,* for a broader discussion of museum trustee liability.

24. Index No. 41416/75 (N.Y. Sup. Ct., N.Y. County, June 27, 1975).

25. With regard to restricted gifts, that policy reads:

Title to all objects must be free and clear. [The museum] cannot accept specimens on which restrictions are placed, which would prevent effective research, examination, normal exhibition use, loan, or disposal in accordance with this document. [The museum] also cannot accept specimens on conditions which would require that they be placed on permanent or long term exhibition, or that the collection of which they form a part should be kept together permanently and/or displayed only as a discrete collection. Exceptions to this rule may be made for particularly rare or well-documented items, where the restrictions imposed by the donor are in accord with scientific and scholarly needs, e.g., that groups of objects never be deaccessioned except to another public institution with deaccession policies comparable to those set forth herein.

In the late 1970s the Museum of the American Indian published this collection policy in a leaflet titled "Indian Notes, vol. 12." The quotation used here appears on page 9 of that leaflet. In 1989 the Museum of the American Indian became part of the Smithsonian Institution. (See Public Law 101-185 of 1989.)

26. *State of Washington v. Lippaluoto,* No. 11781 (Wash. Super. Ct., Klickitat County, April 1977).

27. *People of the State of Illinois v. Silverstein,* 86 Ill. App. 3rd 605, 41 Ill. Dec. 821 (1976) and 408 N.E.2d 243 (1980). See also *People ex rel. Scott v. George J. Harding Museum,* 58 Ill. App. 3rd 408, 15 Ill. Dec. 973, 374 N.E.2d 756 (1978).

28. *Harris v. Attorney General,* 31 Conn. Supp. 93, 324 A.2d 279 (1974).

29. *Hardman v. Feinstein,* No. 827127 (Cal. Sup. Ct., San Francisco County, July 1984).

30. Ibid., p. 2 of plaintiff's complaint.

31. *Rowan v. Pasadena Art Museum,* No. C 322817 (Cal. Sup. Ct., L.A. County, Sept. 22, 1981).

32. When used in this chapter, the term "museum trustees" or "board of trustees" refers to the governing body of a museum. Museums that are part of governmental units or university museums may have different organizational structures from the typical museum, but, as a general rule, the observations made herein concerning "trustees" should apply to all types of museum-governing bodies. Also, as a practical matter, the director of a museum working with the staff usually formulates and suggests a collection policy to the board. While staff play an important and often major role in developing the policy, the board's informed approval and support are essential.

33. Collection activity is the core work of museums. It can be rationalized that this is one area where trustees should be held to a higher standard as distinct from areas of governance that are shared by other charitable organizations as well as for-profit organizations.

34. Some commentators suggest that nonprofit board members should be judged by business standards, but with an expansion of the ability of members of the public to sue for abuse of power. Such remarks usually focus on financial issues. See, for example, Hansmann, "Why Do Universities Have Endowments?" *Programs on Non-Profit Organizations,* Working Paper No. 109 (New Haven: Yale University, 1986), 28, and Thompson, "Financially Troubled Museums and the Law," *Nonprofit Enterprise in the Arts,* ed. DiMaggio (New York: Oxford University Press, 1986), 238. But see also Hansmann's major treatise, "Reforming Nonprofit Corporation Law," *University of Pennsylvania Law Review* 129 (1981): 500, in which he argues for a uniform and rigorous standard for all nonprofits. In the opinion of this author (Malaro), the justification for and public confidence in the entire charitable organization sector is threatened if the business standard is applied to core service activities of such organizations (regardless of whether the organization is incorporated or not). A preferable approach is to insist on a standard closer to that required of traditional trustees when core services are at issue. Such a standard gives a clear message and fair warning to board members that, overall, the activities of the charitable organization must reflect a strong public service orientation and a commitment to public accountability.

35. Under current standards, collecting is not haphazard. The object must "fill a need" in the collecting objectives of the museum. It must be worth preserving and the museum should have the means to care for it.

36. Museums that collect contemporary art or current history can only make educated guesses. Invariably selections must be reevaluated after time has provided a better perspective. Also, subsequent research can establish that a collection object, no matter what the discipline, is a fake or is misattributed.

37. For most museums, only a small portion of collections are displayed at one time. Exhibits may be designed for the long term (often called permanent ex-

hibits) or for relatively brief periods (temporary exhibits) depending on the then current public-oriented educational objectives of the museum. The fact that an object is not on display does not mean it is not being utilized for educational purposes. All collection objects and their documentation are available to scholars, researchers, and other interested parties. As a practical matter, a museum contributes most to the advancement of knowledge by its maintenance of comprehensive collections for research purposes.

38. Consider the exhibit techniques that were popular in this country many years ago: the room replications, the display in one area of works by the same artist, rooms dedicated to gifts from a single donor, and so on. Today, the formulation of an exhibit incorporates many scholarly, educational, and technological advances that alter radically these older methods of presentation.

39. *In Re Hill's Estate* 119 Wash. 62, 204 P. 1055 (1922).

40. *Central University of Kentucky v. Walters' Executors* 122 Ky. 65, 90 S.W. 1066 (1906), 83.

41. *Wilstach Estate* 1 Pa. D.& C.2d 197 (1954), 207.

42. See cases described in earlier section titled "Obligations of Museum Trustees."

43. See n. 31 above.

44. The natural response is that donors will not give if their conditions are not accepted and, therefore, the public will get nothing. Over fifty years ago, Blackwell in "The Charitable Corporation and the Charitable Trust," *Washington University Law Quarterly* 24 (1932): 1, noted strong support for this argument when the question at issue was whether charities should assert more control over their endowment funds. One commentator insisted that more control by charities would "destroy the very foundations of our endowed institutions" (p. 32). In fact, more flexibility has been allowed in this area and donors have continued to give. According to recent research conducted by Elizabeth Boris of the Council on Foundations (*America's Wealthy* [New York: The Foundation Center, 1987]), individuals who create foundations are usually motivated primarily by a desire to help others, not by a desire to create memorials to themselves. This indicates that donors, if seriously challenged regarding proposed restrictions, may well withdraw their demands. See also n. 104 below.

45. If, for example, endowment funds were at issue, the conflict usually would be much more remote (assuming the purpose of the endowment is sufficiently broad). The fact that the charity could not invade principal and had to be cautious when investing such funds would not, as a rule, constitute a real conflict with the charity's obligation to its public. While the endowment may restrict the amount of funds available to accomplish a purpose, if properly drafted it does not dictate how the purpose is to be achieved. This is a crucial difference when the purpose is education. It should be noted that in the early 1970s, when "growth stock" was much more profitable than traditional investments, there

was great pressure to move charities toward the adoption of the "total return" concept for the determination of an appropriate portion of realized and unrealized gain in investments to be allocated as "expendable" income of an endowment fund. Advocates of the total return concept, a concept that eventually gained broad acceptance, argued the merits of giving fund managers more flexibility to determine, in light of contemporaneous events, what constitutes prudent investment for the long-term health of the fund. If the issue of flexibility is so important in fund management, why are museums so ready to accept restrictions that directly affect scholarly judgments? See Cary and Bright, "The Developing Law of Endowment Funds: The Law and the Lore Revisited," a Report of the Ford Foundation (New York, 1974).

46. While problems of "influence" associated with corporate sponsorship were recognized early, time showed that once again the museum community proved itself better at rationalizing than at taking a stand. One by one, policies in many museums were changed to accommodate corporate marketing goals.

47. *Estate of Rothko,* 43 N.Y. 2d 305, 372 N.E. 2d 291, 401 N.Y.S. 2d 449 (1977). On remand 95 Misc. 492, 407 N.Y.S. 2d 954 (1978) at. p. 935, citing George Gleason Bogert, *The Law of Trusts and Trustees,* rev. 2d ed. (St. Paul, Minn.: West Publishing, 1977), sec. 481, p. 130. See also *Conway v. Emery,* 139 Conn. 612, 96 A.2d 221 (1953), a case involving museum trustees who were charged with favoring, but not for personal advantage, a third party to the detriment of the museum. Also, it is worth noting that in *Hardman v. Feinstein* (n. 29, above) one of the mismanagement charges lodged against the defendant trustees was that the trustees favored socially influential and prominent private individuals by allowing them special privileges with regard to the museum's collections.

48. *Stern v. Lucy Webb Hayes National Training School for Deaconesses and Missionaries* (see chap. 1, n. 11), at p. 1018.

49. See "Obligations of Museum Trustees," within this chapter.

50. There is a range of serious governance questions facing nonprofits today. As is stressed in these chapters, the fate of the nonprofit sector hangs in good measure on the willingness of trustees to give the time and attention necessary to study these issues so that foresighted decisions are possible.

51. Although it is conceded that maintenance, management, and conservation of collections are among the most expensive activities of a museum ("Caring for Collections," a report on an American Association of Museums project, Washington, D.C., 1984), little has been published regarding actual costs. In the 1983 proceedings of the American Law Institute–American Bar Association seminar on "Legal Problems of Museum Administration," Washington architect George E. Hartman, Jr., did offer some estimates on museum space cost based on his professional experience. He quoted a $50 per square foot per year figure for space and operation costs and estimated that it took two square feet to store the average art or history object and fifty square feet to display such an object. He pointed out

that his figures were most conservative. H. J. Swinney, director of the Strong Museum in Rochester during the construction of the museum's new building in 1979–81, stated in a letter to the author (dated December 8, 1986) that the Strong's new building cost about $100 per square foot to construct (this includes land, professional fees, construction, interior finishing, and capitalization of construction for the first three main exhibits). At the Strong when exhibits are designed, the rule of thumb is that every square foot of exhibit units (for example, cases and pedestals) must be surrounded by a minimum of nine square feet of space for visitors to stand on. Swinney also points out that the storage areas in the new building have an expensive automatic heating, ventilating, and cooling system, and the areas are designed so that atmospheric conditions can be maintained within narrow limits. Many museums that maintain archaeological collections are in the process of determining the costs of preparing and maintaining these collections. (Because federal and state laws require long-term curation of certain materials excavated from public lands, cost figures are of great interest.) Information on some of these cost analysis projects can be obtained from the Archeological Assistance Division, National Park Service, U.S. Department of the Interior, Washington, D.C.

52. Charles Parkhurst, in "Art Museums: Kinds, Organizations, Procedures, and Financing" (*On Understanding Art Museums,* ed. Sherman Lee [New York: The American Assembly, 1975], 88–89), had this observation:

> It must be said that restrictions are, from the point of view of the museum, both undesirable and cumbersome, but museums cannot always be choosey and a stiff-necked director or board chairman who turns down a restricted but otherwise beneficial gift offer may learn that he has substituted his personal prejudice for institutional morality and shunted a most desirable donation to another beneficiary.

(Reprinted with permission.) The statement is a most revealing one.

53. The late Ralph Colin, then administrative vice-president of the Art Dealers Association of America, submitted testimony to Congress in 1983 to the effect that except for the very few museums that have substantial acquisitions funds, 90% to 95% of museum annual acquisitions come from gifts and legacies. (See F. Feldman and S. Weil, *Art Law* [Boston: Little, Brown, 1986], sec. 13.1.1 for more details.) With prices for art increasing dramatically each year, these percentages may now be even higher.

54. Reinhardt, *New York Times,* November 11, 1985, p. C-13.

55. To commemorate the opening of the re-created villa, the Dallas Museum of Art published a lavish catalog that contains a lengthy illustrated biography of the donors and a description of the gift negotiations. See "Wendy and Emery Reves Collection," Dallas Museum of Art, 1985.

56. Ibid., 68–69. Reprinted courtesy of the Dallas Museum of Art.

57. Gardner, "At Home in the Dallas Museum of Art," *Art News* (January 1986): 13.

58. Statement of the director of the museum as quoted in Hartman, "Have I Got a Collection for You," *Texas Monthly* (November 1985): 192.

59. For example, in addition to the citations already given, see Dillon, "Setting for Reves Collection Faithful but Undistinguished," *Dallas Morning News*, November 24, 1985, pp. C-1, C-11; Hoving, "My Eye," *Connoisseur*, April 1986, 19; Kuter, "Rating the Reves Collection," *Dallas Morning News*, November 24, 1985, pp. C-1, C-11; Sokolov, "Wendy's Villa in Dallas," *Wall Street Journal*, January 19, 1986, p. 28; Taylor, "Texas-Sized Artistic Renaissance," *Washington Post*, January 30, 1984, pp. 1, 3.

60. Letter of D. Blinken of the Rothko Foundation to J. Carter Brown, director of the National Gallery of Art, dated December 21, 1983.

61. From the standard gift offer letter sent to museums by the Rothko Foundation. It should be noted that the National Gallery of Art made no commitment to accept at a later date any of the Rothkos given to other museums.

62. In years to come, whether a work is appropriate or not for a museum may depend not on the quality of the work but on the subject or artist. This is because sometimes museums change their focus. For example, the Pasadena Art Museum changed its focus from contemporary art to more traditional works. In the judgment of its trustees, this necessitated deaccessioning certain contemporary works in order to acquire selected traditional ones. The National Museum of American Art once collected eclectically. When its purpose was more narrowly defined, a substantial group of European works was no longer suitable for the museum. It is not unusual for any type of museum, as it matures, to narrow or reform its scope of collecting. In fact, today especially in the history and natural history fields, there are many who believe that in order to collect effectively, museums among themselves must divide collecting responsibilities and rearrange collections accordingly.

63. A possible violation of the Rule Against Perpetuities (see n. 66, below). Also, a possible tax problem for the donor.

64. An *inter vivos* gift is one made during one's life. A bequest is a transfer accomplished by will.

65. The Fifth Amendment to the U.S. Constitution prohibits the federal government from taking property without due process of law. The Fourteenth Amendment prohibits the states from taking property without due process of law. State constitutions invariably reaffirm this protection of property rights. In practice, what this means is that property rights are secure from government interference unless it can be proven that an overriding public interest requires limitation of these rights.

66. See introductory pages of this chapter. It should be noted that under what is called the Rule Against Perpetuities, the creator of a private trust (as distinct

from a charitable trust) can control property by means of the trust only for a limited time. It is deemed to be in accord with public policy to limit the control of the "dead hand" over private property. The Rule Against Perpetuities, however, is not traditionally applied to charitable trusts under the reasoning that charitable trusts benefit the public. See Scott, "Education and the Dead Hand," and Di Clerico, "*Cy Pres*: A Proposal for Change," for discussion of the merits of exempting charities from the Rule Against Perpetuities.

67. Attorneys who advise donors and museum staff who deal with donors are quite familiar with this attachment.

68. An individual who collects unusual items (objects the average person might consider commonplace or trivial) often feels more vulnerable when donating. While realizing that the present administration of the museum acknowledges the historic value of the collection, he or she isn't sure the next regime will be as "foresighted." This type of donor is more likely to want restrictive language.

69. Historical organizations that collect family memorabilia (for example, grandmother's quilt, grandfather's army uniform) face this reaction often. An example is the DAR Museum in Washington, D.C.

70. In the Reves Collection case (see earlier discussion), the donor made it very clear that the gift was to mirror the lifestyle of the donor and her husband; it was to memorialize their standards.

71. See discussion, "Adherence to Trust Purpose Agreement," earlier in this chapter.

72. There is also a form of action called "equitable deviation" which is used when a change is requested not in the donor's purpose, but in the method required by the donor to accomplish the purpose. All of this can get rather muddled and it is not necessary for the purposes of this chapter to belabor the distinction. Accordingly, when the term *cy pres* is used herein, it should be interpreted to cover "equitable deviation" action also.

73. See, for example, *Cleveland Museum of Art v. O'Neill*, 57 Ohio Op. 250, 129 N.E.2d 669 (1955), and *Harris v. Attorney General*, 31 Conn. Sup. 93, 324 A.2d 279 (1974).

74. See Di Clerico, "*Cy Pres*: A Proposal for Change." This approach, of course, would require the court to fault trustees of general purpose museums (refer to n. 3) for accepting such restrictions.

75. See cases discussed earlier, under "Obligations of Museum Trustees."

76. See Bogert, *The Law of Trusts and Trustees*, sec. 369.

77. "State action" requires a finding that the government is substantially involved in the activity. If this finding can be made, constitutional safeguards can be applied.

78. The classic trust case might be the *Girard Trust* situation, which spawned sufficient litigation to keep an army of lawyers busy for generations. Mr. Girard

died in 1831, leaving a good portion of his considerable fortune to the City of Philadelphia to establish a college for "poor, white male orphan children." For over 120 years that section of his will was the subject of repeated legal challenges. The first questioned whether the establishment of a college was a charitable purpose and the last series of attacks dealt with the discrimination aspects. Unwittingly, Mr. Girard probably contributed more to the advancement of trust lawyers than he did to the education of orphans.

79. Friendly, "The Dartmouth College Case and the Public-Private Penumbra," *Texas Quarterly Second Supplement* 12 (1969): 9, at p. 12.

80. Clark, "Charitable Trusts, the Fourteenth Amendment and the Will of Stephen Girard," 1001, reprinted by permission of The Yale Law Journal Company and Fred B. Rothman & Company from *Yale Law Journal* 66 (1956–57): 979–1015.

81. In other words, once this line of reasoning is used, it is difficult to control over-broad applications.

82. See, for example, the pros and cons enunciated by Surrey, "Federal Income Tax Reform: The Varied Approaches Necessary to Replace Tax Expenditures with Direct Governmental Assistance," *Harvard Law Review* 84 (1970): 352; Stone, "Federal Tax Support of Charities and Other Exempt Organizations: The Need for a National Policy," *California Tax Institute* 20 (1968): 27; Andrews, "Personal Deductions in an Ideal Income Tax," *Harvard Law Review* 86 (December 1972): 309; A. Feld et al., *Patrons Despite Themselves* (New York: New York University Press, 1983); A. Pifer, *Philanthropy in an Age of Transition* (New York: The Foundation Center, 1984). For a comprehensive summary see Simon, "Tax Treatment of Nonprofit Organizations," in *The Nonprofit Sector,* ed. Walter Powell (New Haven: Yale University Press, 1987).

83. 461 U.S. 574, 103 S.Ct. 2017, 76 L.Ed.2d 157 (1983).

84. Ibid., 586.

85. Ibid., 592.

86. Ibid.

87. Consider, however, the common law doctrine of public dedication. Under this doctrine, which applies usually to real property not personal property, if an owner offers the use of his property to the public, and the offer is accepted, the property is considered "dedicated" and must be administered to benefit the public. Under case law, the dedicator cannot impose conditions inconsistent with the character of the dedication "or which take the property dedicated from the control of the public authorities . . . and the dedication will take effect regardless of such condition(s) which will be considered void." *Kuehn v. Village of Mahtomedi,* 207 Minn. 518, 524, 292 N.W. 187, 190 (1940). See also *Village of Grosse Pointe Shores v. Ayres,* 254 Mich. 58, 235 N.W. 829 (1931); *Kirsch Holding Co. v. Manasquan,* 24 N.J. Super. 91, 93 A.2d 582 (1952). Property that has been "dedicated" is frequently referred to as property "held in trust for the public" and in this way is

similar to property in a museum's collection.

88. The previously cited codes of ethics promulgated by the museum community and the implementation of these codes would be relevant. There are cases that cite codes of ethics in order to support a public policy finding, but much depends on the particular circumstances of each case. As a general rule, codes of ethics are not per se evidence of public policy. See Lind and Ullberg, "Museum and Professional Codes of Conduct: Are These Beginning to Acquire the Force of Law?," ALI-ABA Course of Study, *Legal Problems of Museum Administration* (1987), pp. 341 et seq.

89. *Green v. Connally,* 330 F. Supp. 1150, aff'd; *Coit v. Green,* 404 U.S. 997, 30 L.Ed.2d 550, 92 S.Ct. 564 (1971). See also *Scott on Trusts,* 3d ed., sec. 368, and Bogert, *The Law of Trusts and Trustees,* sec. 369.

90. See also Schoenblum, "The Changing Meaning of Gift," *Vanderbilt Law Review* 32, no. 8 (1979): 64; Griswold in the foreword to Hart and Arnold, "Time and Attitudes," *Harvard Law Review* 74 (1960): 81.

91. In one case, however, the Internal Revenue Service has ruled that a gift of land which had been dedicated to agricultural use had to be valued at a less advantageous figure (i.e., one reflecting the restriction) for the purpose of determining the charitable contribution deduction. Rev. Rul. 85-99, I.R.B. 1985-27, 7 (July 1985). This situation presented a relatively easy valuation problem when compared to the typical restricted gift to a museum.

92. *Meinhard v. Salmon.*

93. Consider, for example, the many recent challenges to the charity's favored position with regard to the IRS Code, property tax exemption, and postal rates, brought on by a perception that charities are becoming too business oriented, too removed from their public purposes.

94. See n. 32 above.

95. The question could be raised whether the collection management policy in place when a gift is made binds a museum with regard to that gift. A collection management policy reflects current professional standards and such policies are reviewed periodically by a museum's governing authority and revised, as necessary. (The International Council of Museums in its Code of Professional Ethics, Section 3.1 [1986], suggests that such policies be reviewed at least once every five years.) Because the policies are public documents, there is little incentive to adopt revisions that are regressive. Thus, the public would be better served, as a rule, if it were understood that a museum collection should be managed under the current collection management policy regardless of the date of acquisition of individual objects. (This is not to imply that museums that have accepted restricted gifts can, on their own initiative, decide to start administering those gifts in accordance with their collection management policies. Once a binding restriction has been accepted, legal advice should be sought regarding possible relief.)

96. The de Groot matter concerned a major gift with precatory language made

to the Metropolitan Museum of Art. Miss de Groot left a substantial collection of art to the Metropolitan with the "wish" (not command) stated in her will that if the Metropolitan chose to dispose of any of the works, they be given to other museums. In time, the Metropolitan deaccessioned some of the works and decided to sell them in order to obtain funds for new acquisitions. Unfavorable publicity followed. It was the Metropolitan's position that there was no legally binding restriction against sale. The New York attorney general did not contest. A more complete description of the controversy can be found in J. Merryman and A. Elsen, *Law, Ethics and the Visual Arts* (New York: Matthew Bender, 1979), chap. 7, pt. D.

97. See Malaro, *A Legal Primer on Managing Museum Collections*, chap. 4, sec. E.

98. *Howard Savings Institution v. Peep*, 34 N.J. 494, 170 A.2d 39 (1961).

99. *Morgan Guaranty Trust Co. of New York v. President and Fellows of Harvard College*, No. E 1855 (Mass. Probate Ct. for Worcester, Dec. 20, 1983).

100. Ibid., Conclusions of Law.

101. Also in both cases, the burden of bringing court action was placed on the estate in question, not on the charities.

102. See nn. 44 above and 104 below.

103. A. B. Giamatti, "Private Sector, Public Control, and the Independent University," Baccalaureate address, Yale University, May 24, 1980. Colleges and universities have always been more aggressive in preserving their intellectual freedom, and issues concerning appropriateness of gift restrictions are constantly debated. See, for example, "When the Price Is Too High," *Newsweek on Campus*, November 1987, 19.

104. While it is evident that unrestricted gifts to museums far exceed restricted ones, no accurate statistics are available. The problems encountered in gathering such statistics are enormous. Aside from the sheer volume of transactions to be studied, there must be consistency in interpreting the term "restricted," a determination of whether value or number will control and, if value is used, a uniform method of valuation. Considering the usefulness of the information to be gleaned, such a survey is not worth the effort. There are, however, statistics available in the foundation world. Alan Pifer in his 1969 essay, "Foundations and the Unity of Charitable Organizations" (reprinted in A. Pifer, *Philanthropy in an Age of Transition* [New York: The Foundation Center, 1984], 44), states that as of 1967, of the foundations controlling 98.5% of total foundation assets, 91% operated under broad general charters. Pifer points out that most donors of foundations are governed by the philosophy that "they should leave maximum discretion to future trustees." He quotes Andrew Carnegie on p. 50:

> No man of vision will seek to tie the endowment which he gives to a fixed cause. He will leave to the judgment of his trustees, as time goes on, the question of modifying or altogether changing the nature of the trust, so as to meet the requirements of the time. Any board of trustees is likely to become indiffer-

ent or careless or to make wrong decisions. In the perpetual trust, as in all human institutions, there will be fruitful seasons and slack seasons. But as long as it exists, there will come, from time to time, men into its control and management who will have vision and energy and wisdom, and the perpetual foundation will have a new birth of usefulness and service.

Reprinted with the permission of The Foundation Center.

105. Daniel Catton Rich, "Management, Power and Integrity," in *On Understanding Art Museums*, ed. Sherman E. Lee (New York: The American Assembly, 1975), 154. Reprinted with permission.

CHAPTER 11. LENDING FOR PROFIT

1. In October 1993, the Barnes Foundation sought court permission to extend the tour to include stops at the Kimball Art Museum in Fort Worth, Texas, and the Art Gallery of Ontario in Toronto. The petition for extension claimed that the Fort Worth stop would generate $3 million in revenue for the foundation and the Ontario stop $3.2 million. In February 1994, the court approved the extension.

2. Martin Feldstein, ed., *The Economics of Art Museums* (Chicago: University of Chicago Press, 1991).

3. Ibid., 29–30.

4. Ibid., 69.

5. Ibid., 53–57.

6. Ibid., 7.

7. Raspberry, "Defining Deviancy Down," *The Washington Post*, December 28, 1992, p. A15. The Moynihan article referred to is cited as appearing in *The American Scholar* (Winter 1993).

CHAPTER 12. POOR SUE

1. See, for example, Browne, "A Dinosaur Named Sue Divides Fossil Hunters," *New York Times*, July 21, 1992; Frankel, "Tyrannosaurus Lex," *The American Lawyer*, December 1992, 45–50; Morell, "G-Men Capture T-Rex," *Discover*, January 1993, 80–82; Retallack, "Fossils Are for Everyone," *Newsweek*, January 11, 1993, 8; *Black Hills Institute of Geological Research v. U.S. Department of Justice*, 812 F. Supp. 1015 (D.S.D., 1993)

2. The Antiquities Act of 1906. 16 U.S.C. Sec. 432, et seq.

3. Ibid., Sec. 433.

4. *The United States v. Diaz*, 499 F.2d 113 (9th Cir. 1974).

5. Ibid., 114–15.

6. For a general discussion of laws pertaining to the protection of fossils see *Paleontological Collecting*, a report prepared by a committee of the Board of Earth Sciences, National Research Council (Washington, D.C.: National Academy Press, 1987).

7. The Archeological Resources Protection Act of 1979, 16 U.S.C. §§ 470aa–ll.

8. National Natural Landmark Program, *Code of Federal Regulations*, vol. 36, pt. 62.

9. Materials Act of 1947, 30 U.S.C. §§ 601, 602.

10. See *Paleontological Collecting*, appendix R, pt. 4, for a summary of state laws as of 1987.

11. See, for example, the *Black Hills Institute* case.

12. Senate Bill 3107 of the 102d Congress, 2d Session.

13. Rogers, "Visigoths Revisited: The Prosecution of Archaeological Resource Thieves, Traffickers, and Vandals," *Environmental Law and Litigation* 2 (1987): 47–92. (Quoted with permission.) See also Northey, "The Archeological Resources Protection Act of 1979: Protecting Prehistory for the Future," *Harvard Environmental Law Review* 6, no. 61 (1982): 61 et seq.

14. See, for example, the U.S. General Accounting Office report, *Cultural Resources: Problems Protecting and Preserving Federal Archeological Resources* (December 1987). Mounting evidence of poor curation of federally owned archeological material resulted in promulgation of uniform standards for federally owned material in 1990. In this regard see: Curation of Federally Owned and Administered Archeological Collections, *Code of Federal Regulations* 36, pt. 79 (published Sept. 12, 1990).

15. See, for example, *United States v. McClain*, 545 F.2d 988 (5th Cir. 1977), 593 F.2d 658 (5th Cir. 1979), *cert.* denied 444 U.S. 918, and a discussion of that case in Malaro, *A Legal Primer on Managing Museum Collections*, 82 et seq. (see chap. 6, n. 4).

16. "Convention on the Means of Prohibiting and Preventing the Illicit Import, Export and Transfer of Ownership of Cultural Property," adopted by the General Conference of UNESCO at its sixteenth session, Paris, November 14, 1970.

17. Convention on Cultural Property Implementation Act, Title II of Public Law 97-466 of 1982, 19 U.S.C. §§ 2601, et seq.

CHAPTER 14. REPATRIATION AND THE LAW

1. Two articles that demonstrate the importance of time and effort for the successful dispositions of repatriation claims are Merrill, Ladd, and Ferguson, "The Return of the Ahayu:da: Lessons for Repatriation from Zuni Pueblo and the Smithsonian Institution," in *Current Anthropology* (December 1993), and Gonyea, "Give Me That Old Time Religion," *History News* (March/April 1993).

APPENDIX B. INTERNATIONAL COUNCIL OF MUSEUMS CODE OF PROFESSIONAL ETHICS

1. "The Conservator-Restorer: A Definition of the Profession," *ICOM News* 39, no. 1 (1986): 5–6.